PATAN MUSEUM

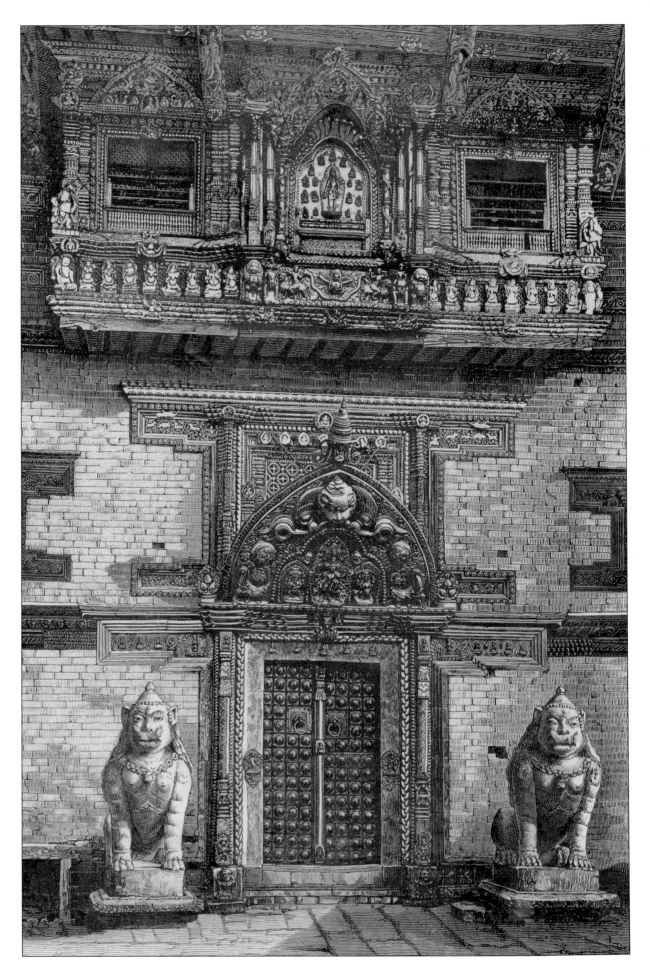

The portal and the Golden Window of *Keshav Narayan Chowk*, the former palace of the kings of Patan (compare with page 42). *Wood engraving after a photograph taken by Gustave Le Bon in* 1885

Götz Hagmüller

with contributions by

Shaphalya Amatya, Kanak Mani Dixit, Usha Ramaswamy,
and Mary Shepherd Slusser

PATAN MUSEUM

The Transformation of a Royal Palace in Nepal

Published in association with the Patan Museum

Serindia Publications
London

ISBN 0 906026 58 x

First published in 2003 by
Serindia Publications
10 Parkfields
London, SW15 6NH

Distributed outside the
United States & Canada by
Thames and Hudson Ltd.

British library Cataloguing
in Publication Data
A catalogue record for this
book is available through the
British Library.

Designed by
Thomas Schrom

All drawings by the author
unless otherwise stated

Edited by Anne Hobbs and
Donald Dinwiddie

Printed in Hong Kong

Funded by Austrian
Development Cooperation

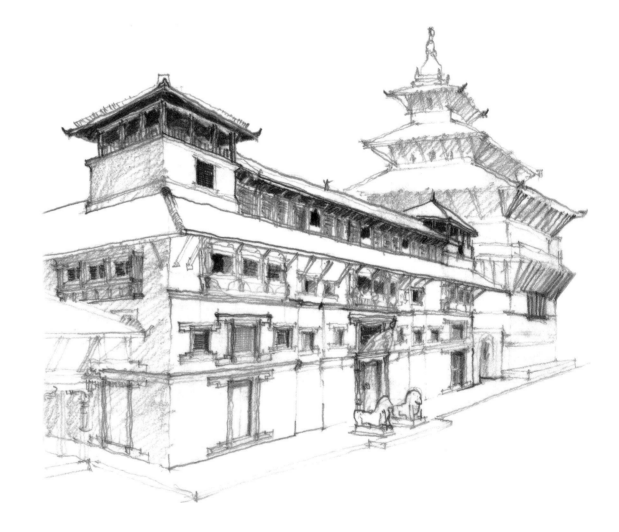

right: **Patan Museum**
(Keshav Narayan Chowk)
drawing by Thomas Türtscher, 1989

Contents

PATAN
MUSEUM

The Endless Knot *(granthi)*. This ancient sign, already found on seals of the Indus Valley civilization, has become one of the eight auspicious symbols of Buddhism, representing an ingeniously abstract image of the endless cycle of rebirths.

The two bronze plaques flanking the entrance to the museum were made in the lost wax casting process, a craft highly evolved in Patan. *Photos Rupert Steiner*

Acknowledgements

Creating this book entangled me like the Buddhist Endless Knot: as I searched further and further back for my motives, the recollections and reviews seemed never-ending. Three good and strong midwives were essential for bringing the process to fruition. Over the years, I have been lucky to work with these colleagues on challenging projects and to intimately discuss our inspirations and reasons for decisions in life and design.

Erich Theophile prompted me to start writing in earnest, to clarify structure and contents, and to maintain the pace. His help with my convoluted and unclear original drafts was a labor of love. To Niels Gutschow I owe the most profound introduction to Kathmandu Valley architecture and to the spiritual dimensions of urban space in this part of the world where we live. He encouraged me to be very personal where it matters and to not submit to objective reasoning only. Thomas Schrom renovated the palace, built the museum and everything in it after my smudgy pencil designs, and shared the challenge of designing this book. Without him, it would not look as it does.

Our discourse, sometimes across continents, gradually shaped my text. It grew from irregular notes, to a lecture in Vienna in 1990 (later published as a booklet), and on to a presentation of the museum project at a symposium in New Delhi in 1996. An illustrated project documentation compiled with Thomas Schrom helped secure approval for publication funding from the Austrian Development Cooperation and got publisher Anthony Aris involved as our mentor.

For their critical reviews of the draft, I am grateful to my brother and fellow architect, Roland Hagmüller, who earlier had guided my first insecure design steps for the museum; to my most influential teacher in architecture, Günther Feuerstein; and to Eduard Sekler, who initiated the palace's restoration and advised me on questions of conservation doctrine.

I was inspired by the works of several authors whose concise and often poetic quotations I used as epigraphs that set forth the major themes of this book. *A Pattern Language* by Christopher Alexander helped me understand the idioms and quality of good building and writing. *Towards a New Museum* by Victoria Newhouse, a comprehensive and critical study on the subject at hand, affirmed my own views on "wings that don't fly" – and those that do – in museum design. Jun'ichiro Tanazaki's deeply pensive essay *In Praise of Shadows* induced me to grasp the value of darkness. *Invisible Cities*, Italo Calvino's beautiful book, took me to 55 awesome and wonderful cities, all adding up to an imaginary canvas of Venice, the only one real in the dreams of Marco Polo.

I thank Mary Slusser and Usha Ramaswamy for allowing me to include their original texts and articles; Kanak Dixit for pouring his heart into the sad subject of Nepal's stolen gods; and Shaphalya Amatya for his informative preface and long lasting friendship. Further acknowledgements in the Project Credits list all who worked on creating the Patan Museum.

Finally, to Ludmilla Hungerhuber, who has given me unfailing support and transformed my handwriting into digital mode, you deserve, and have, my deepest affection.

G.H. Bhaktapur, June 2002

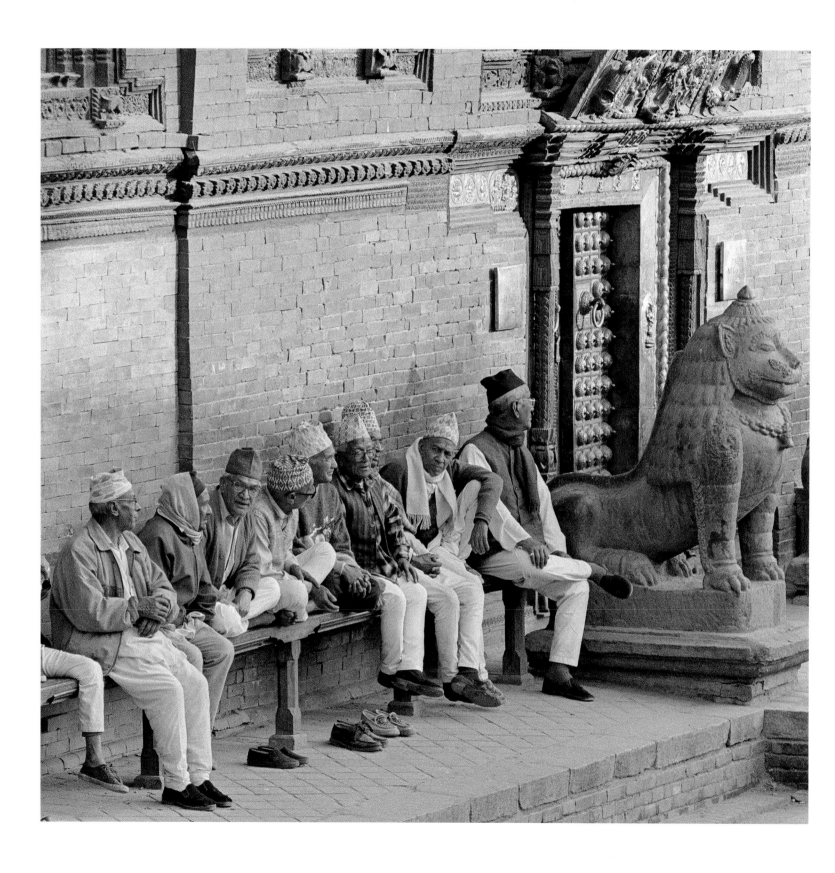

Shaphalya Amatya

Preface

"Isn't it heaven on earth?" With these words, the poet Kunu Sharma praised Patan Darbar Square in 1652 AD and devoted two stanzas to the beauty of Keshav Narayan Chowk which is now the Patan Museum.

Around the same time, the first ever western visitor came to Nepal, the Austrian Jesuit (and mathematician) Johannes Grueber whose published reports were the first eyewitness accounts of our country and culture in Europe. His gift to King Pratap Malla is said to have been not a cross (which may have been expected of a missionary), but a telescope, probably the first piece of western technology to arrive in Nepal.

Some 300 years later, relations between Nepal and Austria were established during the 1960s and 1970s by Austrian individuals in their personal and professional capacities. Carl Pruscha, a physical planner and architect in the services of UNDP, helped Nepal in preparing a detailed inventory of the Kathmandu Valley's monuments and cultural sites. The two volumes, *Kathmandu Valley: Preservation of the Physical Environment and Cultural Heritage, a Protective Inventory*[1] were published with Austrian financial support in Vienna in 1975.

While preparing this inventory, Carl Pruscha was supported by his scholarly friend and mentor Professor Eduard Sekler, the eminent Austrian architectural historian at Harvard University. From the first of his frequent visits to Nepal, Sekler had cultivated a deep sense of attachment to our country and more particularly to the Kathmandu Valley culture. In 1975, upon a request from His Majesty's Government of Nepal, UNESCO sent a team of consultants under his lead-

ership to Kathmandu to prepare a conservation master plan of the cultural heritage in the Kathmandu Valley.[2] Published in 1977, this basic document is still the blueprint for the government's efforts in heritage conservation. The master plan has helped Nepal to nominate seven historical sites within the Kathmandu Valley to UNESCO's World Heritage List – among them, the Patan Darbar – and to seek international assistance for their preservation.

This in turn enabled Eduard Sekler to persuade the Austrian government to contribute bilateral aid to these efforts. Considering the Patan Darbar Square to be one of the most beautiful squares of the world, his proposal was to restore one of the courtyards of its palace complex. Called Keshav Narayan Chowk after the shrine in its center, or "Golden Window" for its most prominent feature, this quadrangle had once been the residence of the Malla Kings of Patan. Sekler selected its northern wing as being in most urgent need of repair, and it is from this relatively modest beginning in renovation that a more comprehensive concept evolved over successive stages of expansion, eventually to include the entire building and its neglected garden area, in the development of the Patan Museum.

From its beginning in 1982 to its completion in 1997, the project evolved in cooperation with the Department of Archaeology of His Majesty's Government of Nepal and Austria's Institute of International Cooperation (IIZ). During these 15 years, the project coordinator was Götz Hagmüller, the third architect in a succession of Austrian conservation advisors to His Majesty's Government of Nepal. He had come to Nepal earlier, in 1979, as manager of the Bhaktapur

Detail of a stone relief at Mohan Chowk of Hanuman Dhoka palace in Kathmandu: a child in the lap of a court lady (or of the queen herself?) peers through the telescope presented to Pratap Malla by an Austrian Jesuit in 1660.
Photo courtesy of the Royal Palace, Kathmandu

left: Vanished long ago, the wooden benches in front of the palace have been reconstructed, providing a welcome resting place for the elders of the local community. The square in front is again free of motor traffic after many years.
Photo Mani Lama

Pencil sketch of *chörtens* in Upper Mustang.
The Kali Gandaki Valley used to be an important route for the trading of goods and the spread of religious beliefs between Tibet, Nepal, and the Indian plains.

Development Project, the first and most comprehensive urban conservation programme in Nepal undertaken with German assistance. This experience in Bhaktapur, and his choice of residence there, in a historical Math, has kept him living and working in Nepal with assignments in various bilateral projects. Worth mentioning is his part (together with Niels Gutschow) in preparing the 1989 *Svayambhunath Conservation Masterplan*[3] and in reconstructing the Cyasilin Mandap, the "Pavilion of the Eight Corners"[4] in Bhaktapur (against which, independently, both Professor Sekler and I had originally voiced our reservations: luckily, we conservationists do not always agree). Gutschow and Hagmüller were also involved in the first exploration of the architectural heritage of

Upper Mustang after this previously restricted area on the border with Tibet was opened for research and tourist development in 1991.

In Patan, Götz Hagmüller widened the scope of the project early on, from the mere renovation of the palace to its conversion into a museum complex. He later succeeded in convincing both countries concerned to change the project definition - from the previous bilateral mode of funding and implementation to a project on a "turn-key" basis. For the last seven years, Austria supplied the entire budget and technical assistance, with the Department of Archaeology, as the custodian of the national heritage of Nepal, retaining its legal authority of conservation control.

The "Pavilion of the Eight Corners" on Bhaktapur Darbar Square, reconstructed from 1987 to 1990 by Niels Gutschow and Götz Hagmüller (see also page 15). *Photo Dornik & Stadler*

we are grateful that her project assignments were made possible by Austrian funding. Her conceptual and scientific work for what has become the Patan Museum have proven a powerful catalyst for looking at our cultural history with new focus and appreciation.

Another unique feature of this museum is its operational concept. For the first time in Nepal, a museum of the public domain has been conceived as a semi-autonomous and economically self-sustaining institution. Already a few years after its opening to the public, its performance can be judged as a solid success. With 15 years of mutual effort and generous help from the Austrian government, not only has a palace been restored to its original beauty, but also a museum of international reputation has been established in Nepal.

The Patan Museum was finally inaugurated on October 28, 1997 by His Majesty, the late King Birendra Bir Bikram Shah Dev in the presence of Mrs. Benita Ferrero-Waldner, the Austrian Minister of State for Foreign Affairs, with a festive concert given by Austrian and Nepalese music ensembles. The audience was enchanted by the harmonious blend of ancient ritual, architecture and music. This was the happy meeting of two distant cultures from the same historical period: the ambience of a candle-lit Malla palace court filled with the sounds of tabla and flute, and enlivened by the notes of Vienna's classical era of music.

Instrumental in bringing about these improvements were the IIZ and its project administrator, Mrs. Gertrude Leibrecht. She had the full support of Austria's development cooperation officials, Mrs. Heide Fenzel and Mr. Günther Stachel, who have been behind the project from the start.

Under this intensified cooperation programme, additional manpower was provided not only from the local resource base of Nepalese craftsmen and consultants but also from abroad. Another Austrian expert, Thomas Schrom, joined the project full-time as its manager, construction supervisor and visual design specialist, as did a range of other Austrian and American consultants. Most prominent among these was Mary S. Slusser, and

Dr. Shaphalya Amatya was Director General of HMG's Department of Archaeology, and later Chairman of the Patan Museum Board. He stood firmly behind the development of the museum from its inception.

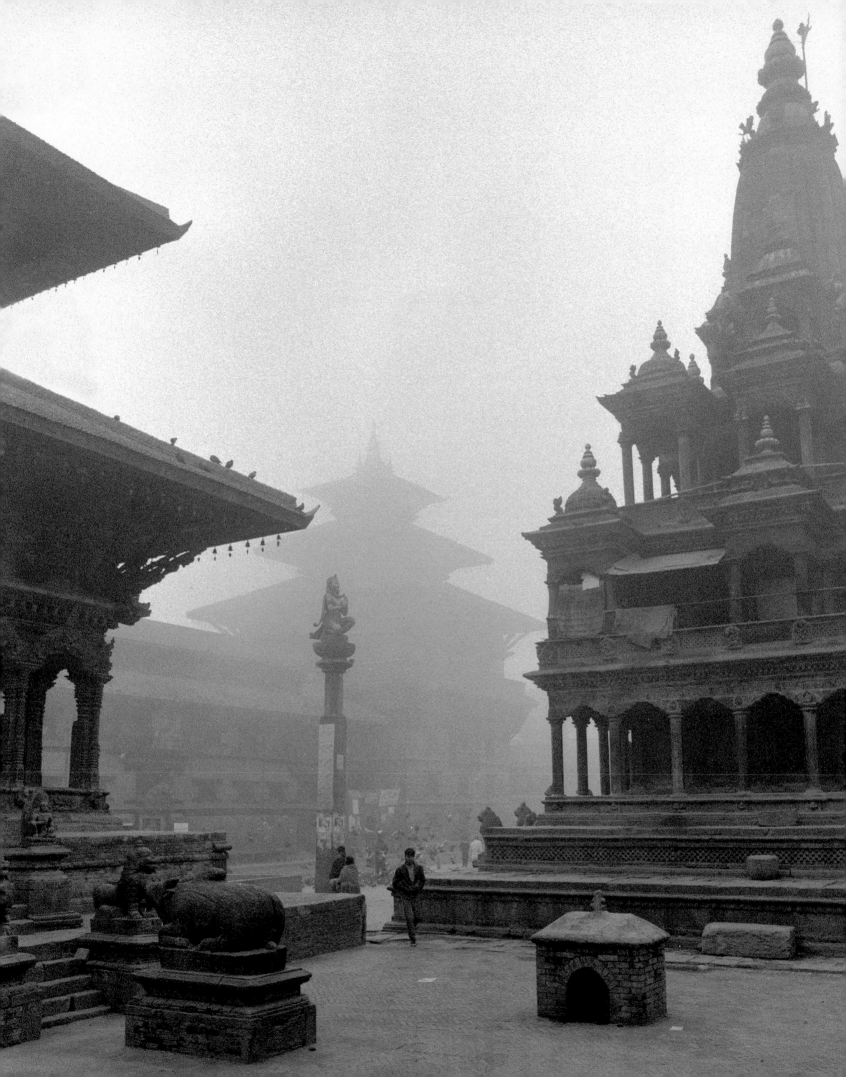

Introduction

One of the donors of a public resthouse at Svayambhu, carved in a stone relief displayed at the Patan Museum. *Drawing by Bijay Basukula*

left: Patan Darbar in morning fog. The palace building is in the left background, with the three-tiered temple roofs of Degutale looming behind. *Photo Götz Hagmüller*

Urban space remains a flat dimension if merely visually perceived, and not enlightened by imagination. Cities become inhospitable the more they lack in imaginary context. Other people, like the Newars, have illuminated their townscapes with "supernatural lights". Presumably, these lights will not shine anymore in cities of the future. It is up to us to seek new dimensions in the twilight.

Niels Gutschow[1]

The question has often been asked why an urbanite and Westerner like myself would choose to live in a "medieval" city of Nepal. One answer is intimated above. It is the semi-darkness between shadow and light that inspires.

There are other reasons, of course, why the urban culture of the Kathmandu Valley has beckoned me to stay since I first came to Nepal in 1968. At that time Patan and Bhaktapur were sleepy agricultural towns, their many squares full of chilies drying in the sun, no cars anywhere. Both cities had lost their former significance as royal centers of power after the conquest of the Valley two hundred years earlier by Pritvi Narayan Shah from Gorkha, and Bhaktapur had also lost its importance as a destination for devout pilgrims from the entire subcontinent. More recently, these two cities were largely bypassed while modern development efforts focused on Kathmandu.

Bhaktapur, in particular, was looked down upon by the new urban elites as a backward community of peasants – and quite a rebellious one at that, as became evident 12 years later, when I had already settled here and felt the early rumblings of social and political change.

By that time, the crumbling vestiges of Bhaktapur's great architectural heritage were being newly restored with German aid, while the ritual and religious significance behind these monuments was still vibrant. Age-old urban festivals and ritual processions reflected and reinforced a cohesive social fabric inseparable from the sacred geography of the urban domain. Each year and each season these rituals were – and still are – renewing the harmony between the cosmic order and the mundane.

But fresh currents sprang up in Nepal, nurturing old dreams of a civic society and seeking new dimensions of freedom. The popular uprising of 1990 finally restored democracy with an elected parliament, the king retaining the esteem of the people as a benevolent monarch and as an *Avatar* of the Hindu Lord Vishnu.

Over the last two decades the urbanization and degradation of the Kathmandu Valley has accelerated at a pace unimaginable a generation ago. Two sad features of this are the encroachment on public space by uncontrolled private development and the destruction of the historical housing stock. However, at the core of the cities amidst general congestion, pollution and urban chaos, the three major squares of the Valley and the royal Darbars of its former mini-kingdoms have been saved as monument zones and pedestrian precincts. Bhaktapur took the lead in preservation and urban management, being the first city to bar traffic in its center, and the first to enforce design guidelines for monument zones in 1999.

In the newly-found safe haven of Patan Darbar Square, the new Patan Museum has been established in the restored residence of the

Kuthu Math, Bhaktapur; courtyard elevation. A *math* is a Hindu religious building and pilgrims' hostel, similar to the Buddhist *dharamsala*, and was originally endowed with agricultural land for its maintenance as well as for its religious and other social functions. As a distinct building type within Newar architecture, it stands between the common courtyard house and the palace compound while incorporating the same principal features of both. Behind the bell, on the typical ground floor arcade, is the main shrine of the *math*. The shrine is dedicated to Shiva as are the pigeons in their nesting boxes below the main window. Founded in 1748, Kuthu Math has been my residence and studio since 1980. *Ink and watercolour by Robert Powell,[2] 1981*

The Baithak of Kuthu Math. Behind the topmost windows of the picture above (if one could look through the façade) lies the communal meeting and dining room, the *baithak*, which runs the full width of the *math*. The windows in the back look down into a narrow lane which is one of the main procession routes of Bhaktapur. *Ink and watercolour by Robert Powell, 1981*

Detail, Kuthu Math. The carving on the capital of the arcade pillar (left of the bell on the preceding elevation) shows the face of Surya, the sun-god. Each of the pillar capitals around the courtyard has a different auspicious or symbolic motif. *Ink drawing by Robert Powell, 1981*

previous kings. It is not merely meant to display a collection of artifacts, many of which were created in the workshops of this city over hundreds of years, but also to exhibit the Malla-period palace itself. It was designed to explain the spiritual, social and geographic context of these treasures within the living culture found just beyond the museum's own walls.

Later pages in this publication enlarge this major theme of the museum and describe its architectural genesis and the process of the restoration project. The story also sheds light on why it proved both worthwhile and challenging for me as an architect from abroad to live and work in this land. Though I have failed to learn the spoken language of my Newar neighbors, I have been rewarded with a measure of understanding of the poetic vernacular of their architecture and the rich articulation of their urban space.

Journeys to the sacred cities of neighboring India and Tibet, and assignments in the old capitals of Cambodia and Laos, have helped me to appreciate the regional context of these ancient cultures among which Nepal may be counted as a crown jewel. Using my residence in an old pilgrim's hostel of Bhaktapur as laboratory and testing ground I have been able to experiment with ideas and designs for new uses in historical settings, most fortunately learning to see architectural niches of light in the semi-darkness.

Bhaktapur Darbar Square. The "Pavilion of the Eight Corners" in the centre commands the position of a crown jewel in this urban ensemble. It left a significant void when the earthquake of 1934 destroyed it. This illustration was the most convincing argument for the pavilion's reconstruction as a gift of the German government in 1987. *Wood engraving after a photograph by Gustave Le Bon in 1885.*

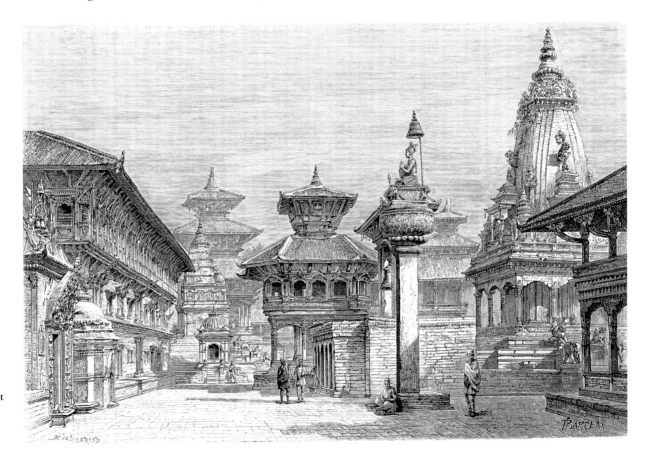

… a common heritage as written in the slope of its roofs, in the waft of its incense, and in the same gesture of reverence in Laos, Nepal and Tibet.[3]

right: Wat Xien Thong in Luang Prabang.
below: the folded hands of a devotee in Bhaktapur.
below right: the Jokhang in Lhasa.

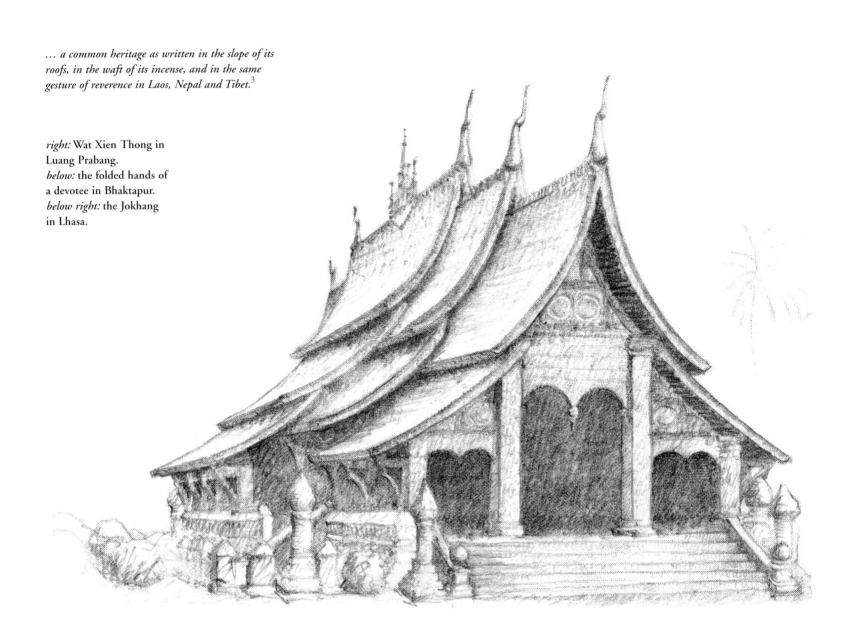

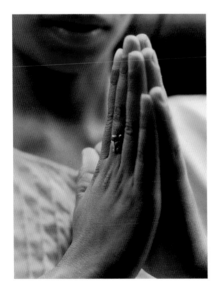

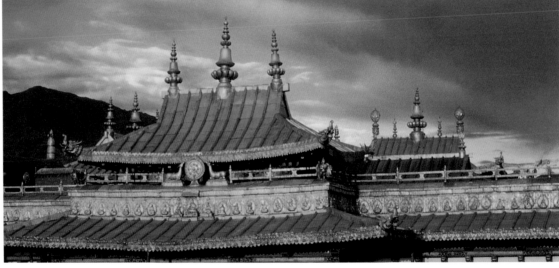

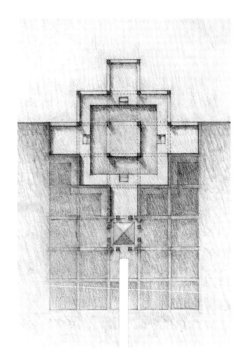

I now threw off my novice's robes – and walked down the few steps to the Ganges, with the four directions as my garments.[4]

above and right: Ganga Mahal in Varanasi. Plan and perspective for a residence project (1994) on the banks of the Ganges. It is inspired by the balcony window of the Man Singh palace built in 1585 at the Man Mandir Ghat *(photo below).*

The main room protrudes from the massive retaining walls along the river towards the sunrise, over the sheer nothingness of the vast, unbuilt plain beyond the Ganges. Based on a square grid, its design interprets the basic geometry of the historic balcony window as a *mandala* – a four-directional diagram of the universe. The central square is lit from above and thus faces the zenith. The lower half of the high external wall would be inundated during the floods of the monsoon.

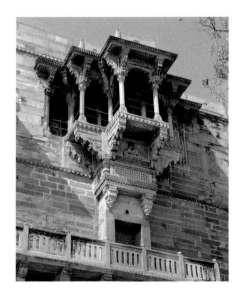

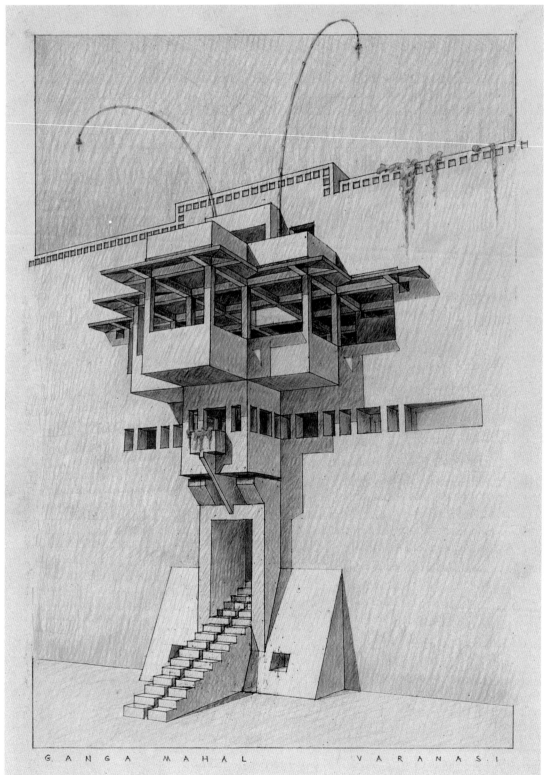

GANGA MAHAL VARANASI

The Setting

The Legendary Origin of Nepal[1]

Aerial view of Svayambhu in the 1960's when the urban sprawl of Kathmandu had not yet encircled the sacred precinct. *Photo G.M. Chitrakar, courtesy Ganesh Photo Lab*

Imagine seeing (from a balloon, by all means) the wide basin of the Kathmandu Valley, filled with a sea of dense fog on a cold winter day, bathed in bright morning light with the snow-clad panorama of the Himalayas above. Only at one point – where according to legend a magnificent lotus appeared upon the primordial waters of the original lake – can the top of Svayambhu Hill with the white dome of its stupa be seen floating above the heaving clouds with the pervading eyes of the Buddha looking in four directions to the far rims of the Valley.

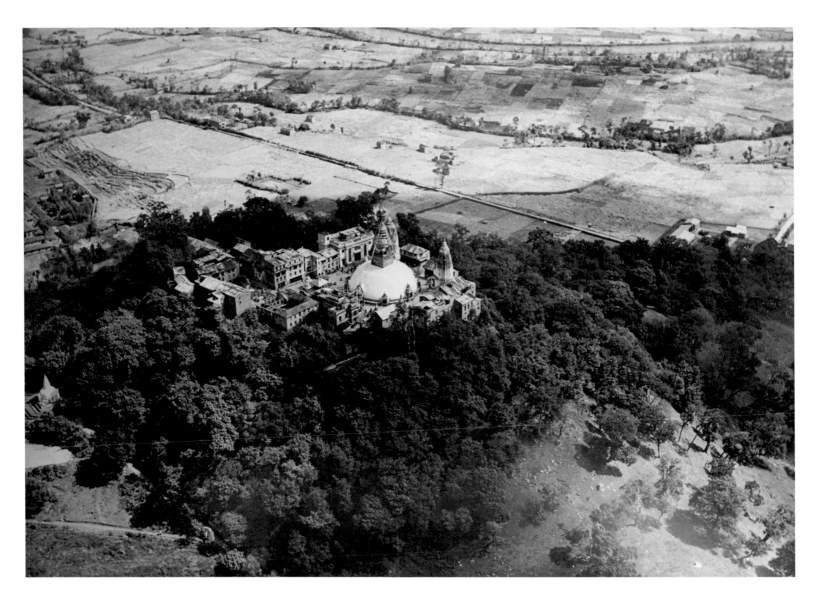

The Eyes of the Buddha.
Contemporary silkscreen print

A bronze lotus floor tile in the entrance to the Patan Museum, copied from a similar one at Svayambhu. The lotus flower[3] is one of the most ubiquitous motifs in Asian art and architecture. It symbolizes water, beginning and growth, and thus stands for creation itself.

For the local myth of creation, as chronicled in a Sanskrit Purana, it is Svayambhu, the "self-born", who manifested himself as a brilliant flame emanating from the lotus, "as big as the wheel of a chariot with ten thousand petals of gold", and studded with jewels, resting for aeons on the surface of the Cosmic Ocean. In time, the compassionate bodhisattva Manjusri, finding the lake "full of monstrous sea animals" and the Svayambhu almost inaccessible, opened the valley with his sword, and drained the lake for the dwelling of man.

Aeons later, with the advent of the menacing age, the present Kali Yuga, "in which mankind would be utterly sinful", a sage protected the primeval flame of Svayambhu by building a stupa above it.

If thus the Svayambhu stands for the legendary origin of the valley of Nepal, the architectural form of its stupa – the most prototypical structure of devotional buildings in Asia – is also a symbol for the myth of creation itself. Among many other possible interpretations, I am inclined to quote the Indologist John Irwin[2] who gathered archaeological evidence for the reading of the stupa's multiple layers of meaning:

If our basic hypothesis is correct, the axial pillar of the stupa is none other than the Axis Mundi itself, metaphysically identified with the World Tree and the World Pillar as interchangeable images of the instrument used to both separate and unite heaven and earth at the Creation. Both are in turn identified with the sun which was released from the

Cosmic Ocean at the moment of separation to create Time and the Seasons. By its orientation to the four cardinal points, the Axis expresses the unity of Space-Time and enables the worshipper, by performance of the rite of sun-wise circumambulation (pradaksina) to identify with the rhythm of the cosmic cycle.

At this point it perhaps needs stressing (as John Irwin does) that

the enormous importance of the Myth of Creation to ancient man had nothing to do with curiosity, nor even with the love of a good story. It was a very earnest concern governed by the insecurity of his existence and the need to get into the right relationship with the source of Cosmic order, which alone gave him the morale needed for survival. In other words, the Act of Creation was for him the supreme model of all regeneration.

In this context, it is especially important to grasp the different notion of Time involved: The Creation of the World was not an event which happened in our sense of Time, once and for all: it happened in Sacred Time, which was cyclic. The Creation was therefore a recurring event, and if our universe was not to collapse in chaos, it had to be re-enacted ritually at each moment of crisis.

Now, with the sea of clouds dispersing under the rising sun, the view again opens upon one of the most fertile cultures of the Himalayas. Divested of its veil of morning fog, the Valley spreads its terraced fields as they climb step by step the slopes of its rim.

Kathmandu Valley:
Cradle of an Urban Culture

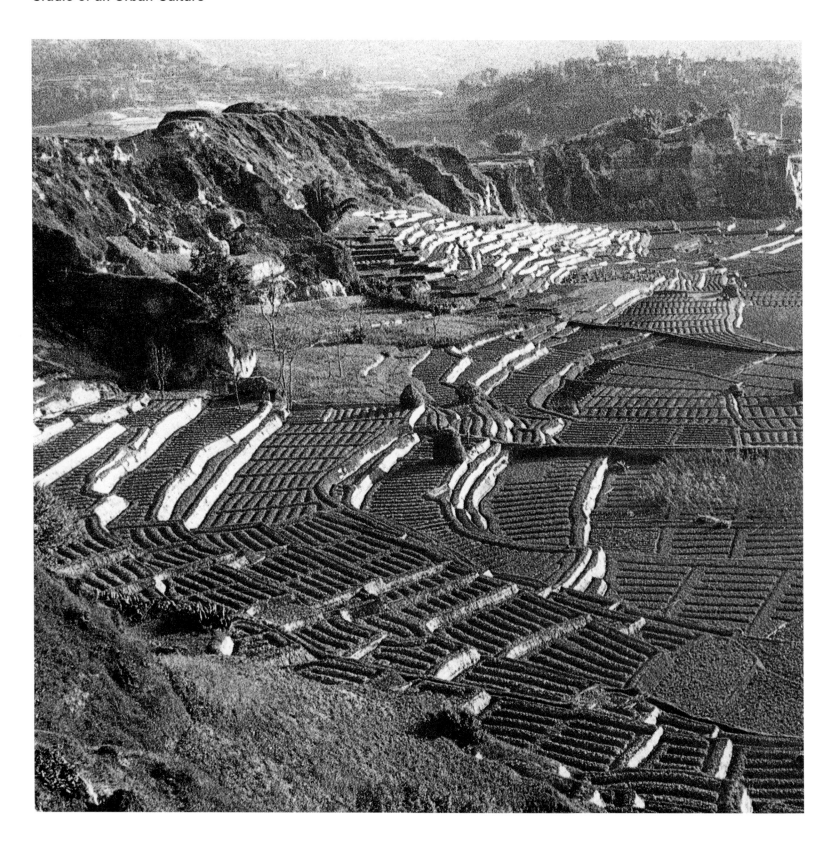

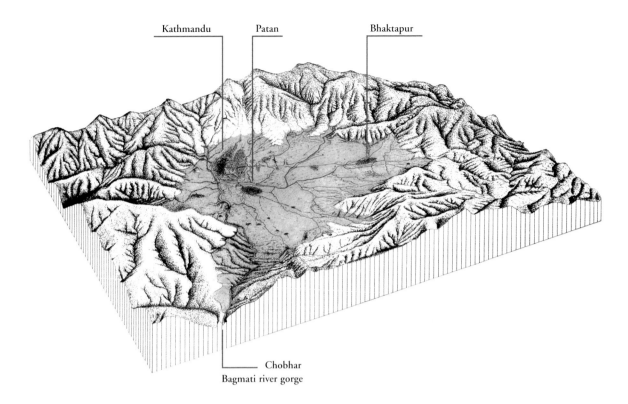

Kathmandu Patan Bhaktapur

Chobhar
Bagmati river gorge

Illustration by Harka Gurung in C. Pruscha (ed.): Physical Development Plan for the Kathmandu Valley, *HMG 1969 (colour rendering of previous lake area added)*

According to ancient myth, the Kathmandu Valley in previous ages was a huge lake until the benevolent bodhisattva Manjusri, with a blow of his sword, cleaved the southern rim of the valley at the gorge of Chobhar to drain the waters of the lake, thus rendering the Valley inhabitable.

left: Terraced fields at the rim of Kathmandu Valley. *Photo Wilfried Kröger, 1971*

The name Nepal originally applied only to the Kathmandu Valley. A large "bowl" of fertile, alluvial land in the middle ranges of the Himalayas, the Valley is the historical core and the cultural heart of the country.

I suppose it is a rare phenomenon worldwide that the Newars, the Valley's predominant people, and previously a mainly agricultural community, would prefer to live in cities rather than villages or hamlets close to their fields. But with two rich harvests a year, they could barter the surplus production and concentrate their homes, barns and shrines in dense settlements which were also ideally located as trade entrepots on the ancient trails between the Indian plains and the Tibetan plateau.

The resulting accumulation of wealth by tillers, landlords, merchants and kings was in turn widely shared and new wealth was created with utilities for the common good. Irrigation waters from the surrounding hills were channeled through well-built conduits, wells and sewers, within an abundance of other amenities and ample public space. It is this creation of wealth by sharing and redistribution – even across barriers of caste and belief –

that explains at least partially the early development of an artistic and sophisticated urban culture in the Valley's tiny kingdoms.

This urban culture was, and still remains, a highly religious one. Some of the holiest, oldest and most venerated shrines and pilgrimage sites of the Hindu and Buddhist domains are located in the Valley, and its ruling elites were always associated with the divine.

The ancient settlements of Kathmandu, Patan and Bhaktapur date back to the first millennium of the Common Era. As capitals of minor kingdoms with shifting centers of power, they flourished in rivalry with one another. Particularly during the later Malla period this sometimes involved warlike means and even the use of tantric powers, but was more often a matter of trying to outdo their rivals in splendor by the peaceful and creative means of art and architecture.

The focus of attention in this rivalry was the Darbar, the royal palace compound of each city, which was the local center of all religious and public life. All three Darbars today are World Heritage Sites.

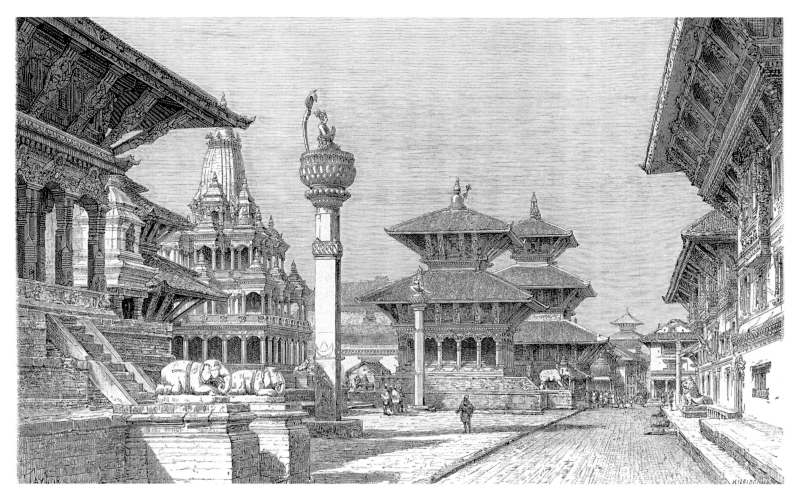

Patan Darbar Square, one of the
most beautiful urban ensembles
on the list of World Heritage sites.
The colour lithograph (below)
shows the square from its
southern entrance, with the
dominating Degutale temple to
the right. The view above is taken
in the same direction but from a
position further north, with
Degutale's lower roof now high
above on the right. Both views
have remained more or less
unchanged.
Gallery of Historic Views of Nepal
in the Patan Museum. *Wood
engraving (above) and lithograph
(below) after photographs by
Gustave Le Bon in 1885*

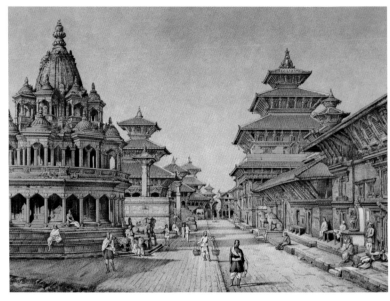

Sacred Urban Space

*Cities, like dreams, are built of desires and fear, even
if the thread of their discourse is secret.
But why does the city exist? What line separates the
inside from outside, the rattle of wheels from the
howl of the wolves?*

Italo Calvino: *Invisible Cities*[1]

A *mandala*, with its concentric
circuits of varying geometric
shape, is basically an imprint
of cosmic order on the plan of
existence. As soul is to body, a
mandala is to the city.

above: Detail from an 18th
century Nepali manuscript.
below: The mandala shape of
the Bodhnath stupa as seen
from above.

Everything inside the ancient cities of Asia was
regarded as sacred and each one imagined
itself to stand at the centre of the world. I see this
in distinction to one classical Western ideal of the
city – from Athens to the medieval cities of
Europe – where republics were born and the air of
the city held the promise of freedom from feudal
and religious oppression (and I know of no better
adage than the German "Stadtluft macht frei").
They were havens, not heaven.

For the peoples of India and for this remote
Himalayan valley, the promise of the city was
rather more like our dream image of Jerusalem as
a terrestrial paradise.[2] The promise was not only
the freedom from fear of the unstructured chaos
around, governed by indomitable forces of nature
and demons, but, and perhaps even more so, "the
desire of man to find himself at the Centre of the
World *without any effort* – the *easy way* which
allows of the construction of a centre even in a
man's house".[3] As Mircea Eliade has suggested, we
may call this the "nostalgia for Paradise", the
desire to transcend the human condition towards
the divine, in this ascending order of things as I
understand it: the self, the city, the cosmos.

The old towns of the Kathmandu Valley have
slowly grown from the agglomeration of rural set-
tlements to market towns and centers of royal

power without any preconceived ideas of func-
tional planning – as was the rule, by contrast, in
the founding of colonial cities of imperial Rome
or, in fact, in the grid of Manhattan. Over hun-
dreds of years, the Newar cities developed an
incomparably rich infrastructure of public ameni-
ties and shrines to all gods, yet some of their
sacred geometry was only gradually and subse-
quently imposed in order to imbue the emerging
physical patterns with the cosmic qualities of
heaven on earth. At the climax of their bloom in
the 17th and 18th centuries, the mental image of
these cities was widely understood as a *mandala*, a
scale model of the universe, just as their temples,
pagodas and stupas were seen as plans and eleva-
tions of cosmic structure and order. Even if they
grew without "planning", the confines of their
sacred territory were always clear. A *mandala* has
definite borders, and so had these cities. I remem-
ber from two to three decades ago how the com-
pact, built-up areas of Bhaktapur and Patan were
still impressively distinct from the surrounding
agricultural land, with the howl of jackals as a
nocturnal horizon – before these tangible borders
rapidly vanished, swallowed up by traffic and
uncontrolled urban sprawl.

However, the outer and inner confines of the
urban *mandala* are still in place, "enlightened by
imagination".[4] Niels Gutschow has shown in his
extensive research of thirty years and recorded on
topographical maps, how the cities and the valley
itself are spiritually guarded by concentric external
rings (or by converging spirals) of shrines devoted
to protective deities of whom the eight Mother
Goddesses may be the most ancient ones. To visit
such sites and landmarks on certain occasions
along predefined routes is – or was – one way of
exploring the sacred geography of a city. But even

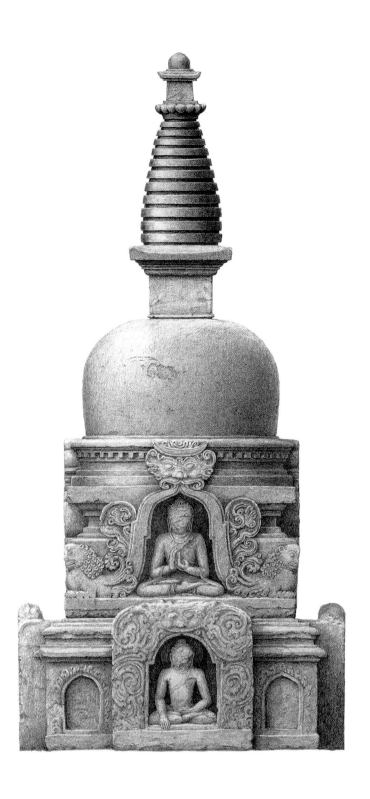

One of the finest Licchavi period chaityas stands in the courtyard of Om-baha near the Patan Museum. A full scale reproduction of this drawing is exhibited in the museum which also sells a poster of it. *Pencil drawing by Robert Powell, 1993*

to physically experience and to collectively re-enact the cosmic structure of the urban domain, in the annual and cyclical rhythm of time.

For the largely Buddhist heritage of Patan, it is its stupas (or chaityas, as smaller stupas are commonly called) that designate sacred space, on both large and intimate scale. On the periphery of the former kingdom, and near its main crossroads, stand four ancient mounds, known as the "Ashokan" stupas, probably the oldest Buddhist monuments of the Kathmandu Valley, over fifteen hundred years old. These large earthen stupas – two are still covered with grass – provide orientation towards the four cardinal directions, even if only in approximation, and define the limits of the city's meaningful, sacred space against the profane and non-signifi-cant territory around. Although they are too far from each other to be visually perceived in their spatial relation, the mere knowledge of their exis-tence is affirmation of the city's cosmic order.[5]

Another and more hidden religious infrastructure is evident in the multitude of devotional chaityas all over town, in the courtyards of its monasteries and in many a private yard. Some 600 of these chaityas and other holy sites are visited annually during the urban ritual of *matya puja* in August, a few days after full moon, when thousands of resi-dents join in a day-long procession which covers the urban core area and its historic confines. To circumambulate clockwise around a chaitya in worship or, by the same token, around the city itself, is to unconsciously identify with the sun's daily course, regarded auspicious, and with the moving shadow it casts on the ground from the top of the stupa in a circle of shadow and light – between desire and fear.

today, the most vivid experience of urban space for every citizen is the privilege to partake in the public ritual of each city's grand processions. To take the gods out of their shrines, to carry and escort them around town, to move and dance in the midst of one's clan from one sacred place to another along well-remembered courses and old city boundaries laid out by former generations, is

far right: This "four-image" chaitya from the 7th century at Dhvaka-baha in Kathmandu is a well-known Licchavi monument of the Valley, repeatedly referred to by art historians. According to Prataditya Pal, it is one of the most significant sculptural works in Nepal.[6]
Ink and watercolour by Leonhard Stramitz

right: Terracotta chaitya in Patan, detail of its main niche. The design and craftsmanship of this 17th century chaitya is the most exuberant and delicate of its kind. Made of terracotta components, it is the artistic pride of the potter community's quarter at Cyagma and may contain ancient molds for imprinting Buddha images onto bricks.
Ink drawing by Ian Goodfellow

Two maps showing the historic core area of Patan with its medieval maze of lanes and public squares, and with the royal Darbar in the center, at the intersection of its major crossroads. The left one locates the 105 most ancient chaityas of Patan, established during the Licchavi period (6th to 8th century), and the four "Ashokan" stupas which define the limits of the sacred urban domain. *Drawings courtesy Niels Gutschow*

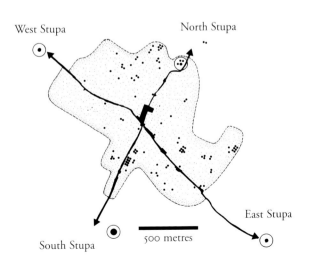

West Stupa

North Stupa

South Stupa

East Stupa

500 metres

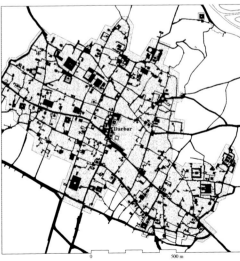

Darbar

Krishna Mandir, the most popular temple on Patan Darbar Square, with the pillar of Garuda in front. It was built by king Siddhi Narasimha in the shikhara style of North India and Bengal, and was completed in 1637. On Krishna's birthday, worshippers come from far away, as even the king of Nepal visits the shrine. Female devotees who make love on that night believe they are making love to Lord Krishna himself.[1]

Wood engraving after a photo by Gustave Le Bon in 1885

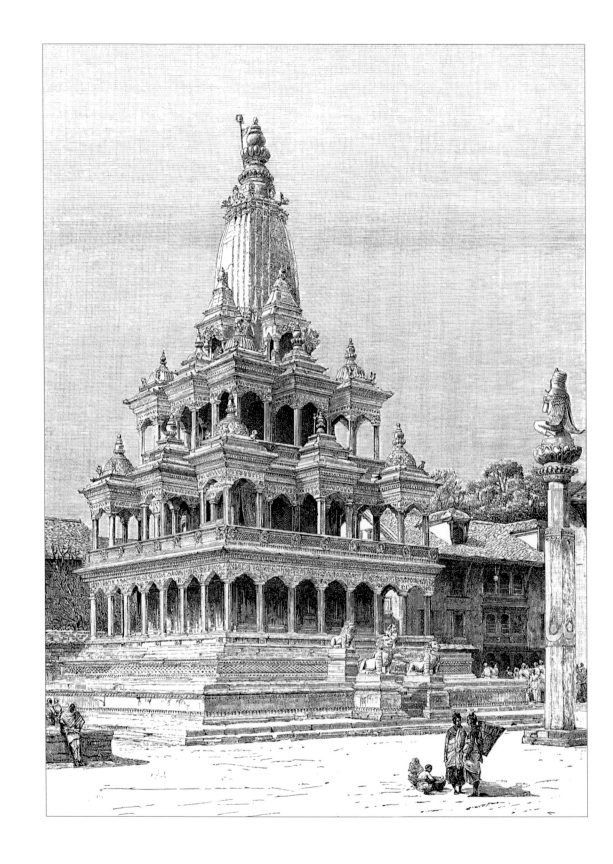

Patan Darbar in Legend and History

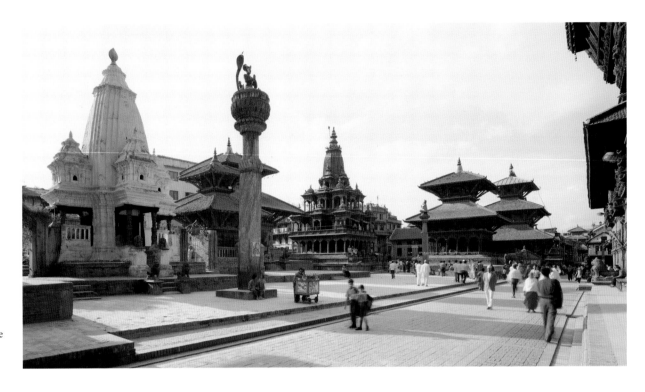

Patan Darbar Square as seen from the South. In the foreground, the pillar and image of king Yoganarendra, erected in 1693, faces the temple of Degutale, the lineage deity of the Malla dynasty.
Photo Rupert Steiner

As an ensemble, the Darbar Square in Patan probably remains the most picturesque collection of buildings that has been set up in so small a place by the piety and pride of Oriental man.

Perceval Landon [2]

In the centre of Patan, at the intersection of its main crossroads, is the palace square, locally known as Mangal Bazaar for its Sanskrit connotation of being auspicious, or simply as "Mangah", its root in Old Newari meaning "centre". To reside at this auspicious centre of a tiny but wealthy kingdom was the divine prerogative of its rulers, themselves thought to be incarnations of Vishnu. Over generations and more than two centuries, the dynasty of the late Mallas held the privilege (and the means) to embellish the square with impressive buildings and temples and with a select choice of other monuments, pillars and minor shrines. All major temples in front of the palace are devoted to the pure, high and male Hindu gods who stand for moral values and salvation from the mundane, and take no blood sacrifice.[3] In distinction to this, the temples to the exclusively royal and female deity Taleju (or Degutale, another form of the tutelary goddess) are a part and the pride of the palace building itself. Taleju, in turn a specific manifestation of the Mother Goddess, is supposed to ensure royal power within this world. Even if this aspect failed the Mallas in the long run, her worship is still a tradition involving the ritual sacrifice of numerous buffaloes during the great autumn festival of Dasain.

Although some of the palace's earlier history is lacking in evidence and conclusive detail, and the existing inscriptions are shrouded in obscure devotional language, its past is not "unknown" to the

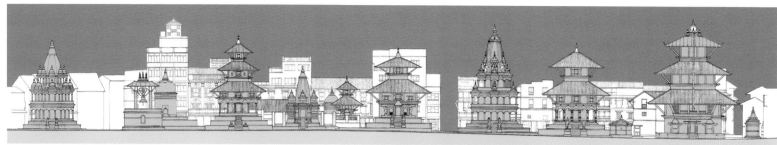

Western elevation of Patan Darbar
Square as seen from the palace (the
opposite elevation is shown on
page 40). *Drawing after E. Sekler
& M. F. Doyle[4], 1983*

Plan of Patan Darbar Square.
Main monuments:

1	Keshav Narayan Chowk	1734
	(Patan Museum)	
2	Café and Gardens	1997
3	Degutale Temple	1661
4	Taleju Temple	1671
5	Mul Chowk	1666
6	Sundari Chowk	1647
7	Bhandarkhal (tank)	1647
8	Mahadeva Temple	17th c.
9	Lampati	17th c.
10	Krishna Temple	1723
11	Taleju Ghanta (bell)	1737
12	Fountain	1904
13	Vishvanath Temple	1678
14	Shankar Narayan Temple	1706
15	Narasimha Temple	1589
16	Yoganarendra Pillar	1693
17	Narayana Temple	1652
18	Char Narayan Temple	1566
19	Krishna Mandir	1637
20	Vishveshvara Temple	1627
21	Manigupha ("cave")	17th c.
22	Bhimsen Temple	1680
23	Lakhe Shrestha Agam	17th c.
24	Kopeshvara Temple	1893
25	Saravati Pati	17th c.
26	Maniganesha Temple	17th c.
27	Ayahguthi Sattal	17th c.
28	Bahadur Shaha Palace	1792
29	Manicaitya	17th c.
30	Manidhara (stepwell)	570
31	Manimandapa	1701

Plan based on surveys by Carl
Pruscha & Wolfgang Korn, Niels
Gutschow & Bijay Basukula, Eduard
Sekler & Michael Doyle, Erich
Theophile & Rohit Ranjitkar, and
Kutsohiko Watanabe.
*Compilation by Götz Hagmüller,
drawing by Sushil Rajbhandari, 1996*

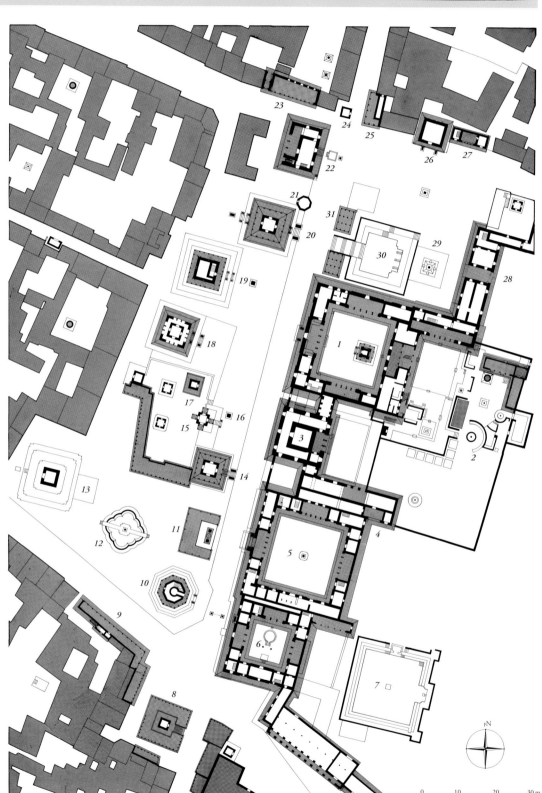

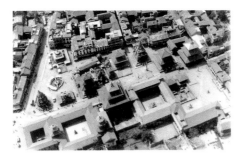

Aerial view from Southeast.
Photo Niels Gutschow, 1973

people of Patan. It is full of legend and myth, often with a different version of the same story or two conflated in one. According to Nutan Dhar Sharma,[5] who gathered an exemplary compilation of available chronicles, inscriptions and archaeological evidence, one aspect seems to be rather certain: the palace area must have already been a center of royal power during the first millennium, as testified on a stone inscription *(silapatra)* in the museum's main courtyard, and on another one (dated 560 AD) at Manidhara, the ancient stepwell just north of the museum. A small river once ran along what is now the palace front – it is still there under ground, as a storm water and sewer drain since Malla times. A Buddhist monastery was built on its bank where a bright flame had auspiciously emanated from the waters.[6] In a later time, the monastery was shifted to another location to make space for an extension of the palace.

However, the sanctity of this site and its relation to water are still remembered after centuries, and reverently revived in public ritual. Every year, dur-

ing the holy month of *gunla*, a Buddha image is immersed in the consecrated water of a copper vessel placed directly in front of the Golden Door and worshipped by the faithful (see page 43). I consider this a remarkable testimony to the collective memory of a city and to the longevity of its traditions. By contrast, the once familiar name for the palace itself is forgotten and no longer used. Mentioned as early as 1630, it was called "Chaukot", denoting a castle or fort with four towers – the built recollection of which are the two surviving tower pavilions at the corners of the palace's front wing.

Most of the monuments of the square, and many rituals associated with them, were the creation of Patan's most famous three kings, grandfather, father and son, who ruled Patan during the 17th century at the height of the kingdom's power and wealth. The first one in this succession was Siddhi Narasimha who inherited Patan from the king of Kathmandu (his own grandfather), established it again as an independent kingdom, and made its

Aerial view from the West
Photo Erwin Schneider, 1986

Erwin Schneider was one of the pioneers of Himalayan cartography from the 1930's onward. The so-called "Schneider Map" of the Mount Everest region, published in Vienna in 1956, is still highly valued among mountaineers. He flew across the Kathmandu Valley for the last time in 1986, when this picture was taken.

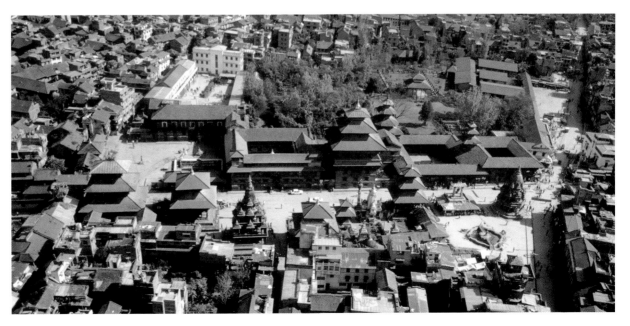

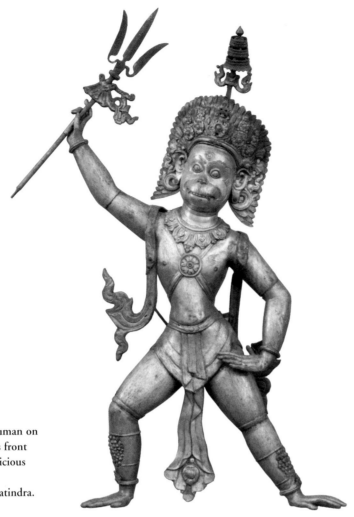

The gilt image of Hanuman on the ridge of the palace's front wing, said to be a "malicious gift in disguise" from Bhaktapur's king Bhupatindra. *Photo Thomas Schrom*

right: The Golden Window above the palace portal (see complete views on pages 4 and 42). The fire-gilded copper sheathing of the window shows in the center Avalokiteshvara, the Buddhist protector deity of Patan, surrounded by the pantheon of Hindu gods. This peculiar blend of iconography expresses the tolerant policy of the Malla kings (themselves being held as incarnations of Vishnu) to encourage the cults of their predominantly Buddhist subjects in Patan, while requiring them to conform to the social norms of Hinduism. *Photo Rupert Steiner*

four-cornered fort the permanent residence and *darbar* of the Mallas. In the course of extensive renovations of the palace compound, he rebuilt Degutale "better than before" and gilded, as a further offering to the goddess, one of the five pagoda roofs the temple had at the time. He also created the intimate courtyard of Sundari Chowk and the wide gardens behind, built the temples of Vishveshvara and Krishna Mandir in front of the palace, and initiated a ritual dance still being performed every year during the lunar month of *kartik* in winter. As a Hindu king, Siddhi Narasimha was not only tolerant of his mainly Buddhist subjects, supporting the establishment of new monasteries in the kingdom, but seems to have been very pious himself. Known as a sage among kings, he indeed relinquished the reign in favour of his son to go on a pilgrimage to Benares, and devoted the rest of his life to religion.

Srinivasa Malla continued the policies and artistic endeavours of his father, again extending and restoring the palace and Degutale temple after a disastrous fire in the second year of his reign, and adding the famous well and royal bath within Sundari Chowk. Like his father, he established further shrines on the square, such as Bhimsen temple, and blessed the undertaking of his prime minister to erect a substitute for the Visvanath temple in Benares which had been destroyed by the zealous Moghul emperor Aurangzeb (never rebuilt and thus a continued cause of communal strife in today's Varanasi). In contrast to the largesse of his commissions for the satisfaction of gods and for the splendours of Patan, Srinivasa seems to have been rather modest himself. From the little I glean of what legends tell us about this remarkable man, I can well imagine him sitting on the floor as everyone else, while allowing his

splendid gilt throne to be used by anybody who was willing to pay a token amount to the artisans who had made it (see page 104).

His son Yoganarendra followed these noble traditions in person, and as a patron of the ritual arts. He gained fame as a musician himself, and became the most popular king in the memory of his subjects although, in the end, he fell victim to the continuous squabbles between the three kingdoms of the late Malla period and abdicated in grief. At the time, "the order of the day consisted of insults, feuds, quarrels and brief skirmishes of open warfare", as Mary Slusser[7] has so vividly observed from a detailed chronicle of events in 1698, while the disputes were often "accompanied by solemn treaties of external friendship" between these jealous and bickering kings. Blood related for generations, they "were especially quick to profit from any momentary weakness of the others brought about, perhaps, by the death of a king, an unsuccessful battle, or devastation from natural calamity". However, during periods of peace, the cousin kings attended each other's public ceremonies and family celebrations. They freely "borrowed" novel ideas of urban and architectural design from each other, competed for the Valley's best artisan groups of the day, and even sponsored the building of temples in their rivals' domain.

A curious aspect of the time was the growing influence of Tantrism on all matters of life. After a century of harassment by foreign pillagers whom the Malla kings were unable to defy in their pre-occupation with internal intrigue, and constantly ravaged by earthquakes, fires, drought and famine, the Kathmandu Valley was prone to seek salvation from these disasters by propitiating its gods and demons in their powerful multitude. Yet the immortals were not only worshipped but also manipulated in tantric ritual to intervene in man's mundane or royal affairs. The most telling example is recorded in chronicles pertaining to the rivalry between Bhaktapur and Patan during the reign of Yoganarendra, and to the tangible testimony this has left on the buildings of Patan Darbar.

Yoganarendra probably suffered the most from the "malevolent designs" of Bhupatindra Malla, Bhaktapur's most ambitious of kings. In good faith, he did not foresee what Bhupatindra really intended when he offered to improve the Chaukot Darbar. At that time, there was still an open terrace between the front tower pavilions (see pages 51-52) used for extensive rituals of sacrifice and propitiation when draught and disaster prevailed. A bell in the southern tower was incessantly rung until the rains would fall again. In order to defeat this purpose, but under the pretext of protecting the building, Bhupatindra not only covered the terrace with a roof, but also walled up the bell so it would not ring anymore. Another malicious gift in disguise was the gilt image of Hanuman (beloved monkey-king of the Mahabharata) which Bhupatindra had installed on the ridge of this new roof, right above the royal bedroom: according to local legend, it is actually an icon of Saturn who is believed to be a source of bad fortune. As its restoration revealed, the statue is held upright with a bar of iron – and iron indeed represents the planet Saturn.

The most successful scheme of the "evil minded" Bhaktapur king to achieve political gains with tantric means was to build an elaborate Shiva temple just south of the palace, its lingam's water spout, as usual, pointing North, *i.e.* exactly towards the royal residence. Tantrics maintain that anyone living in the line of this spout will suffer

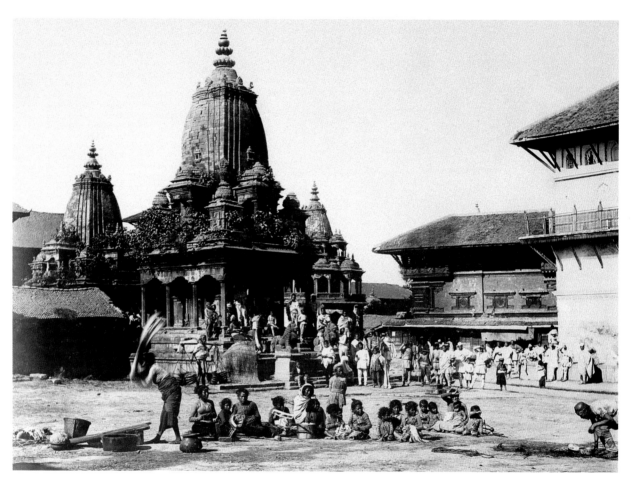

Bhasmesvara Mandir, the Shiva temple built by Bhupatindra Malla just south of the palace in 1700. Destroyed by the earthquake of 1934, today only its central cult object, a linga of milky crystal, survives in a small shrine on the same location. *Photo Kurt Boeck, 1899. Courtesy Völkerkundemuseum Wien*

misfortune, but Yoganarendra was apparently unaware of this hidden intention. When his son and heir apparent died young "the Raja from grief relinquished the world and went away. He told the minister that as long as the face of his statue remained bright and untarnished, and the bird on its head had not flown away, he would know that the Raja was alive, and should cherish and respect his memory. For this reason every night a mattress is still laid in a room in the front of the durbar, and the window itself kept open".[8] Another source says that the king died from poison in a fort near Bhaktapur, evidently engaged in fighting the latter. Anyway, the tradition of keeping the king's bedroom ready behind the Golden Window, and

his water-pipe prepared every day, was actually followed until 1950; and the face of his statue on the high pillar in front of Degutale is still untarnished after three hundred years although it has never been cleaned or re-gilded.

The succession of Yoganarendra, manipulated by Bhupatindra, led to seven weak kings within a span of 25 years until Vishnu Malla held the throne for a while. It was he who renovated and reshaped the palace for the last time under Malla rule and in 1734 consecrated its major courtyard Keshav Narayan Chowk, as the Chaukot Darbar is now commonly known, in the form which survived till the earthquake of 1934.

According to oral tradition, King Yoganarendra bequeathed several wishes for the good of his people before he relinquished the throne of Patan in 1705:[2]

• *May jewels rain on my city of Lalitpur.*

• *May the stone elephants guarding the Vishveshvara Temple go to the water spouts at Manidhara to drink water.*

• *May Garuda on his pillar in front of the Krishna Temple lay two big pearls the size of a hen's egg.*

• *May the stone lions in front of the royal palace walk out and ambulate around the Manicaitya Stupa.*

• *May the bird perching on the crest of the serpent over my own golden monument take wings and proceed to Vishnu's heaven, so that my soul also reach there along with that bird. My beloved subjects should be assured that my soul will depart only when these wishes of mine are fulfilled.*

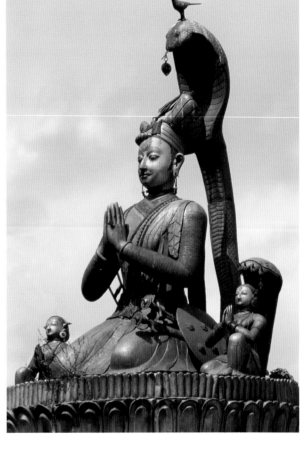

clockwise from top left:
The image of the bird-god Garuda on top of his pillar; the gilt statue of Yoganarendra with the bird on top of the serpent's crest; the stone elephants in front of the Vishveshvara temple; and the three water spouts of Manidhara, the royal step-well north of the palace.
Photos Stanislav Klimek

Panorama of Patan Darbar Square,
view from the South. Gallery of
Historic Views of Nepal in the Patan
Museum. *Photo Kurt Böck, 1899,
courtesy Völkerkundemuseum Wien*

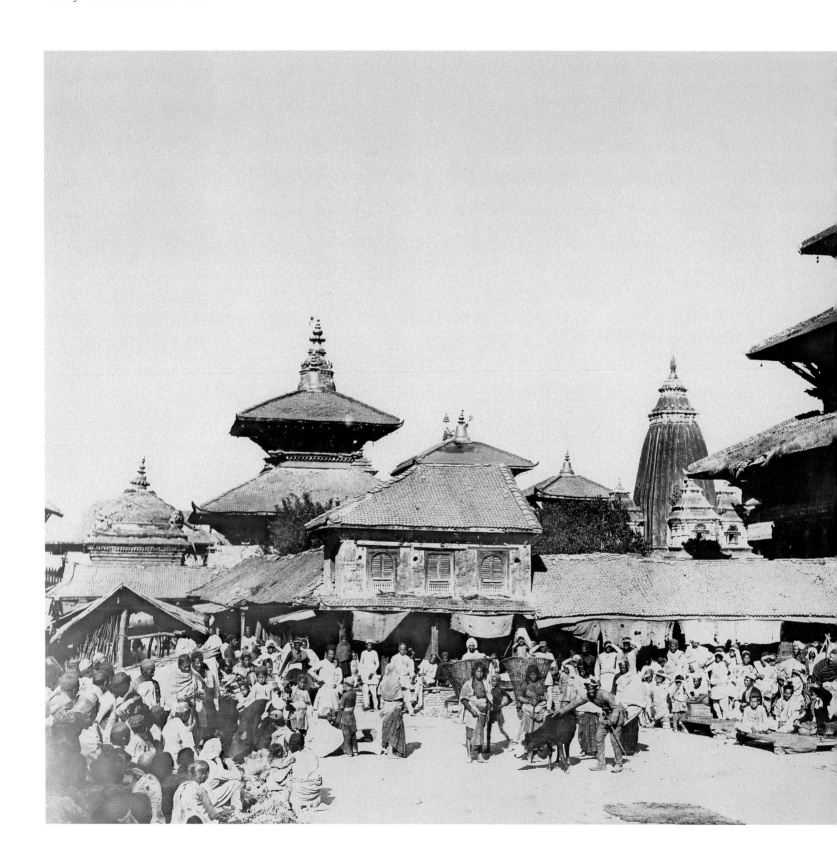

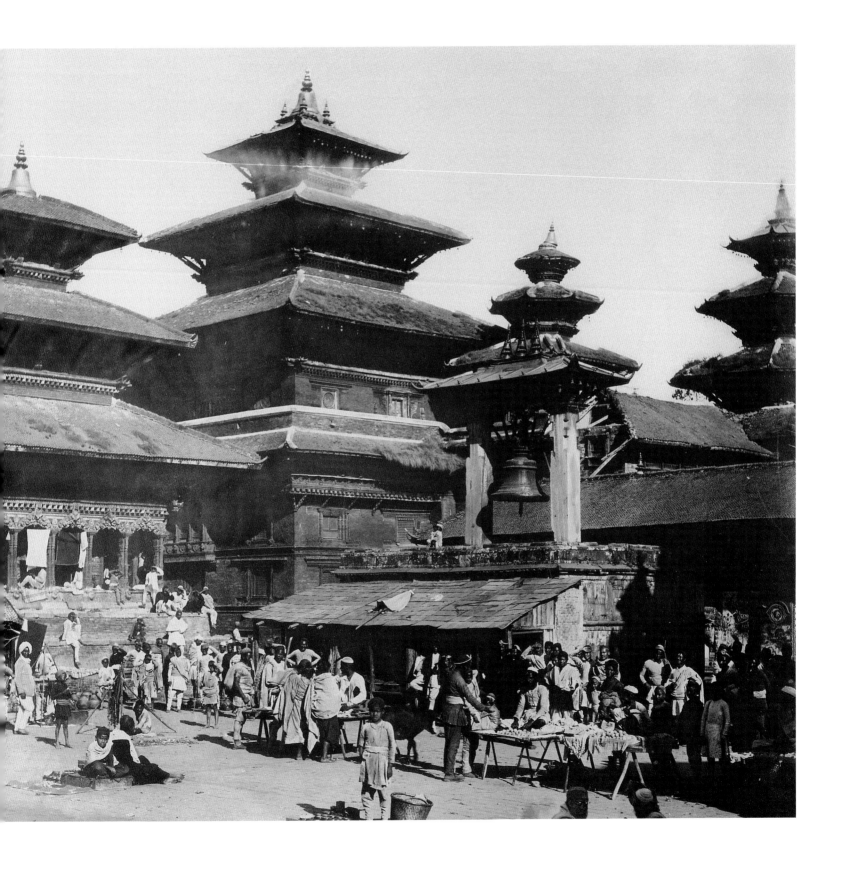

Paradise Lost, Heaven Regained:
a Pedestrian Precinct

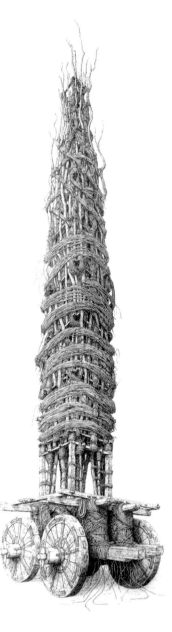

The ceremonial chariot of Matsyendranath in Patan.
above right: The heavy timber wheels are more than two meters in diameter.
above: The chariot in its yet unadorned structure.
Ink drawing by Robert Powell, 1981. Collection Heike Scheffer-Boichorst

Isn't it astonishing that in Nepal the wheel, one of the oldest and most useful inventions of mankind, was until not so long ago exclusively reserved for the conveyance of the gods? During the great annual festivals celebrating the cyclic renewal of the sacred urban domain, huge temple chariots still rumble across town on solid timber wheels taller than a man. But no vehicle, cart or carriage was ever used (nor would animals have been put under the yoke) to transport the heavy loads of harvest within the Kathmandu Valley – at least until the arrival of bikes, trucks and tractors.

Everything was carried on the back. Within living memory, the only wheels that ever passed Patan Darbar Square were those of the great chariots of Matsyendranath, the god of rain, and of his companion. It was only some ten years ago, when motor traffic began choking the core of Patan, that its Darbar Square was threatened with becoming a major thoroughfare.

In the lives of conservationists and urban planners sometimes the best one can hope to achieve is to

prevent something bad. In the case of Patan, the banning of motor traffic from the inner city was an utopian goal to begin with. Not only was it contrary to the interest of those few who already owned motor vehicles, but it mainly clashed with the general and perhaps unrealistic hope of many others to have cars in the future and to park them – of course – right in front of their own houses and shops.

After lengthy debate the concerned authorities consented to the erection of traffic barriers by our project in 1993 in order to save the monument zone of Patan Darbar as a pedestrian haven. However, it didn't take long till the heavy chains were broken and removed, and buses and trucks again had free reign.

At the time, I was also involved in an urban conservation and development programme for Patan, funded from German aid. Our team (with Niels Gutschow and Erich Theophile) soon came to know of another imminent risk: the government's Road Department was planning a new road link

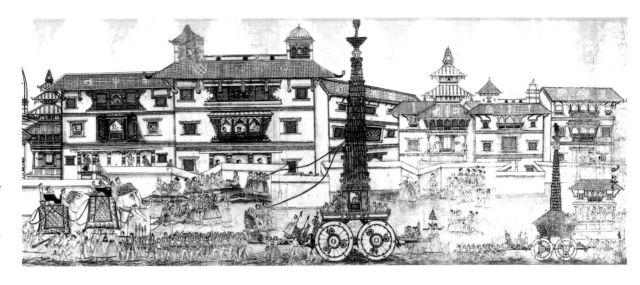

Detail of an anonymous drawing which illustrates the earliest known (though slightly imaginary) view of Patan Darbar with the procession of Rato Matsyendranath's chariot. *Photo courtesy Musée Guimet, Paris*

Sketch of traffic barrier at the southern entrance to the Darbar Square with bollards of stone, and a wrought iron chain of traditional blacksmith design removable for emergency traffic. The bollards feature a detail from the nearby Garuda pillar.

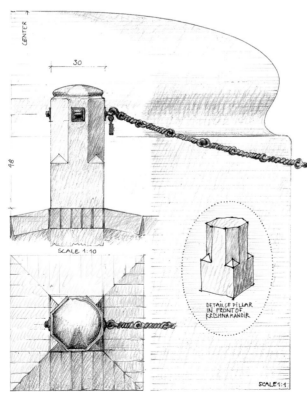

The bollards being made by stone masons from Bhaktapur.

to connect Patan Darbar Square directly with the New Baneshwor expansion of Kathmandu, a scheme to relieve traffic on the only existing road bridge between the two cities. Blue-prints were ready to widen the alley leading north from the square to the cremation ghats on the banks of Bagmati and, encouraged by an offer of Japanese aid, to build a two-lane vehicular bridge replacing a shaky bamboo catwalk across the holy river. One thing seemed clear: if this bridge, cast in reinforced concrete for heavy traffic loads, was to become reality then all hope would vanish of ever again keeping cars off the Darbar Square.

That summer, after an intense flow of communication between the aid agencies and embassies of Germany and Japan, and with HMG of Nepal, it was finally agreed to build the bridge with only one lane, for pedestrians and two-wheelers only, and to scrap the planned thoroughfare. Not long afterwards, the Municipality decided to put new chains on the stone bollards still in place, and to make Patan Darbar Square again the "heaven on earth" as the poet Kunu Sharma had praised it in 1652.

37

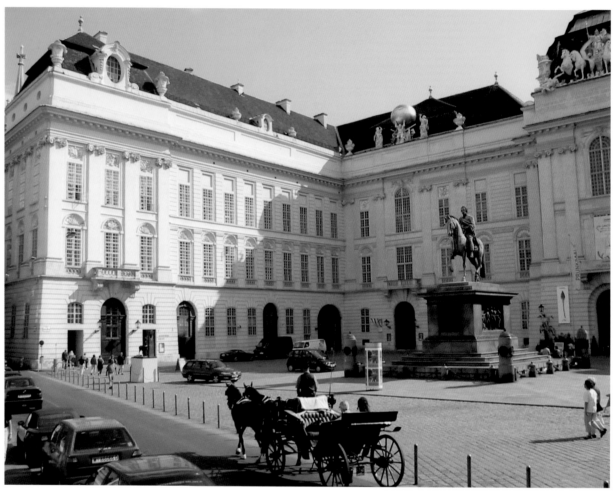

The National Library on
Josephsplatz, Vienna

━━━━━ 50 m ━━━━━

Patan Darbar Square
Photo Mani Lama

Both views from the North in
the afternoon sun. The side
wing of the National Library is
as long as the elevation of
Patan Museum and Degutale
temple taken together, but
three times as high.

Malla and Habsburg

Marco Polo imagined answering (or Kublai Khan imagined his answer) that the more he was lost in unfamiliar quarters of distant cities, the more he understood the other cities he had crossed to arrive there; and he retraced the stages of his journeys and remembered the port from which he had sailed, and the familiar places of youth, the surroundings of home, and a square in Venice where he gambolled as a child.

Italo Calvino: *Invisible Cities* [1]

After years of acquaintance with Patan's Darbar Square, I became curious to find out in more factual detail how it compares with a square in Vienna which I thought to know equally well. Not only was I surprised by the outcome of this inquiry, but it also gave me some insights into urban design: cross-cultural similarities of intention and motive, as well as some astonishing differences in result.

Both squares are grand open plazas of roughly equal size, planned and built as a manifestation of monarchic rule at the center of power, and designed as urban scenery and backdrop for the staging of court ritual and public processions. Both were conceived and experienced as an opening up, in the sense of arrival, from the surrounding dense maze of medieval houses and lanes that contained them.

The present shape of both squares dates back to the early 18th century, although both are built partially on much older foundations. The National Library, which dominates the Josephsplatz in Vienna, was designed around 1720 as part of the imperial court of the Habsburgs. The Keshav Narayan Chowk (which now houses the Patan Museum) was built as the residential court of the Malla Kings in 1734. Today both squares share the fame of being counted among the world's most beautiful.

If one compares the two site plans below, it is hard to believe that they are presented in the same scale. The Viennese square looks like a much enlarged detail of the Patan plan. The actual differences are not only in size; they also suggest a discernible contrast in complexity.

right: Patan Darbar Square
far right: Josephsplatz, Vienna. Both site plans are shown at the same scale. The comparative elevations of the preceding views are indicated in red.

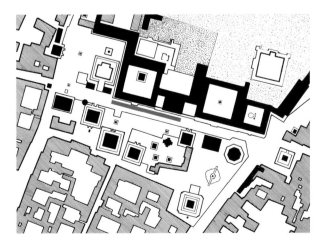

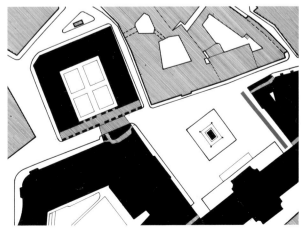

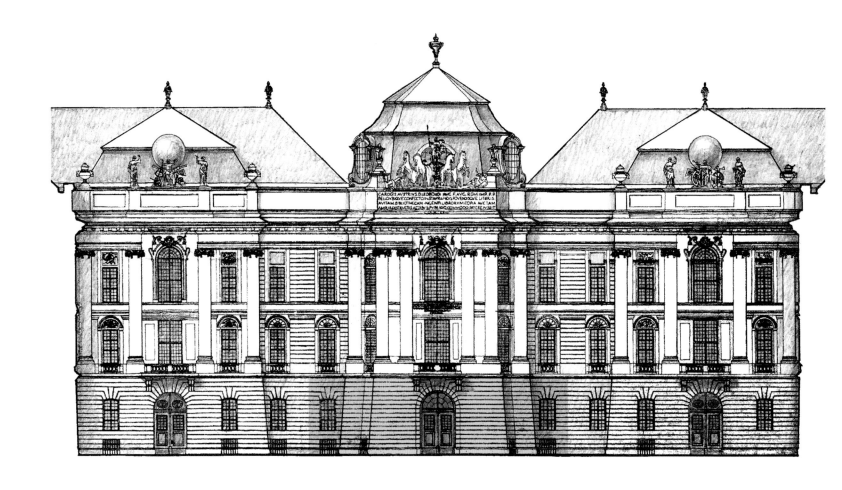

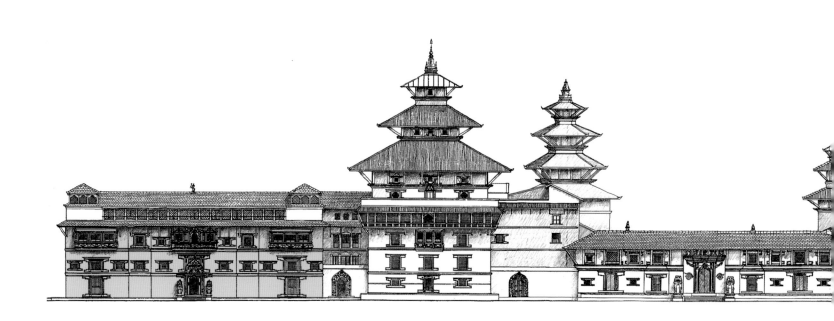

The lot size and depth of buildings on and around Josephsplatz, for example, are about three to five times larger than those in Patan. In comparison, the Patan Darbar houses a much greater number of buildings and monuments within the same area as the Viennese example, its configuration of urban space considerably more varied and intimately articulated.

While the use of axis and symmetry in both cases is a basic feature for the expression, and perception, of hierarchic order in architecture and urban design, the square and the monuments in Patan together display many more central axes, focal points, and complex layers of symmetry than the few dominating ones in Vienna (see also page 52).

The difference in the heights of the buildings is particularly striking. Though each has the same number of floors, the building in Vienna is three times as tall as the one in Patan. Standing before either of them, it is difficult to imagine that the three main floors of the Patan Museum should be exactly as high as merely the ground floor of the National Library in Vienna. And here is a key to what is missing in our attempts to make new cities

friendly: in my opinion, it is the very low floor-to-floor height of common buildings and even of palaces in Nepal that defines the intimate height scale of its historic townscapes and explains why we feel so much more comfortable within their embrace.

Obviously, the House of Habsburg, in representation of its absolute power under one single god, has built its palaces on an imperial scale to awe and overwhelm the common man. It appears to me that, during the same period, the Malla kings of the Kathmandu Valley competed with each other on a more human scale. With a perhaps more pluralistic concept of worldly and divine power, they embellished their Darbars with a variety of architectural gems and great monuments, each devoted to one of the many gods of Nepal.

But then, who am I to define what is human- as opposed to imperial-scale? I merely observe that people always sit on the benches before the Patan palace in the afternoon sun (chewing freshly fried peanuts when it gets cold), and not in front of the Hofburg buildings in Vienna. And why is it that children have never gambolled on Josephsplatz?

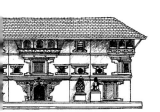

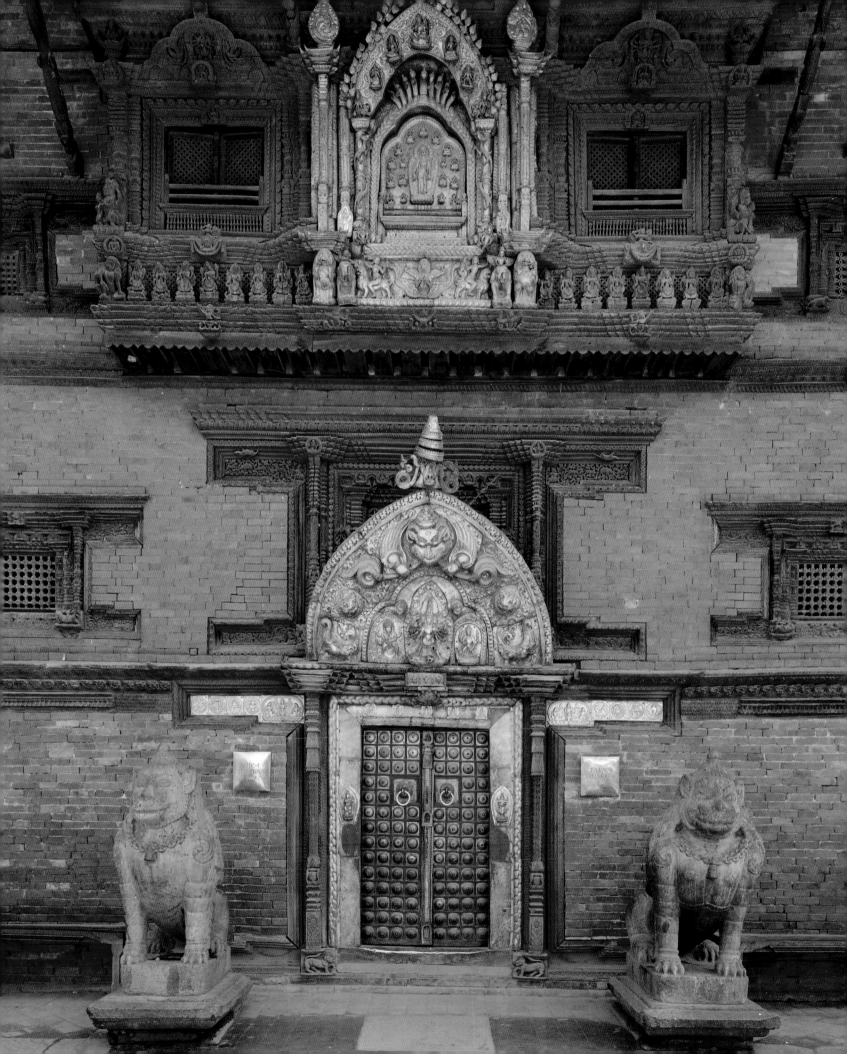

Usha Ramaswamy

Musings on the Patan Museum

When a museum and its contents come together as an integrated esthetic whole, something special happens. The art is enlarged and exalted, and the viewer's rewards and responses are increased. Creating that synthesis of art and setting is the challenge that still faces architects and directors. It is the secret of a great museum.

Ada Louise Huxtable [1]

left: The palace portal created under king Vishnu Malla in 1734, with its famous "Golden Window" (see detail page 30). The carved wooden door was clad in gilt copper under prime minister Jung Bahadur Rana in 1854, as stated on the copper plate inscriptions on both sides of the lintel. In 1997, two cast bronze plaques were added, saying only "Patan Museum" in Devnagari and Roman script. *Photo Rupert Steiner*

below: Once every year since olden times a square vessel is placed in front of the gate containing a Buddha image immersed in water. For a month, this Buddha is worshipped in a public ritual, recalling the ancient sanctity of this site where once a monastery stood at the edge of a stream.

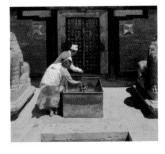

Of all secular buildings, museums are the most intriguing. While other structures have consistently attempted to turn their function into a visual metaphor – grandeur for palaces, grace for places of worship, monumentality for memorials, solidness and impenetrability for banks, fear and authority for courthouses – museums, specifically the newer ones, in attempting to represent the socio-cultural evolution of a society, can and do end up being more exhibitionistic than their exhibits.

The Louvre in Paris, the British Museum and the National Gallery in London, the Metropolitan Museum in New York and countless others in the Western world belong to a traditional genre that we have come to recognise as "museum architecture". Typically they have a classical façade in stone, marble and stucco, a sweeping entrance above a plinth the height of a floor, cold and cavernous rooms arranged around a large court…For buildings intended to celebrate the human spirit they are disconcertingly dehumanising. This accepted formula for museums meant they could have served as convincingly as other types of public buildings of their time. And since the overriding concern of 19th and early 20th century secular buildings was impact and assertion of power,

museums too ended up awing, overwhelming and humbling the visitor even as they sought to commemorate human achievement.

The recent shift from museums as power buildings to arty containers has resulted in a crop of bizarre new structures. To be sure these "look at me" buildings are "read me" buildings too, for commissioned modern art museums today are as quirky and complex as their contents. Reflecting an age in which packaging and branding is as important as the product, and everything, even museums, must be marketed, the visitor is told what to expect from miles away. These museums aim to advertise as well as exhibit, delight as well as shock. The latest of these is Frank Gehry's Bilbao Museum of Modern Art. Wether perceived as an amorphous and even beautiful sculpture or an outrageous structure, it is at the same time a perfect example of the container becoming an advertisement for its contents. If classical buildings house the Old Masters then it is fitting that a dented steel shoebox should contain soup-can art.

So where, in this scheme of design, does the Patan Museum fit? In a word, nowhere. The Patan Museum is not a national museum, in the orthodox understanding of the term. In scale it can be compared to a county museum, and in type it is akin to a history of art museum. It fosters an understanding and appreciation of Hindu-Buddhist religion through artefacts and explanations, and briefly traces the religious-cultural history of Nepal. As for the building itself, it is part of the unbroken line of a Malla palace and temple complex facing the Eastern side of the Patan Darbar Square. Three storeys high, in exposed brick inset with the inclusive and exquisite timber windows typical of old Patan, you could easily

43

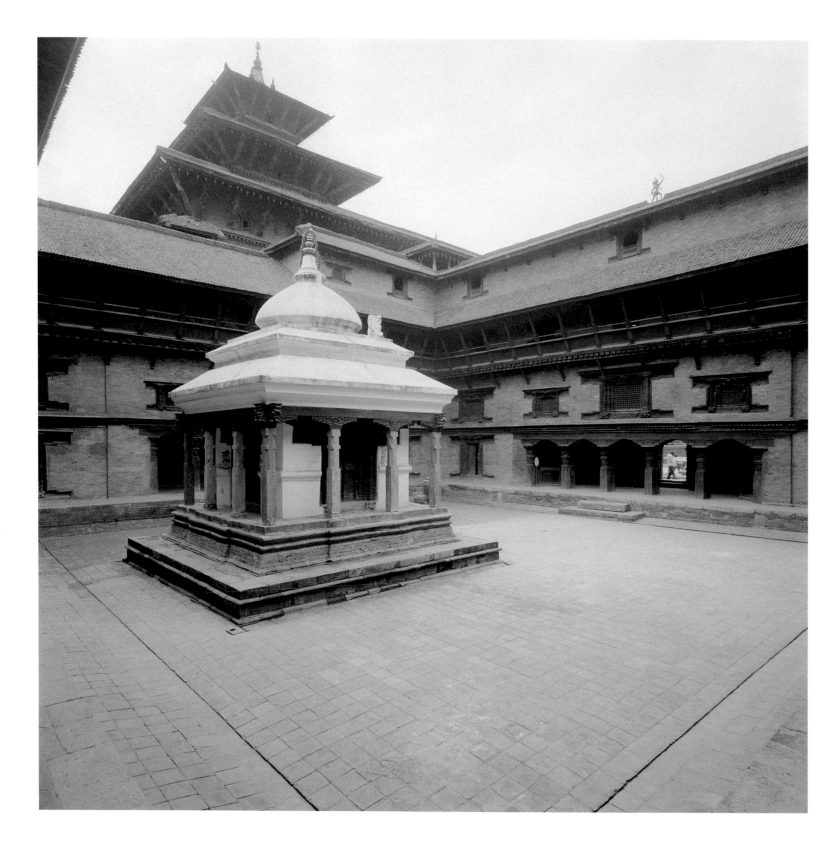

pass it as being one more structure among those massing the Square. Only small bronze plates above the guardian lions flanking its entrance give an indication of what lies beyond.

What awaits you within is the hush of centuries interrupted only by the mesmeric sound of piped temple bells. What you discover is a jewel of an interior, polish-perfect, and glowing under layers of transparent wrappings. It is packaging that excites your curiosity, invites you to open and examine and to marvel at the contents. This sensation of peeling layers, rather than going from room to room, has been effected by playfully designed partitions and subtle lighting. In the first gallery one enters, and in the Buddhist galleries on the floor above, the articulation of interior walls, with large openings for passage and narrow slits to peer through, offers tantalizing glimpses of what lies behind - a sort of imploded perspective. The exhibits are deliberately sparse, accordingly the full impact of each treasure can be experienced. And because the spaces are so intimate – more like living rooms in a house than an institution – and the artefacts so casually displayed, an appreciation of their finer points is within the grasp of even those new to Hindu-Buddhist culture.

As you move through the layers you are, in effect, travelling within a temple to uncover the mysteries of the East. This mysticism, so skillfully achieved here, is the essence of Hindu-Buddhism. A basic premise of both religions is that every human being is on a path of transformation, the ultimate destination being perfection, or self-realisation. The body is a temple and the soul or self is the sanctum sanctorum. The function of the body is to convey the soul to its destination, deep in the recesses of the temple. In the Patan Museum the interplay of walls and spaces gives you the feeling of being in a Hindu temple. The display of exhibits in sensitively illuminated altar-like niches heightens the mystery of this journey of approaching, although not quite arriving, in its innermost sanctum. That enigma of arrival is for you to solve through the exhibits.

The exhibition areas of the museum are housed on the first and second floors of the renovated 18th century palace. While it is hard to comment on the changes without having seen the original, one can say with impunity that the remodelled "new" premises are exceptionally beautiful. Curiously, it also has a spiritual quality. This spirituality can be felt the moment you step in from the busy Darbar Square into the monastically simple entrance arcade – a transition in scale that has the immediate effect of quieting the mind while simultaneosly, preparing it. In fact, the whole building is more like a monastery than a palace, and this too is in keeping with the Buddhist tradition of austerity – and the fact that long ago a monastery was at this site before it was replaced by the palace.

The ground floor comprises the utilities – museum office and shop and cloister-like arcades on three sides of the courtyard. The latter is a serene enclosure typical of those found in Patan's old houses and monasteries. It is thought-provoking to imagine how this quadrangle was once used as a royal court, with a small temple slightly off-center and yet still its main focus. In the wing opposite the street entrance is the staircase where the museum really begins. By traversing these covered, half-covered, and open spaces, you have already begun your journey to the "soul".

An alcove in the main Buddhist gallery. Indirect daylight enters from outside between wall tops and roof, just enough for visitors' orientation in case the electrical lights should go off. *Photo Rupert Steiner*

From a gallery label in the Buddhist section of the Patan Museum:

The Four Noble Truths

This is the Noble Truth of Sorrow:

Birth is sorrow, age is sorrow, disease is sorrow, death is sorrow, contact with the unpleasant is sorrow, separation from the pleasant is sorrow, every wish unfulfilled is sorrow …

And this is the Noble Truth of the Arising of Sorrow:

It arises from craving … the craving for sensual pleasure, the craving for continued life, the craving for power.

And this is the Noble Truth of the Stopping of Sorrow:

It is the complete stopping of craving, so that no passion remains …

And this is the Noble Truth of the Way which Leads to the Stopping of Sorrow. It is the Noble Eightfold Path:

Right Views, Right Resolve, Right Speech, Right Conduct, Right Livelihood, Right Effort, Right Mindfulness, and Right Concentration.

Balcony running around the main courtyard.
Photo Rupert Steiner

With its curiously angled handrail (see page 84), the timber staircase is reminiscent of those found in old Tibetan temples. Front-lit with latticed windows and flanked by tall wall exhibits, it gives on to a low doorway through which you must stoop to pass. This doorway is a recurring element in the museum as some original doors have been retained, complete with thick wooden jambs and high thresholds. The elaborately carved and spacious bay windows with inbuilt seating are also an original feature, as are the balconies over the courtyard. These incorporate timber railing-and-roof supports that slant outwards, giving the narrow gangway an illusion of spaciousness. With its prow-like struts, and tiny windows like portholes, the balcony is like the deck of a ship. Then, between the roof and the outer walls, a gap has been provided for natural light in the exhibition rooms - an airy strip upon which the roof appears to float.

A system of similar internal staircases connects the exhibition floors, the last of which leads to an open gallery on the top floor looking out on the splendid Darbar Square. Within the galleries, display ledges on different levels emerge from the walls, finished with the same tiles as the floor. In this way floor, ledges, and walls form an integrated whole. Moreover, the display ledges double as perches in places where there are no exhibits, so you often come across a visitor resting beside an exhibit.

Lighting is a defining aspect of the Patan Museum. It adds warmth and depth to the wall and floor colours – peach, apricot and terracotta, and augments the relaxed ambience. During the day natural and diffused light filters through the gap between the ceiling and walls. Focus lights enhance the details in the displays but preserve their romance, their timeless and elusive secrets. The displays, remarkable in themselves, are rendered more meaningful through clear explanatory labels. One of these, *The Four Noble Truths* of the Buddha's teachings attracted my attention.

I thought it summarised the spirit of the Patan Museum. It explains how the museum reflects the gentle, self-effacing Buddhist religion that teaches the absence of desire as the path to self-realisation. The icons complement the words of this text. They manifest a similar purity of purpose by not forcing their simple truths upon your sensibilities. They wait for you to discover them: *"We are here should you seek us."*

Little more remains to be said except for a word about the landscaped garden behind the museum. This is yet another surprise in a series of surprises – an oasis just yards away from the hustle and bustle of the Darbar Square, an informal garden with noble old trees, breezy pavilions and a delightful museum café. From its rustic picnic tables one can contemplate the museum's rear façade, a tightly rendered composition of solids and voids similar to a musical scale.

The Patan Museum is an extraordinary and moving experience. To miss it would be to miss an irretrievable moment in time and space, something that can only be described in terms of absence – like a skipped heartbeat.[2]

Usha Ramaswamy has worked as an architect in Delhi, Bangalore and Calcutta and recently, as a writer, she has published a novel and a biography. She is currently working on another novel.

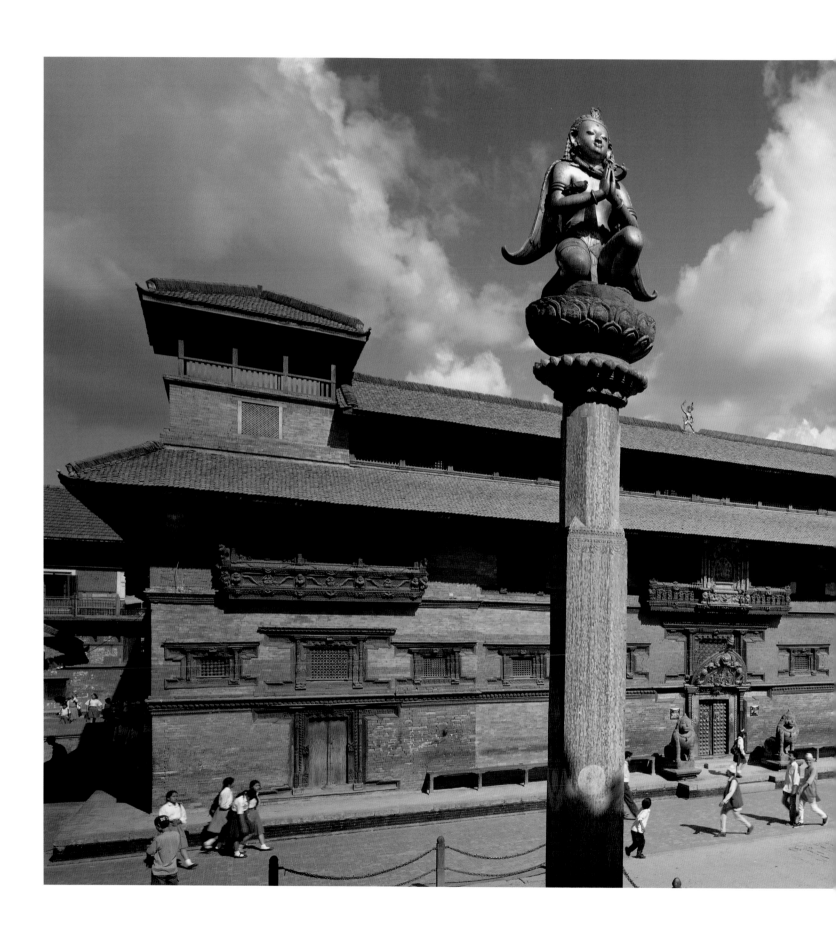

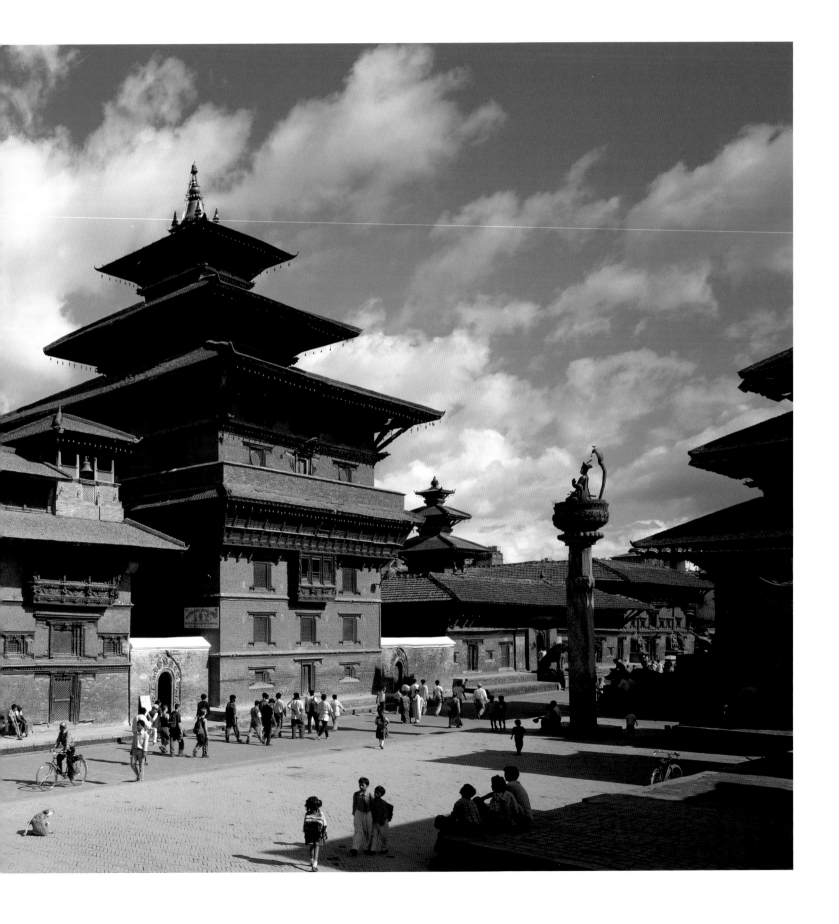

The Building

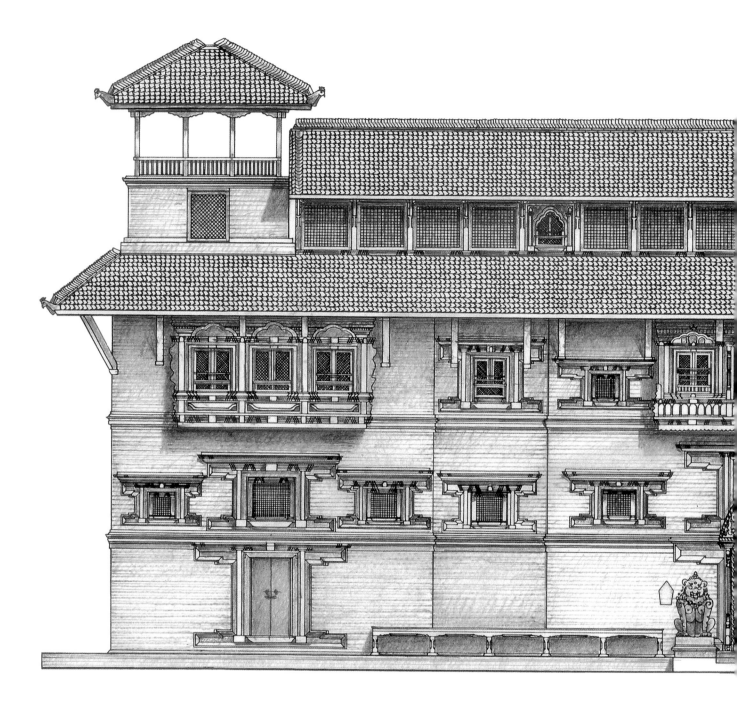

preceding double page:
**Keshav Narayan Chowk seen
from the North.**
Photo Stanislav Klimek

Keshav Narayan Chowk, which now houses the Patan Museum, is the northernmost part of the Patan Darbar palace complex, with the dominating Degutale temple next to it. It is the site of the earliest Malla palace in Patan and rests on the even older foundations of a Buddhist monastery which it replaced long ago. It was also called Chaukot Darbar, the four-cornered fort, in reference to four tower pavilions of which only the two front ones are still in place. Although the date of its original construction remains unknown, repeated renovations of the palace have been recorded. In 1734 it was rebuilt for the last time under Malla rule. The top floor gallery, the roofs, the bell tower pavilion, and the benches in front were reconstructed by the Patan Museum Project from pre-earthquake photographs.

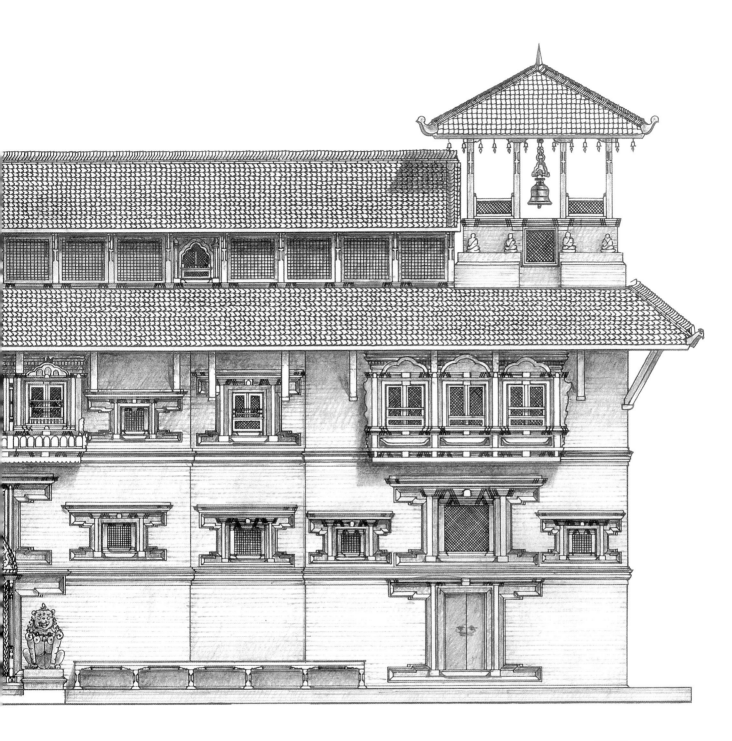

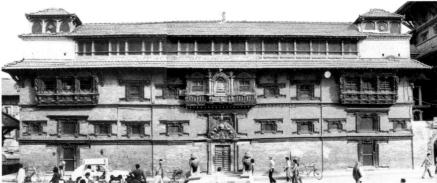

above: Front elevation after
restoration. *Ink drawing by
Surendra Joshi, pencil
rendering by the author*

right: Front elevation in 1982
before restoration.
Photo John Sanday

The Musical Structure of a Palace Façade

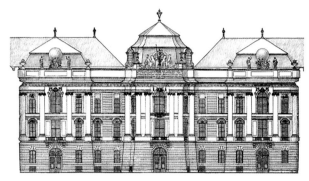

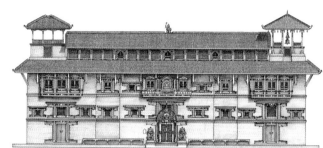

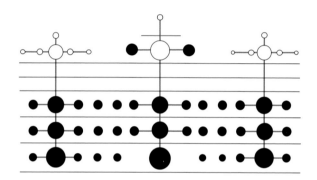

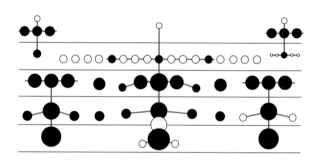

The National Library in Vienna and the Patan Museum: comparative elevations with notational interpretation of their main features. The drawings are not on the same scale (see also page 40).

At the risk of alienating even the most attentive reader, I am tempted to go into some detail about a particular aspect of architectural façades of the Malla period which intrigues me and many, the world over. I promise to stick to a discussion of what anyone can perceive when comparing the above palace elevations as more or less structured and poetic arrangements full of meaning – even if the meaning itself may remain hidden.

The main elements of a building façade are typically its windows and doors. Like the eyes, ears and mouth or the nostrils of our face, these openings mediate between inside and out. The roots *wind* and *eye* for the word window describe exactly its prime functions: to allow ventilation, and to see what is outside. But their position on the *face* or on a *façade* (in this case, both words have the

same root) – either above each other or on a horizontal plane – also manifest the primary directions of our orientation and posture in space: upright and level.

And again in likeness to body and face, builders of the past achieved a human dignity in their works by ordering windows and doors along a central vertical axis as well as in symmetrical balance on both sides. Later, when designing larger structures for powerful clients and kings, they added even more of such symmetrical features, suggesting an alliance of powers around an obvious axis – in formal as well as in political terms.

Of the many historic examples which could illustrate this discussion, the comparable elevations of the National Library in Vienna and the Patan

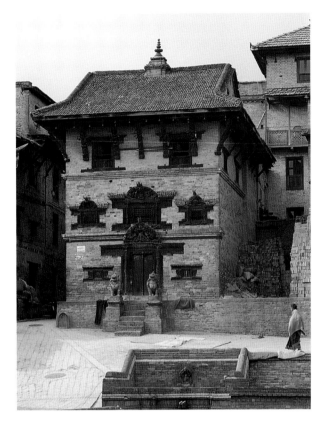

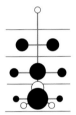

The Salan Ganesh godhouse in Bhaktapur: photograph and diagram of its elevation. Note the different layers of symmetry on each floor, as typical for even smaller buildings of the Newars. *Photo Leonard Stramitz*

group of notes and bars at a time) whereas a building's elevation rises vertically from bottom to top, and is perceived in its totality all at once.

I do not believe that the artistic composition of elements in music or architecture can be reduced to principles of harmony and proportion. But in the creation of a musical theme, with its variations or repetitions in subsequent movements or stanzas, I can see some equivalent to the varied and rhythmic articulation of architectural features on the subsequent floors of an elevation. It is these essential criteria for the aesthetic perception of compositional structure which the diagrams intend to reveal, in order to help in understanding the simple but significant difference between the two palace façades.

Whereas the traditions of Western classical and neo-classical order demand that windows and doors on subsequent floors should be positioned exactly one upon another (thus emphasizing the vertical aspect), the Newar builders in Malla times did not follow such a doctrine. They deliberately avoided the vertical alignment of windows (except on the central axis), conspicuously varied their size, and often placed them on different levels. Thus, they arrived at a different arrangement of symmetries on each floor, giving their façades an ambiguous balance between upright and level, and a more anthropomorphic and complex "facial" expression. I think this playful, non-dogmatic, and rhythmic layering of symmetries distinguishes Newar architecture as a "notable" variation to a universal tune. And it came as no coincidence that many of those who commissioned the abundant repository of art and architecture in Nepal, the Malla kings and their courtiers, were themselves poets, and active musicians or dancers.

Museum may suffice. The diagrams of their façades use an abstract notation, almost like that of sheet music. The wall openings are the primary elements in the articulation of structure and rhythm: they are rendered as black notes of varying size (in relation to their real size), while other prominent features are given in white circular symbols. Less discernible relationships of symmetry are shown in red lines to describe major groupings of elements within the composition.

Horizontal black lines, separating the "notes", indicate the floors (and cornices) of the two buildings while also resembling the five lines in musical staff notation.[1] But one should not take this metaphor too literally since music includes the dimension of time (just as a musical score proceeds from left to right and reveals merely one

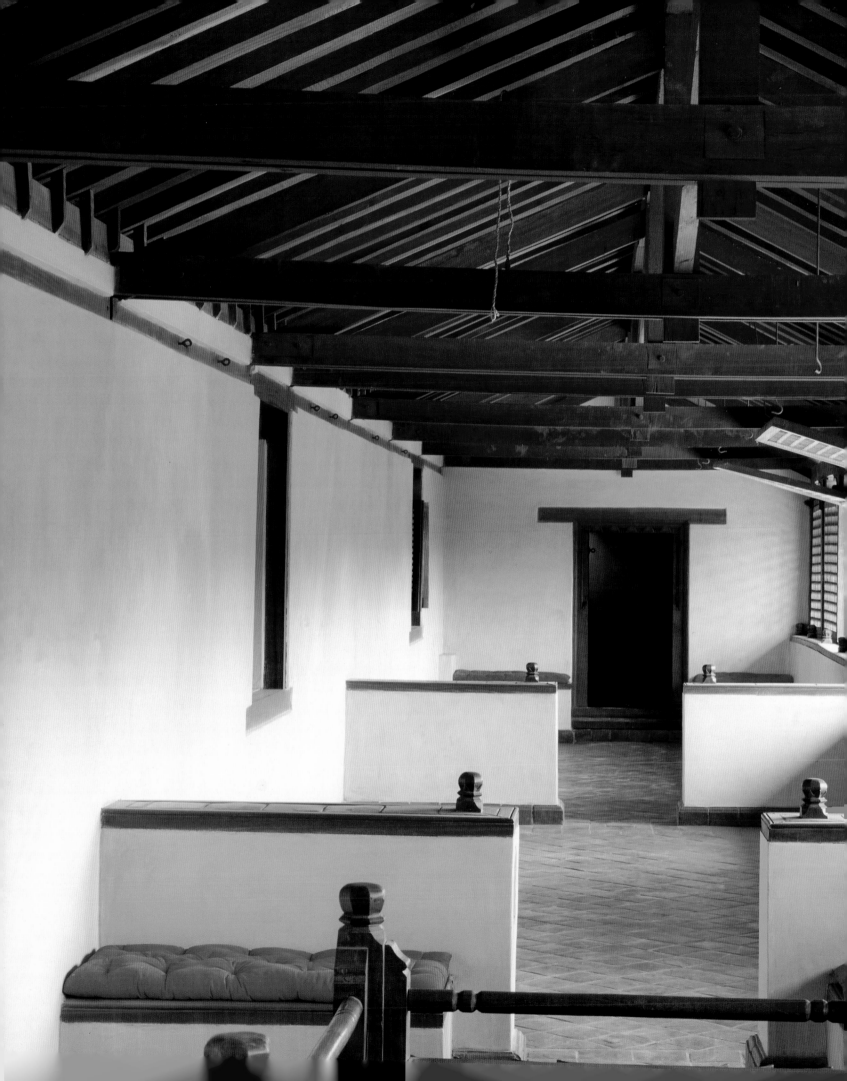

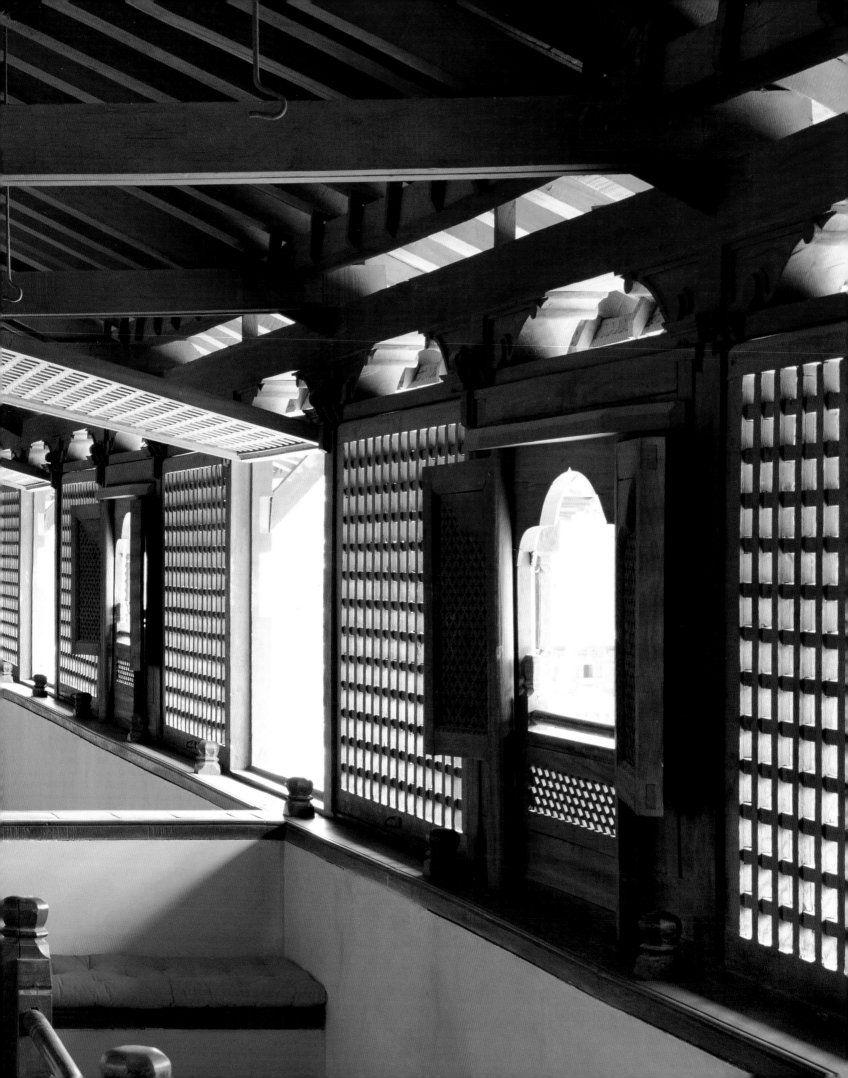

Restoration and Adaptation

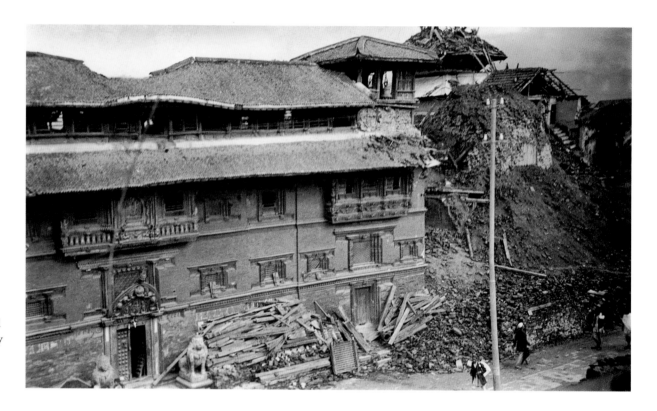

Earthquake 1934: the roof and bell tower pavilion are severely damaged, and the Degutale temple behind has collapsed completely.

preceding double page: interior view of the front wing's top floor gallery after reconstruction. *Photo Rupert Steiner*

The restoration of the palace compound had three major and sometimes conflicting goals: to repair and preserve the damaged structure; to restore its historical design as far as this could be determined based on research and comparable structures; and to adapt the building to its new function as a museum.

Most of the damage to historical buildings in Nepal is caused by Mother Nature in the form of water and earthquakes. Frequent, often devastating earthquakes have taken their toll, as was the case here at Patan Darbar in 1934. Since the arrival of modern conservation techniques in Nepal in the 1970's, it had become standard practice to reinforce historic masonry buildings with the help of concrete ring beams[1] or slabs, to afford some protection against seismic activity. Advocated by renowned structural engineering experts, this rein-

forcement of the historical structure was also carried out in our project.

The damage caused by water, whether in the form of rain seeping through leaking roofs and terraces or ground moisture penetrating the masonry walls, is less catastrophic than earthquakes, but still constitutes a permanent threat of deterioration for the common structural materials, such as timber, mud-mortar, and brick, particularly in a monsoon climate. To safeguard against this, we employed appropriate modern techniques, such as damp-proof barriers between foundations and walls or the introduction of waterproof membranes under the clay beds of the tile roofs.

Architectural changes were necessary to accommodate the new functions of the museum. To achieve any convenience of circulation required removing

56

non-bearing partition walls and adding stairs. Moreover, traditional mud floors were replaced with handmade terracotta floor tiles for the same practical consideration of wear and tear, just as lime plaster was used on the interior walls instead of the original, yet fragile, mud plaster.

These multiple goals and requirements raised the most critical question of the international conservation debate: what degree of intervention is possible and permissible without changing the so-called authenticity of the historic fabric?

The reader may not be aware of the fact that restoration can be controversial and in fact has been so for more than 200 years in Europe, as has been so convincingly presented by the critical Dutch scholar Wim Denslagen in *Architectural Restoration in Western Europe: Continuity and Controversy.*[2] One typical generic conflict pits the practitioners of restoration in a kind of power play with academics or officials, the latter tending to regard monument conservation as a matter of science, or of administrative regulation. Yet if one has no practical site experience or inclination to see that sensible care of the cultural heritage requires an intense and hands-on dialogue with the intentions and means of master builders long dead, one can probably not understand that restoration is a matter of art and engineering no less creative than the original act of design and construction. Sadly, Nepal was not spared the impact of this conflict, particularly in the notion of historic authenticity in contrast to the "stamp of our time" as the subsequent discussion will show.

Since the Patan palace had been subject to considerable remodeling and changes immediately after the earthquake and in later years, we aimed at restoring at least the principal elevation and the main courtyard to their original design of 1734. On the basis of pre-earthquake photographs, the entire top floor gallery and roof configuration of the front wing were reconstructed with relative exactitude based on these visual records, while for the façades of the courtyard, no drawings or photographs existed. In the latter case, we relied on analysis of the surviving fabric and on comparative design solutions in buildings of the same era to correct the obvious, and often insensitive alterations of these elevations. Oral history even played a role in researching or confirming certain historical details, as the story on page 68 will tell.

More than thirty years ago, the then Department of Road Construction was entrusted with the task of repairing the palace and adapting it as a school. It was at that time that the open balcony running around the historical courtyard received a vertical safety grill and the exposed bricks of all exterior walls were covered in cement plaster with a false 'brick' rendering. The roofs were re-laid using modern factory tiles. These changes reflected the practical but ahistorical attitude of a road building department.

It was not a hard decision to remove the layer of cement plaster from the walls to reveal the old brick face underneath, or to replace the large industrial roof tiles with handmade traditional ones (which were easily available from demolition sites in Patan). However, for the design of lost historical details such as roof overhangs, balconies, doors and windows, and façade layout, a great deal of research, design, and work with craftsmen was necessary in order to establish what was most likely to be historically correct. Since master craftsmen, long trained in this and other restora-

In a previous renovation, the courtyard's exposed masonry walls had been rendered with cement plaster, concealing their original brickface while pretending the use of much larger bricks. No one objected to the removal of this "falsification of history".

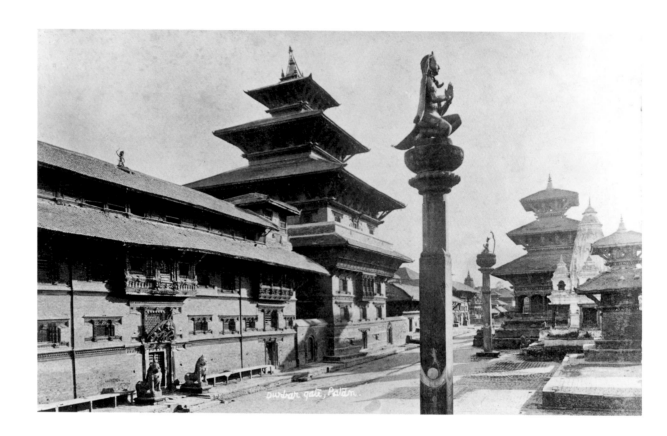

A postcard from before the 1934 earthquake provided many details for the reconstruction of benches, roofs and tower pavilion.

right: After the earthquake the tower pavilion was rebuilt with little regard to its original proportions and detail. Large modern rooftiles replaced the traditional small and hand-molded ones.

far right: The 1987 restoration reversed these changes, recreating the original shape with wider eaves and the traditional roof cover. The bell and the stone reliefs beneath were found and re-installed. *Photo Leonard Stramitz*

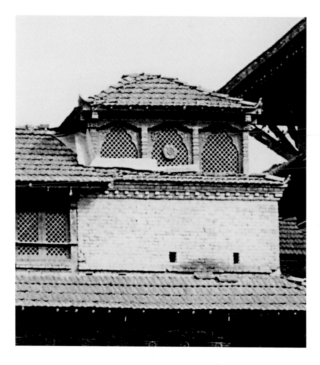

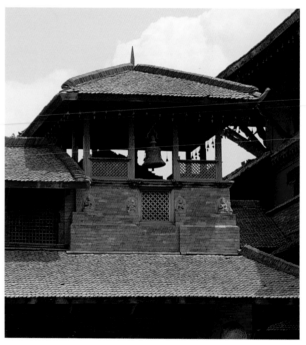

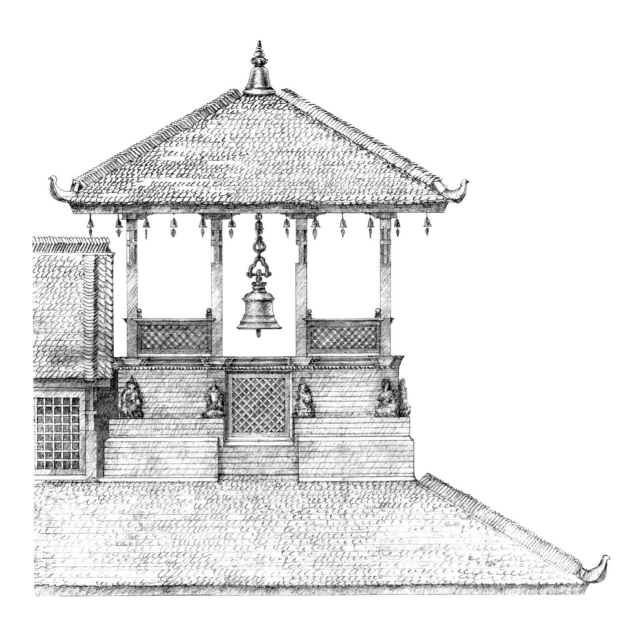

Sketch of the bell tower pavilion, reconstructed after historic photographs.

tion projects, could reproduce the historical designs and adornments without difficulty, the front portion and the main courtyard of the palace now have regained to a fair degree their appearance of 250 years ago - even if some new elements are authentic only with regard to their rich and unadulterated historic design.

It should be noted, however, that this approach to finding the historical "truth" of a building is not what some architectural historians or international guardians of cultural heritage preservation agree with. Ignoring the continuity of Asian traditions where the ritual of repair and rebuilding (and not the authenticity of materials used) is the essence of preservation, they would condemn replacement design "by conjecture" as falsification of historic

evidence and reject the imitation of a traditional design pattern, or even the reconstruction of lost building elements within a given historic setting. According to the 1964 Charter of Venice[3] (which is still the euro-centric basis of international conservation guidelines) each indispensable new component "must be distinct from the architectural composition and must bear a contemporary stamp" - whatever that is. Applied thirty years later and in view of contemporary building in Nepal, this dogmatic rule may well have justified a balcony with concrete balusters, and a corrugated tin roof.

Ironically, in several situations where we actually complied with this doctrine to build in the "spirit of our time", for example in the unapologetic

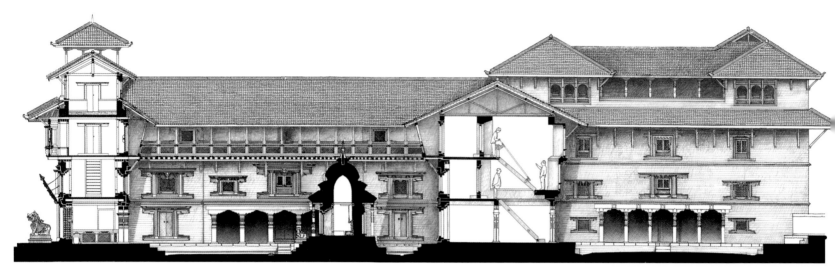

West wing North wing and Keshav Narayan temple East wing Northeast wing

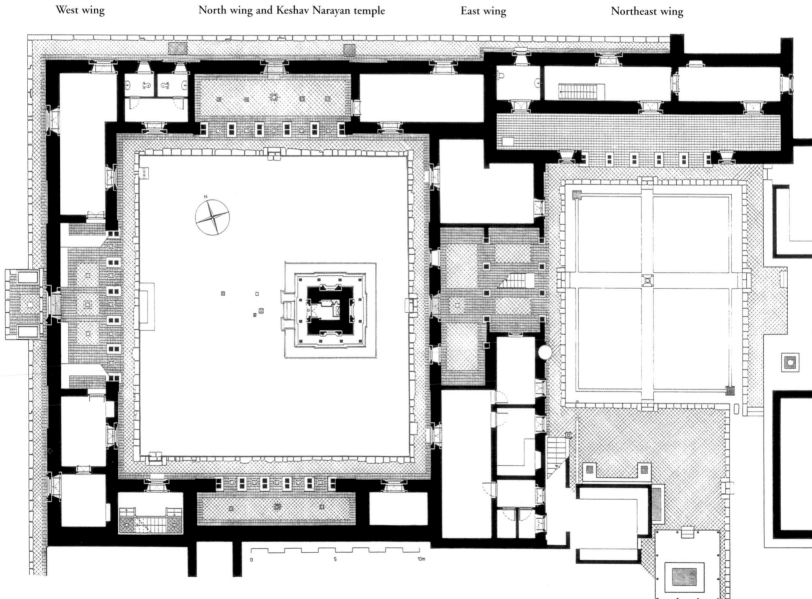

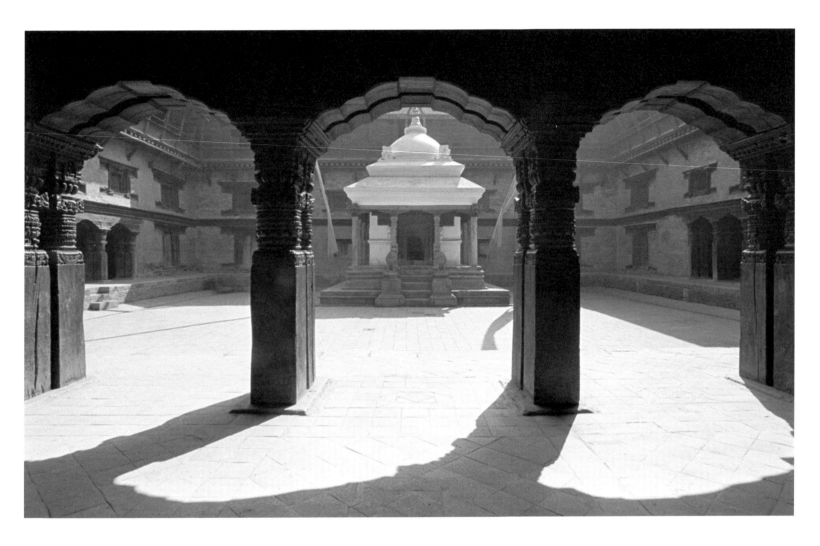

The quadrangle of Keshav Narayan Chowk opens into arcades on three of its sides, supported by pairs of carved timber pillars. The small domed shrine in the center is devoted to Lord Vishnu as Mani Keshav Narayan - from which the common name of this part of the palace derives. The eastern wing is visible behind the temple. *Photo Mani Lama*

left: west-east section and ground floor plan after restoration. *Ink drawing by Surendra Joshi*

introduction of visible steel sections for a new arcade at the museum's rear wing (see page 73), the intention was not appreciated at all by some local and foreign critics. These same people, however, had no qualms with electric light fixtures or modern plumbing and sanitary installations.

The dogmatic insistence of some UNESCO advisors, dispatched in the 1990's on missions to enforce the adherence to such rules in Nepal's own conservation efforts, in their wisdom even went so far as to ban altogether contemporary construction materials and methods in conservation. On account of

this patronizing attitude, inconsiderate towards Nepal's location on top of the Himalayan seismic fault lines, even the use of concrete or steel for structural reinforcement in foundations or for invisible ring beams under the roof is no longer allowed.

The last concrete slab for such a purpose was cast at the Patan Museum in 1995, already in violation of this regulation and done clandestinely over an extended holiday weekend, but irrevocably preventing further damage and fracture to this precious old palace.

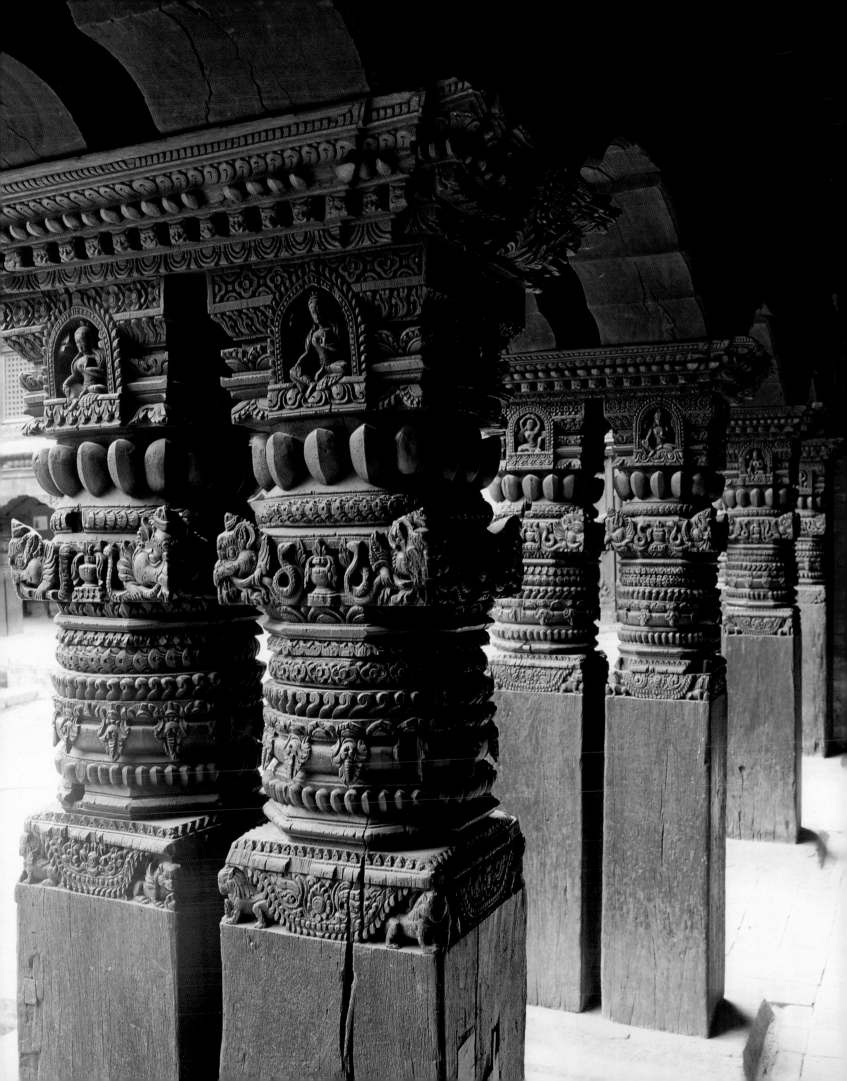

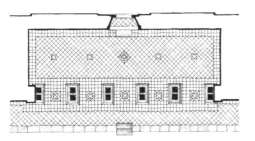

A typical floor tile pattern reconstructed with *mandala* motifs in the North wing arcade.

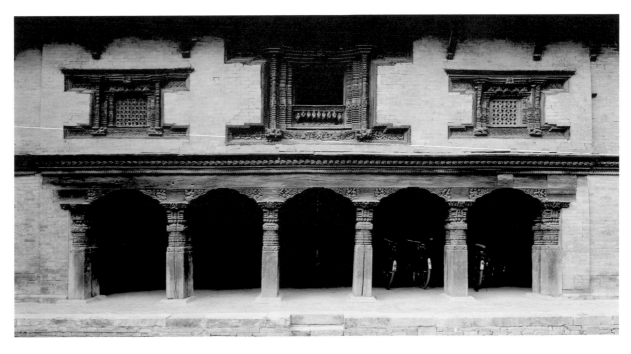

right: North wing arcade. The central window shows nine horses, the mounts of the sun god Surya. *Photo Rupert Steiner*

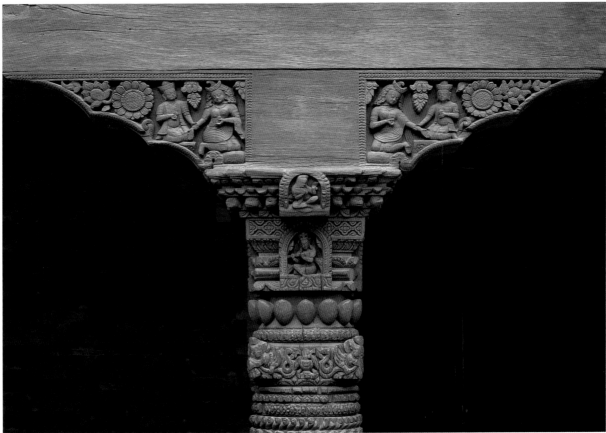

left and right: Carved pillars of the courtyard's northern arcade. *Photos Stanislav Klimek*

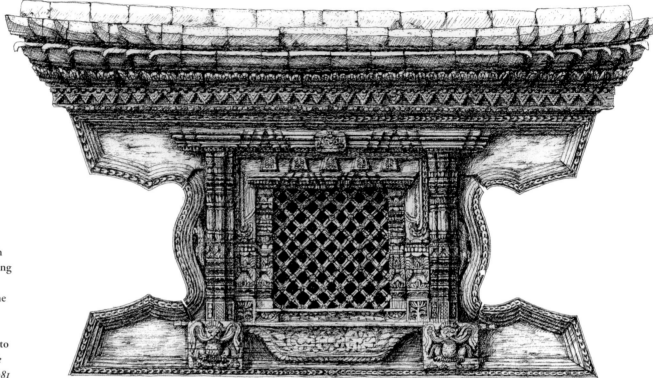

This window of Kuthu Math in Bhaktapur is an outstanding example of Newar wood carving. Also the bricks of the protective cornice above the window are hand-crafted, adding a prominent "brow" to the "eye" of the window. *Ink drawing by Robert Powell, 1981*

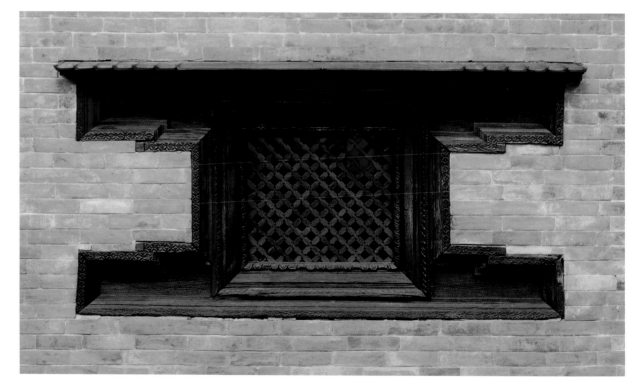

Historic window of the main courtyard's eastern façade. Its simple archaic form is typical for windows on the ground floor in contrast to more elaborately carved upper storey examples.
Photo Stanislav Klimek

Detail of a window of the main courtyard. Its rich adornment is typical of upper floor windows.
Photo Stanislav Klimek

Detail of a door lintel on the northern courtyard façade. Among the predominantly religious motifs of the palace adornments, there are a few secular ones like this royal hunting scene. The boar is still a favourite quarry and a delicacy of the upper classes in Nepal. *Photo Stanislav Klimek*

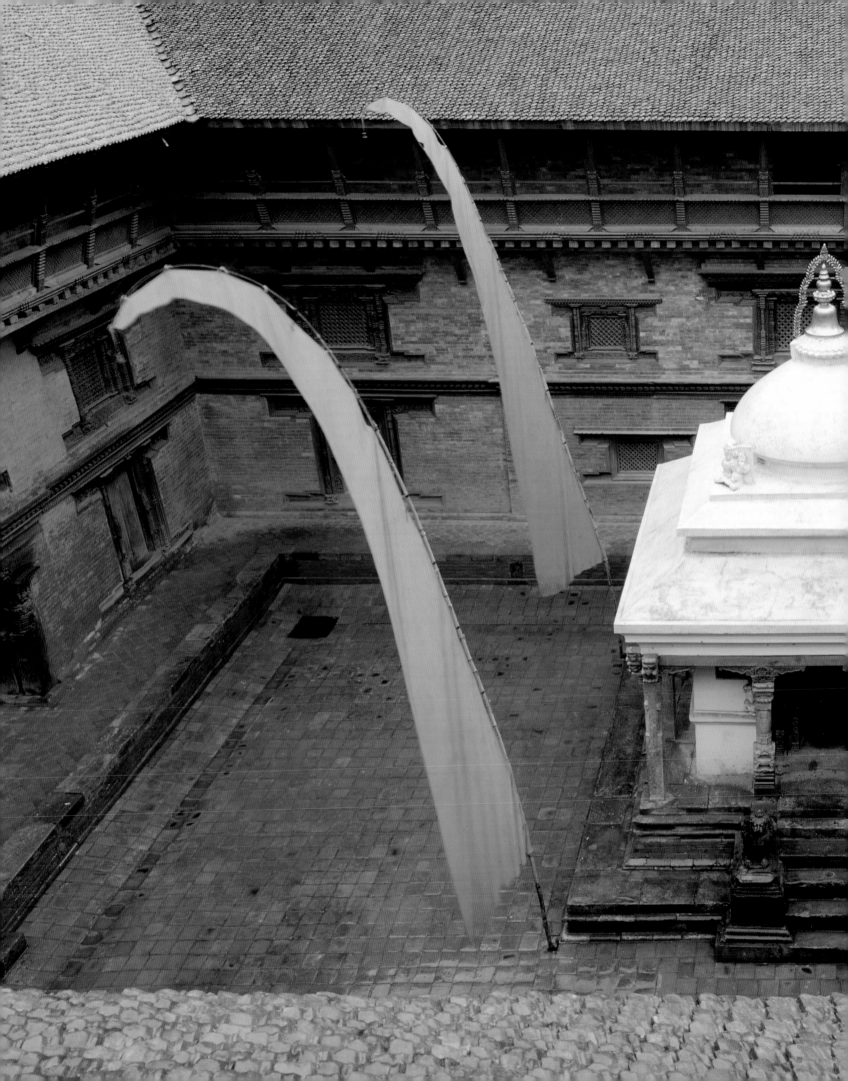

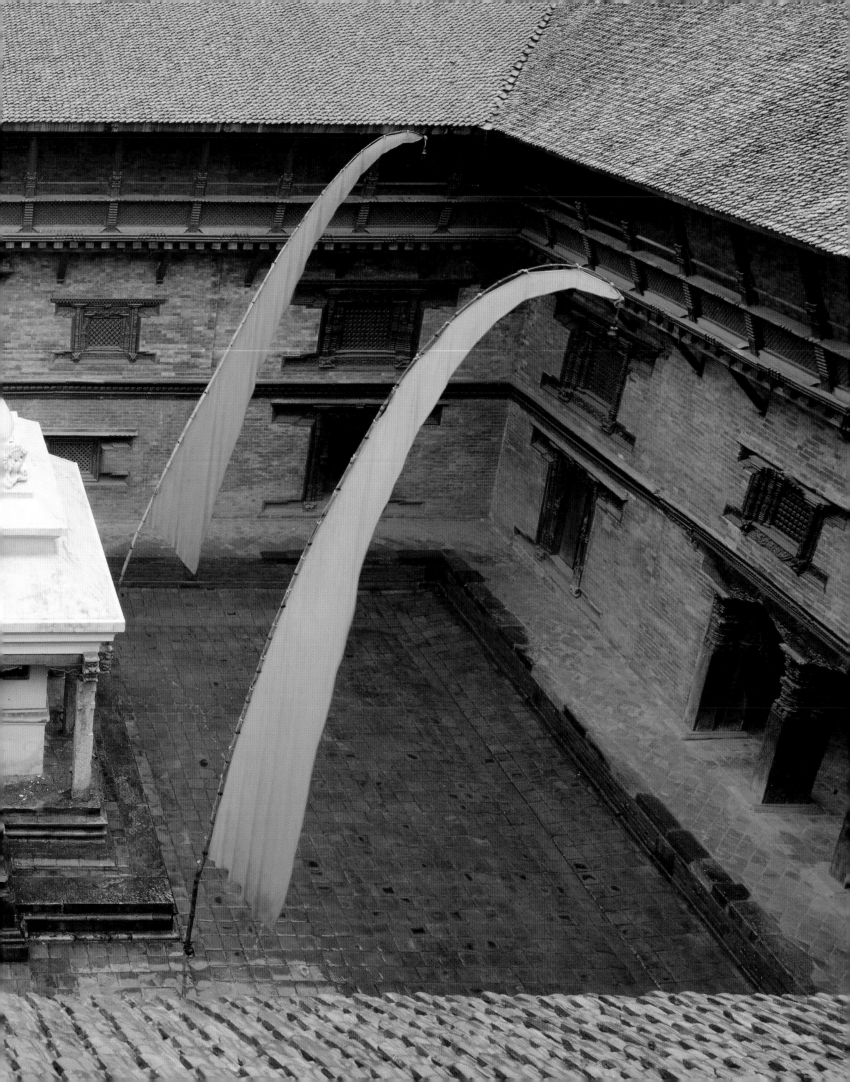

Reconstruction of the Rear Wings

After its total collapse in the earthquake of 1934, the east wing of the palace quadrangle had been hastily rebuilt and – as other parts of the building – with obvious and substantial deviations from its original design. Of the historical substance only two carved wooden doors and some windows of the courtyard façade had survived and were put back into place, combined with new ones of indiscriminate shape. In 1990, barely 60 years later, the wing was structurally in such a poor and unsafe condition that its demolition and complete reconstruction became inevitable. This

proved to be both a chance and a challenge. The chance, on the one hand, was to restore not only this courtyard elevation and its aesthetic coherence with the other three elevations, but also to reconstruct the traditional roof shape with its wide overhang above the open balcony running continuously around the entire yard. The challenge on the other hand, and with no evidence of the original interiors left, was to create galleries more spacious than the other wings would allow, with an open and modern steel frame for the roof structure visible from below, and an equally spacious new stairwell, to be easily accessible from the courtyard.

I assumed by analogy to the spatial concept of similar courtyards from the Malla period, that an open arcade had originally also led into the east wing. With the purpose of thus connecting the main courtyard by an open passage to the new staircase and to the backyard and garden beyond, we devised a central five-bay arcade like the other

Proposed configuration of pillars for an open passage through the East wing, from the main to the back courtyard. *Sketch by Mohammad Sharique*

East wing ground floor during reconstruction: after the pillars of the passage were already in place *(left)*, further research made it clear that the presumed arcade opening towards the courtyard actually never existed. With its front columns removed and replaced by a wall and a door *(right)*, the space turned into a pillared entrance hall, with an open portico only at the rear.

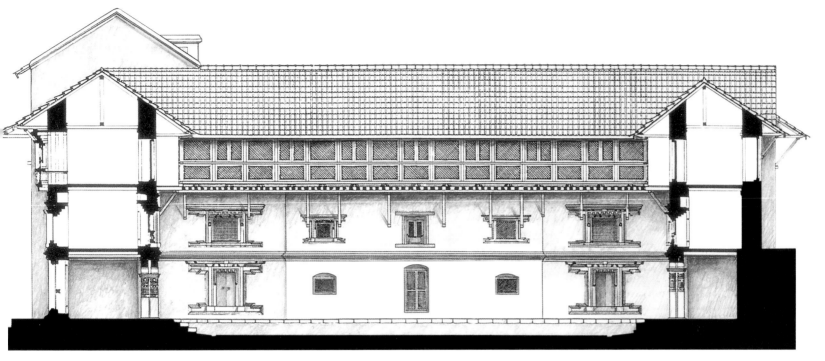

North wing section

South wing section

above and below: The East wing's courtyard elevation before and after reconstruction. *center:* Sketch of the arcade and passage through the East wing, later abandoned.

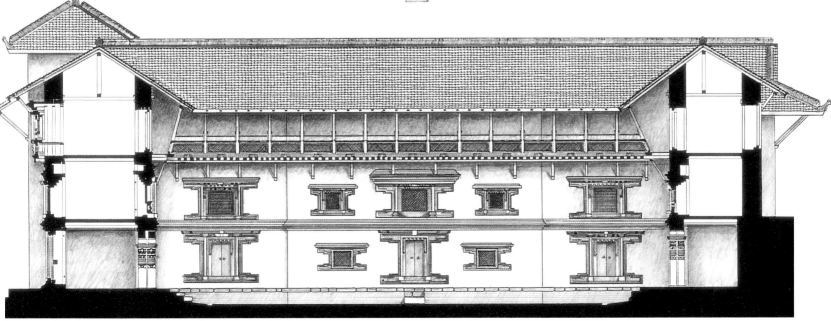

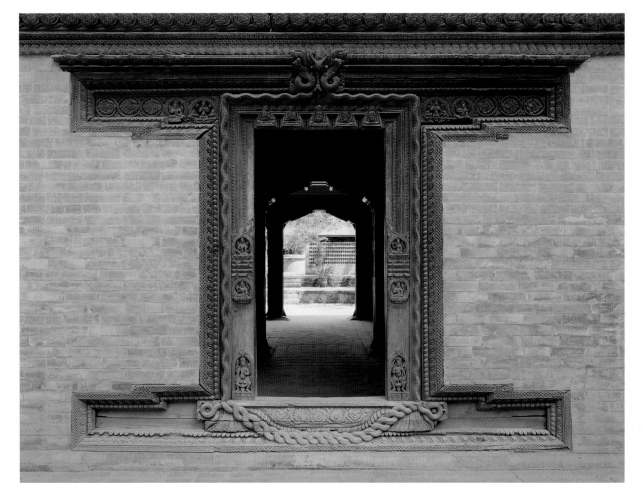

Courtyard entrance to the museum. After abandoning the planned entrance arcade, the access and threshold to the museum proper is now framed by this exquisitely embellished historical gate (in all likelihood even the original one), which had been used inadequately as an interior door elsewhere in the palace. What the photograph does not tell is the door opening's very low height of only 135 cm. This being an almost standard measurement in Malla-period architecture, alike for palace and common house, it requires a referential deep bow of the head when entering the sanctity of a building. *Photo Rupert Steiner*

ones of the existing three wings. However, in this case of conjecture I proved to be wrong. After the new arcade was already constructed, ongoing efforts by project staff to confirm my assumption in interviews with ten elderly people who could remember the palace in the time of their youth, revealed that they did not recall the existence of such an arcade before the earthquake.

Acknowledging this case of oral history research as a legitimate tool to verify the past form of a build-ing in the absence of documentary evidence, we abandoned the arcade and reverted to putting a wall with a central door in its place. As a lucky reward for this somewhat painful revision, an old and prominently carved exterior doorframe, found misused for an internal partition, was available for this more appropriate purpose. It may even be that the very same door has thus returned to its original site. The welcoming gesture of its broad lintel and threshold, delicately receding from the wall's brick-face, and its adornment with protective deities and

sacred snakes entwined around the doorway, certainly suggest a palace portal.

Passing through this door and the arcade behind, one may be taken aback to find the rear elevation of the east wing designed in a manner quite different from the rest of the palace (see following pages). If its present shape nonetheless appears like an eclectic mix of familiar features, it is actually the result of various layers of compromise in composition and style which are worth recalling.

After the 1934 earthquake, the façade had been rebuilt as an entirely new exterior wall with no traces of the original left. The new elevation was a modest example of the colonial style prevalent at that time, a mixture of local and European vocabulary made popular by the Rana Maharajas who ruled Nepal from 1846 to 1951. The façade's simple A-b-A rhythm of big and small openings vertically aligned, and the white-washed elements of cornices and plaster surrounds set against the exposed brickface, clearly bore the distinct, contemporary stamp of the so-called Rana-style still visible on many a townhouse in the vicinity of the palace. The irony is that the neo-classical idiom of the elevation would not have been considered "contemporary" by the propagators of the first international convention on monument conservation thirty years later (the before-mentioned 1964 Charter of Venice), convinced as they were that copy and regurgitation of a historical style should have no place in the future.

Something like creative compromise was required to solve this conundrum of contradictions posed by a "historic" structure barely 60 years old, by the need to rebuild the entire wing due to its poor structural state, but lastly also by the possibility thus given to accommodate certain requirements of its future function as a museum. Taking neither copy nor eclectic compromise to be necessarily adverse to good adaptive design, I basically chose to retain the neo-classical character and material texture of its predecessor for this new rear elevation instead of opting for a purely conjectural Malla-period design, or going the other way with an unfettered contemporary solution. A few changes, however, were introduced. In a minor one, the external stair was shifted from its central position to a more suitable one, now serving as a separate access to the museum's offices. A prominent additional feature is the new arcade with a double-storey bay window above that provides entrance and light to the main staircase behind. In addition, some windows on the top floor were either closed to avoid glaring daylight inside the galleries, or even replaced by alcoves protruding beneath the wide roof, enabling the display of some larger exhibits to figure prominently within them.

These features now enliven the stoic rhythm of the previous façade composition with a few different beats, recalling the presumed musical air of the original Malla-period tune. Yet, the semi-cylindrical shape of bay windows and alcoves is a theme also found in Rana-style houses nearby, and may even be taken as deliberate application of a late 20th century, post-modern stamp – none the worse for its implicit mockery which begs the question: what is "contemporary" in conservation?

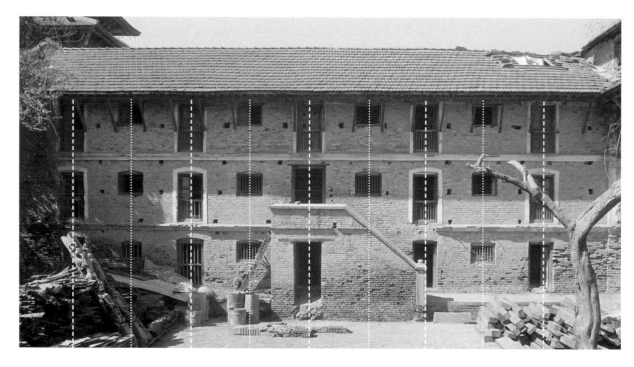

The East wing's rear elevation before and after the reconstruction which maintained the basic neo-classical character of its Rana-style elements and articulation.
Photos Kiran Shrestha 1990, Rupert Steiner 1997

A A b A b A b A b A

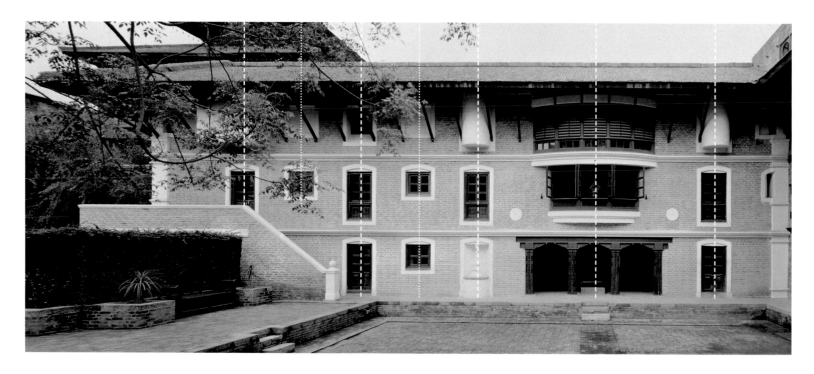

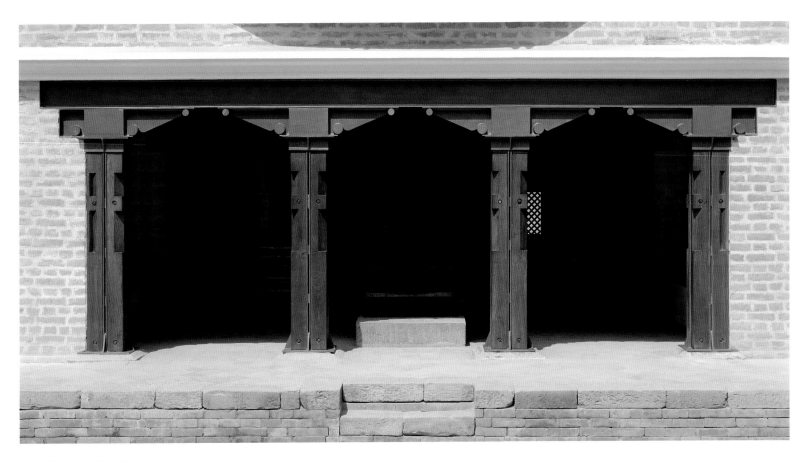

New elements of the elevation.
Photos Rupert Steiner (above),
Stanislav Klimek (below)

The real bone of contention turned out to be a matter of steel, rather than bone. At the new portico of the rear elevation, it seemed appropriate to repeat the size and proportions of the existing arcades (in this case with only three bays), and the basic design features of their beams, brackets and pillars, while visibly employing composite steel sections for these structurally essential components. Had we chosen to hide the steel and to encase it with timber (as we did with the columns anyway), most likely this would have hardly been noticed. But we didn't. We deliberately exposed the simple elegance of industrial steel, avoiding historic decor and pastiche, and for once complying with international conservation doctrine that new components should be clearly distinguishable from the original work. Not surprisingly, this caused considerable debate at the time. Regrettably it also abetted the imposition by UNESCO advisors, as earlier mentioned, of regulations to discontinue the use of modern construction materials from restoration sites in Nepal, even for invisible structural reinforcement against earthquake hazards.

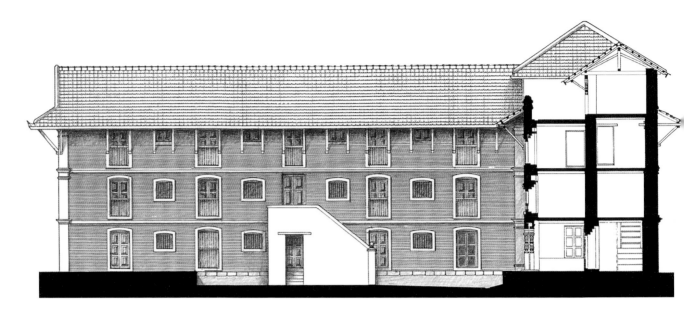

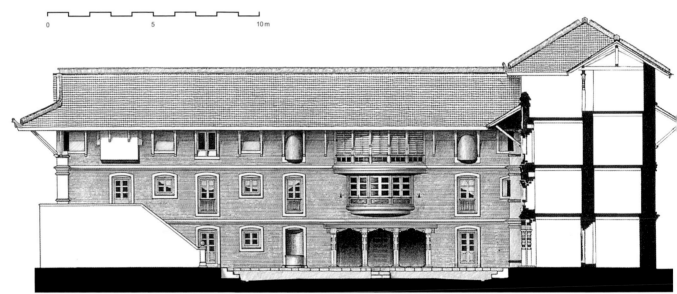

Drawings of the rear
elevation before and
after reconstruction.

Notational scheme of the
rear elevation before and
after reconstruction,
highlighting the difference
of their rhythmic
composition. For
comparison with more
complex "layers of
symmetry" see page 52.

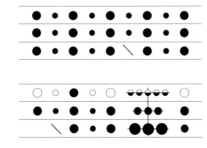

right: New rear elevation of the East wing, with the octagonal pagoda roof of the Taleju temple in the background. *Photo Rupert Steiner*

below: Semi-circular balconies of a Rana-style building in Patan and a post-modern detail of the "Haas Haus" in Vienna, designed by Hans Hollein.

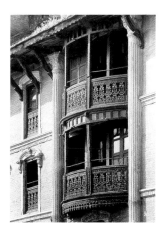

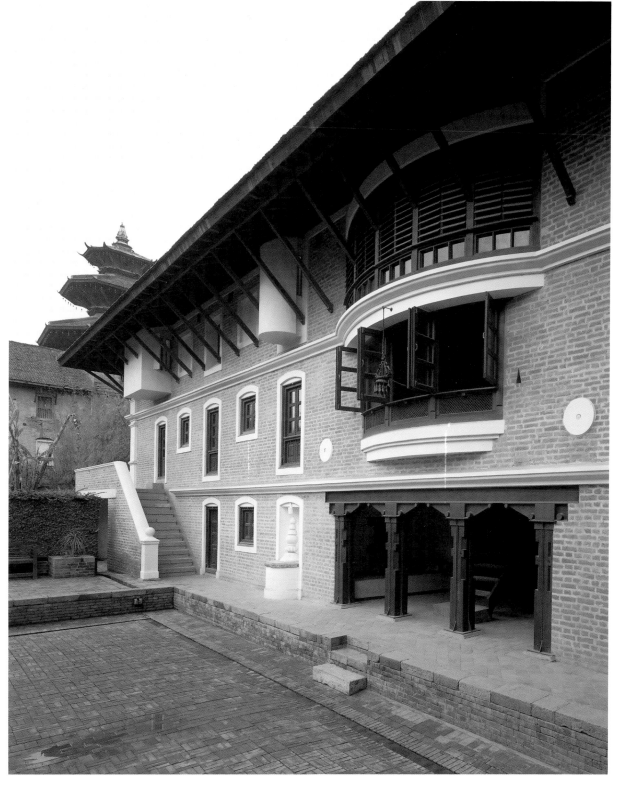

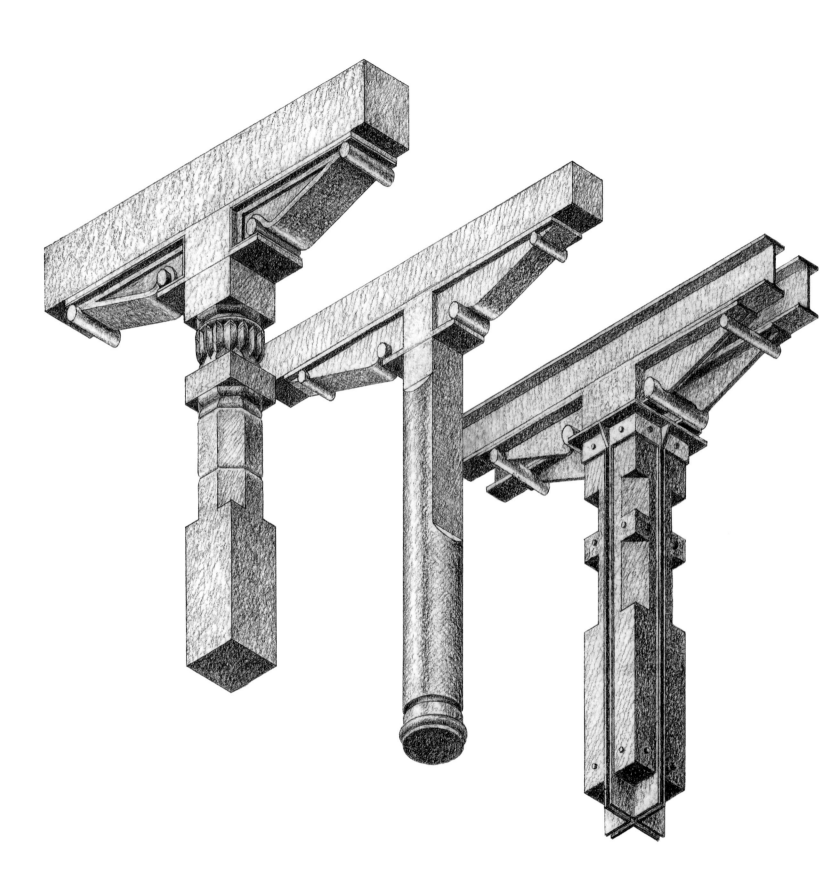

Timber bracket of a dismantled historic resthouse in Patan.

left:
Beams, brackets and pillars.

Typical design motifs from the Malla period (example on the far left) have inspired two modern interpretations at the Patan Museum: in timber for the garden pavilions (center); in composite steel and timber sections for the East wing arcade (right).

The beam: in contrast to brackets and pillars, the horizontal beams were traditionally unadorned. They were also left plain for the two modern adaptations.

The bracket: this type of historical bracket (with its peculiar "rolls") can be seen on some of the oldest buildings in the Kathmandu Valley. Its archetypical motifs are given a simplified modern shape.

The pillar: the historical pillar design is based on a combination of square, round, and octagonal cross sections. The two modern variations play with the same geometrical forms.

right: Photo Rupert Steiner

Cross section of the composite steel-timber pillar.

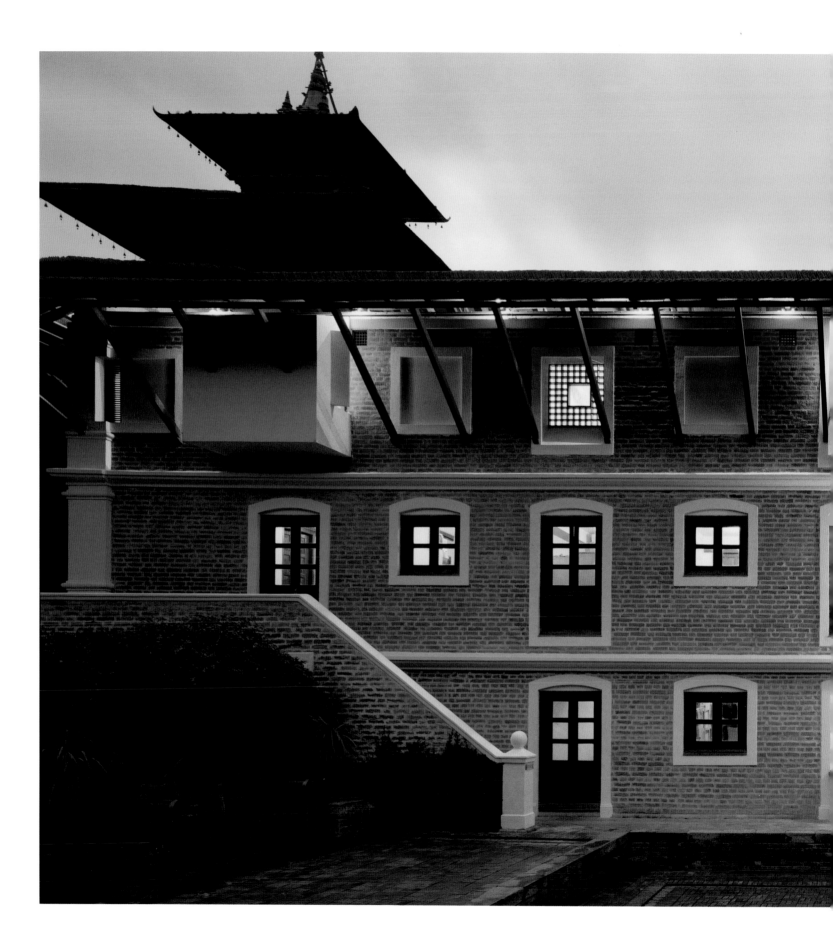

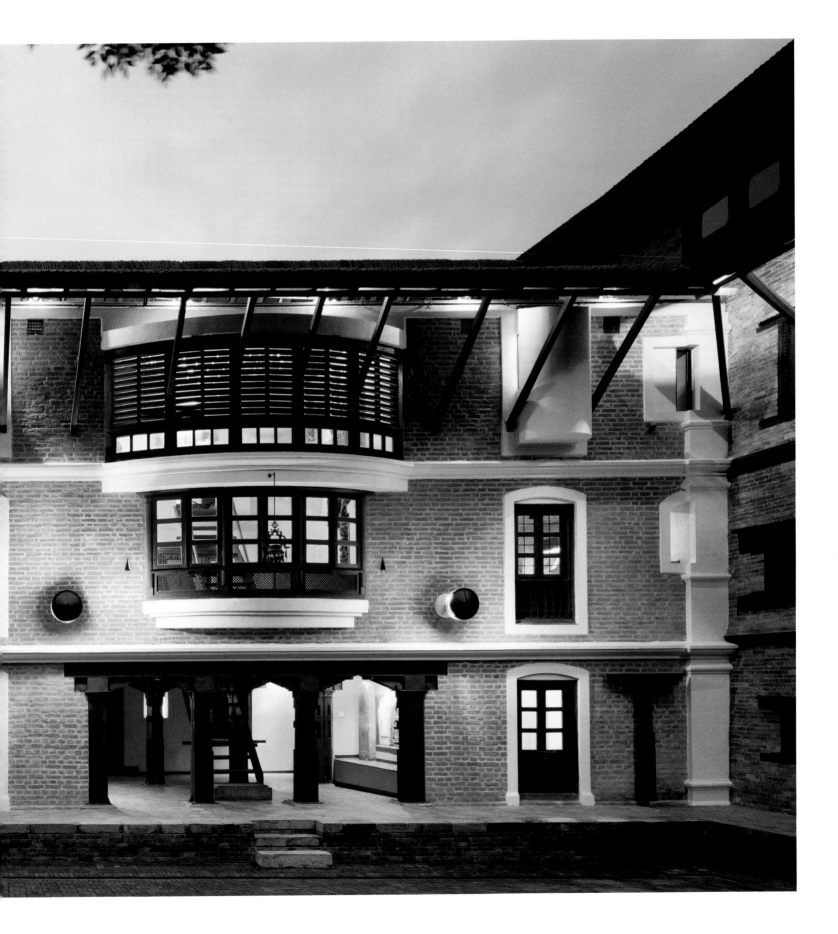

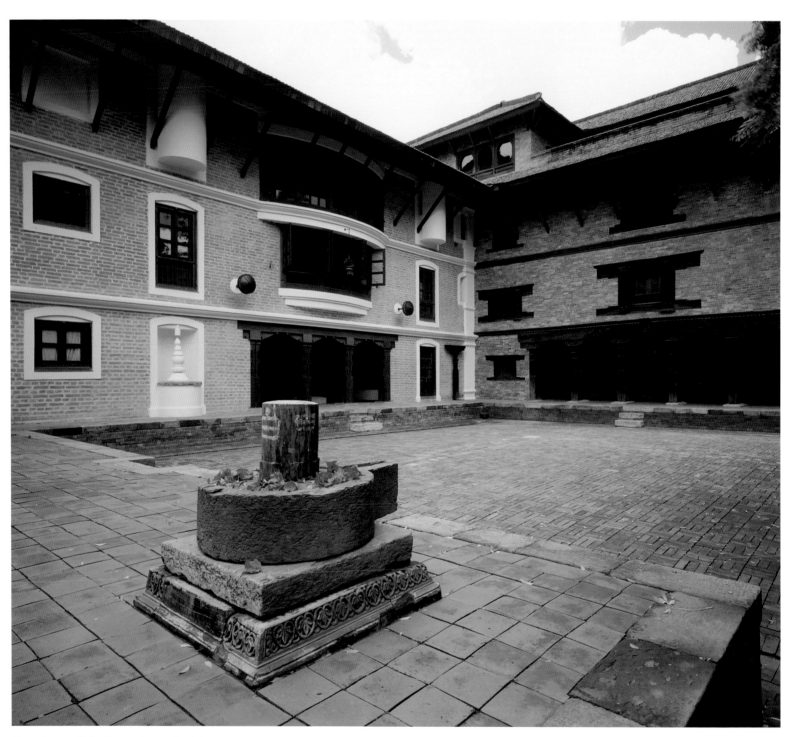

East wing, and Northeast wing to the right.
The *linga* in the foreground was excavated
from the earthquake rubble in the garden.
Photo Stanislav Klimek

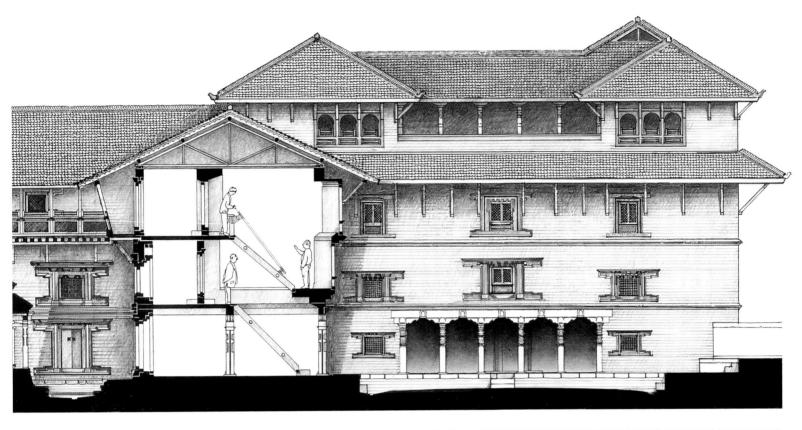

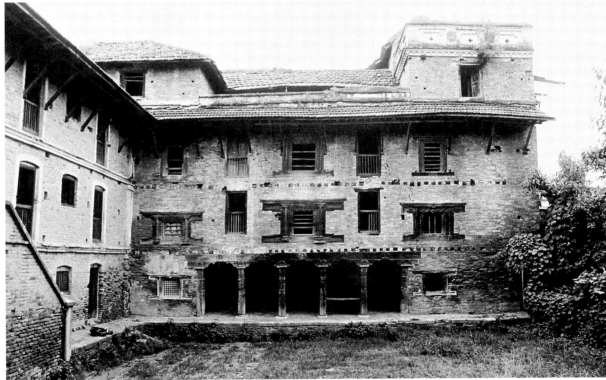

above: Reconstruction of the Northeast wing by "conjecture."

right: The Northeast wing in its deplorable state before restoration.
Photo Kiran Shrestha

This part of the palace had also undergone previous changes and was used for many years as Patan's first public school. In 1995, the roof and top floor were renovated in reference to similar Malla-period manors with the typical layout around an open terrace (see page 127). On the lower floors, two pairs of more recent windows were removed, adding the benefit of more wall space and of less glaring daylight for the galleries inside.

A Flight of Stairs

A temple roof bracket. It depicts Bhairava, a fierce manifestation of Shiva, in tender embrace with his consort beneath a tree, abode of angels and birds.
Photo Stanislav Klimek

Do angels ascend in the manner of man?
Newari proverb

One wonders if angels in Nepal might fly in order to avoid the narrow, steep stairs of the common house, tucked away as they are in a dark corner and taking up only minimal floor space. Even kings would climb the same type of steep timber ladders in their palaces of the past.

The adaptation of the royal residence in Patan to its new function as a museum demanded a more convenient circulation between the floors of the building. In expectation of possibly large numbers of visitors in the future (a new class of "royalty" if you will, not to mention the financial allusion of the word), a new, spacious and well-lit main stairwell was devised.

For the peculiar angle and design of the hand rails I was inspired by the typical stairs of important buildings in Tibet. Convenient and practical, they are also meant to be a subtle homage to the artistic and religious relations between the two countries, as amply shown in the Buddhist galleries to which the stairs lead.

The height of the new stair hall also allowed the display of ancient timber roof brackets so tall that they would not have fit anywhere else within the low ceilings of the palace. These architectural fragments are remnants of temples which were destroyed in previous earthquakes.

Going up the new stairs, one can now see these elaborately carved brackets at close range, affording a view of mythological scenes deeply carved in the time-worn cracked wood, which in their previous location, looming high up in the roof's shadow, were seen perhaps only by angels in flight.

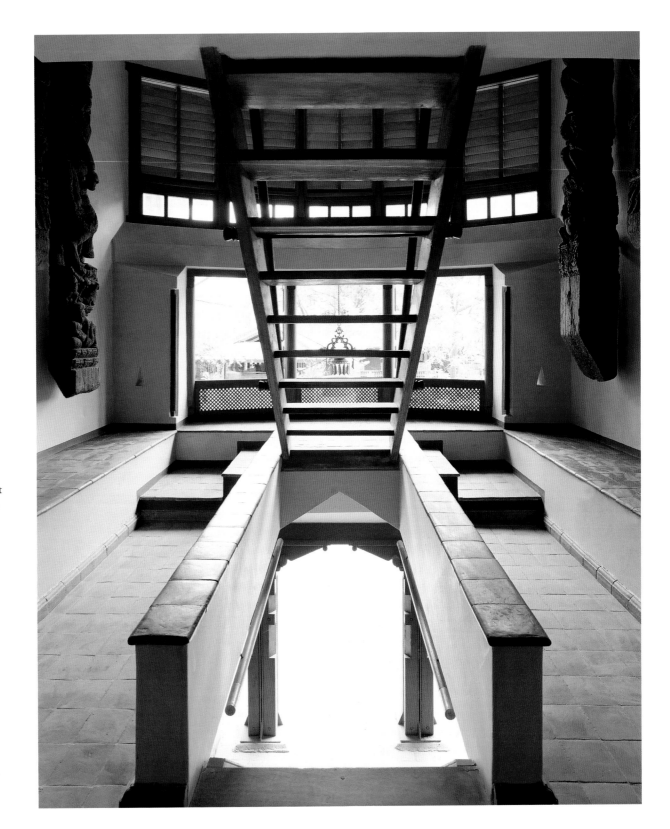

left: As a typical feature in front of major windows, a bronze oil lamp is hung before the staircase, to be lit on special occasions for the attraction of angels.

Main staircase, with a view towards the garden.
Photo Rupert Steiner

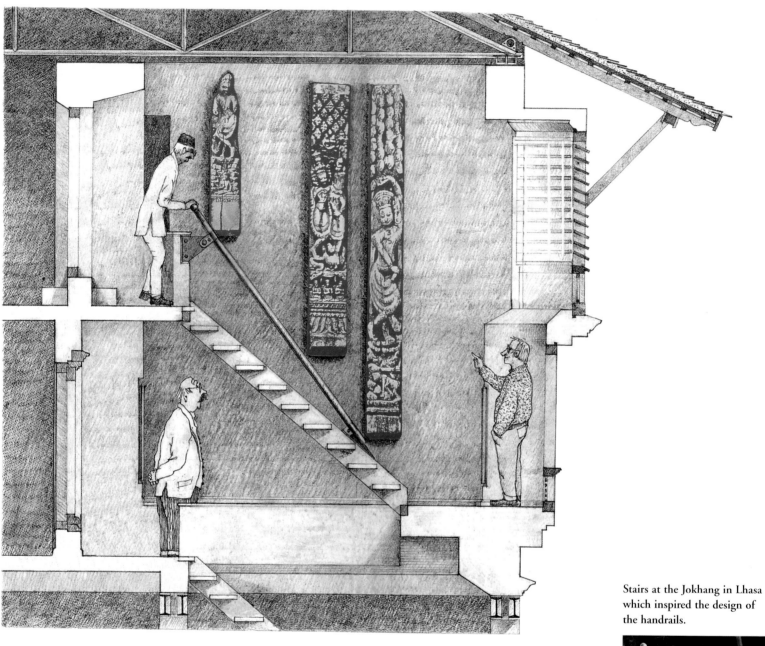

Section through the new main
staircase. The walls of double
floor height allow the display
of the tall temple struts to be
seen at close range.

Stairs at the Jokhang in Lhasa
which inspired the design of
the handrails.

above: Detail of handrail with brass casing.

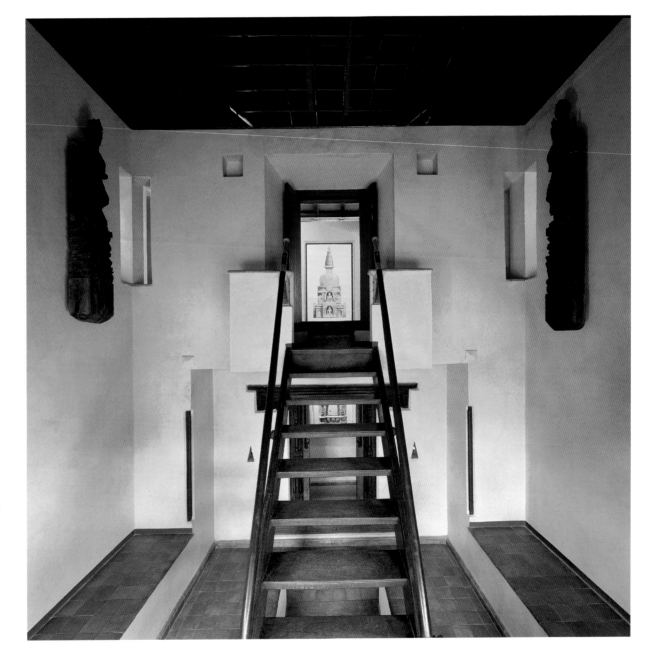

right: Main staircase, leading to the Buddhist galleries. Hidden within the open roof space is a wind chime interrupting the "hush of centuries" in these galleries with "the mesmeric sound of piped temple bells" (Usha Ramaswamy).
Photo Rupert Steiner

Thick Walls and Long Vistas

The crux of the matter lies in the walls. Give them depth wherever there are to be alcoves, windows, shelves, closets or seats.

Christopher Alexander: *Thick Walls*[1]

From the main stairwell we step into the first floor galleries, again with a bow, through an ancient door which frames another wall opening behind, and a niche, in receding layers of space.

A short passage leads further into an ambience of deep walls and long focal vistas, into rooms that pulsate between narrow and wide. Everything here is new and yet breathes the air of a different time.

We can safely assume that interiors of the Malla period, even those of a palace, were quite modest, even plain, with mud plastered floors and walls, and no furniture to speak of. Every impulse to adorn was reserved for the artistic

Gallery entrance, first floor. The carved wooden door was salvaged from the demolition of an old house. The triangular loopholes are a traditional feature for the passage of spirits who avoid thresholds in their flight path.
Photo Rupert Steiner

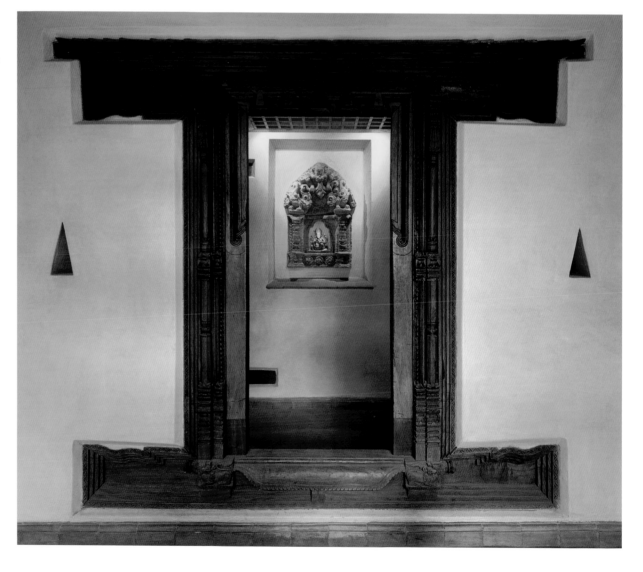

Design sketch and view of the first gallery which introduces some basic aspects of Hindu and Buddhist iconography. It also initiates the architectural theme of thick walls, deep niches, and perspective vistas employed in this wing.
Photo Stanislav Klimek

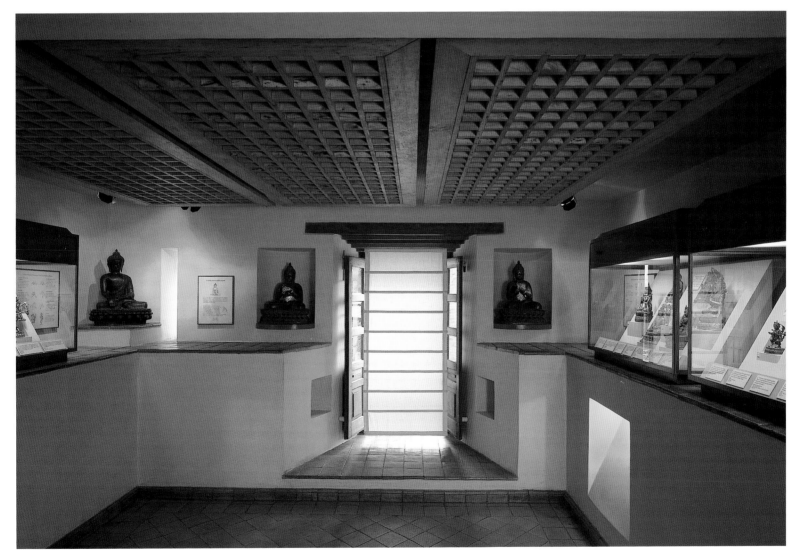

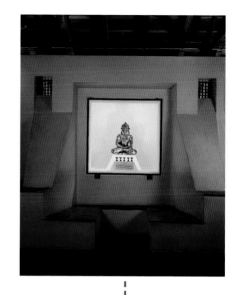

top: One of the alcoves set in the external wall. The embracing gesture of the thick wall emphasizes the eminence of the exhibit (see page 94) which, in addition, is lit from the sides by indirect external daylight.
Photo Stanislav Klimek

right and below: Wall elevation and floor plan of the Buddhist galleries on the top floor. Major orientation vistas (indicated in red) establish a visual connection with the adjoining galleries. The southern gable wall (to the right) is pierced under the ridge with a small triangular hole which allows a ray of sun to trace a shortlived arc on the floor at noontime.

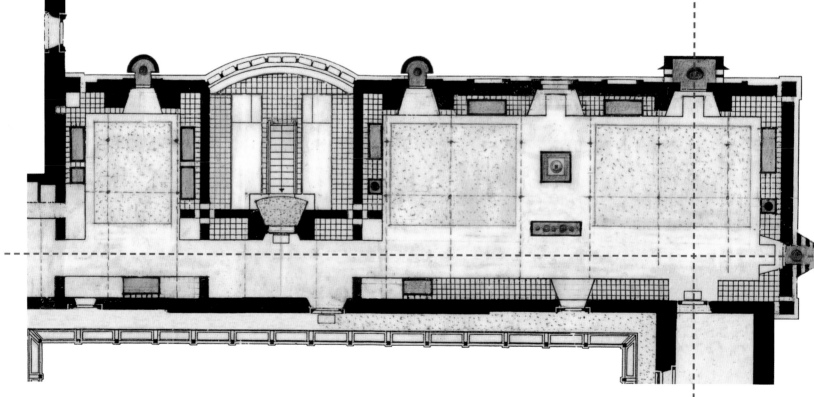

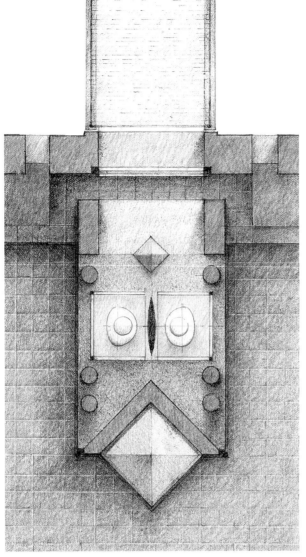

Design drawings and view of an early exhibit installation, later abandoned because it was too dominant and space consuming. *Photo Peter Auer*

exuberance of the outside architecture, the elaborate decoration of windows, doors, and façade. In our restoration of the building, this plainness has been retained without any historic pastiche, in the simple plastered or tile-covered surfaces of the interior galleries.

The impressively thick masonry of the historical bearing walls even became a source of inspiration. Since I live and work in an ancient house of the same era, I have been imbued with an appreciation of the practical and physical comfort of deep walls (which thin ones do not render), and the beauty of their modulation with deep-seated windows, niches and alcoves. They often remind me of what Christopher Alexander has so sensitively observed in *A Pattern Language*,[1] a source book of

universal themes and patterns in architecture: the memory of a building can be written in the thickness of its walls, "so that character accumulates in their depth and volume, with time."

His cue was taken. Rather than going for a modern thin wall solution, it seemed more appropriate to inscribe a new architectural idiom into the depth of thick masonry walls – a kind of physical resonance of the structural history of this building, but also a testimony to its future character as a museum. An additional aspect of this idiom lies in the unmistakably novel articulation of interior volumes and voids, but also in the arrangement of spaces along visual axes which add a new element of perspective and orientation towards focal points at the end of long vistas.

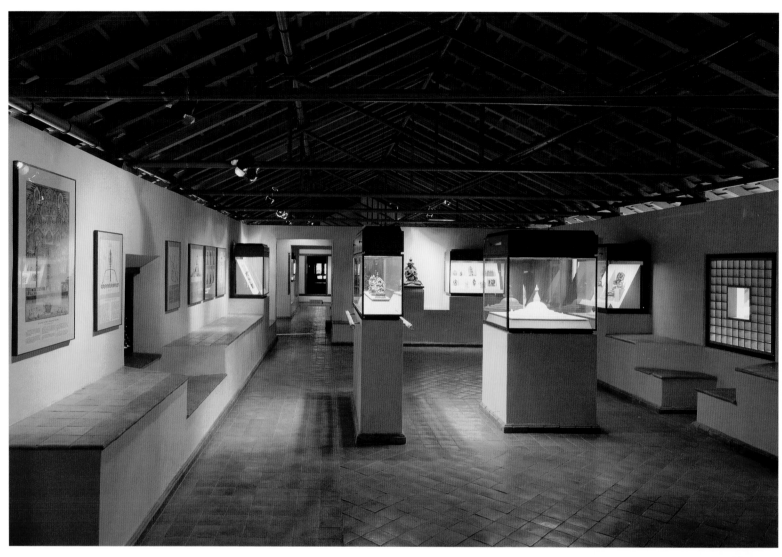

above: The main Buddhist gallery. The view leads the eye towards a far window of the adjoining wing. The contemporary interior does not hide the roof structure of modern steel trusses.
Photo Stanislav Klimek

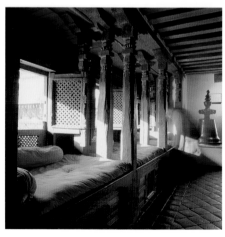

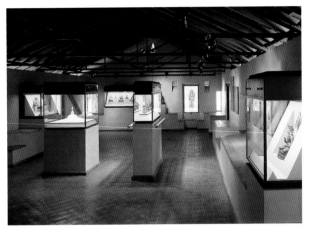

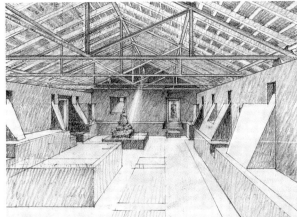

The opposite view and perspective from that shown on the left-hand page. It converges towards an alcove at its far focal point.
right: Photo Rupert Steiner
far right: Drawing by Roland Hagmüller

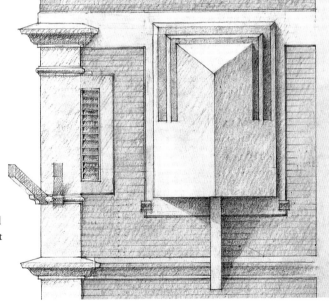

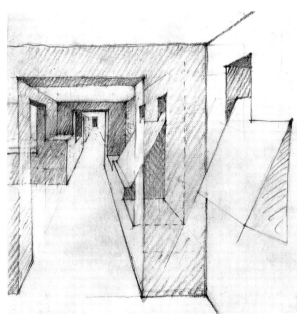

right: External view of the triangular alcove. ∩-shaped slots allow indirect daylight to illuminate the exhibit inside.
far right: The view above from a longer distance.

right: Detail of the floor plan (page 88) with two alcoves marking the end of vistas from two different directions.

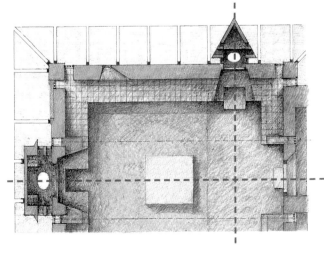

left: Deep bay windows on the second floor provide seating comfort and views of the Darbar Square below.
Photo Tim Linkins

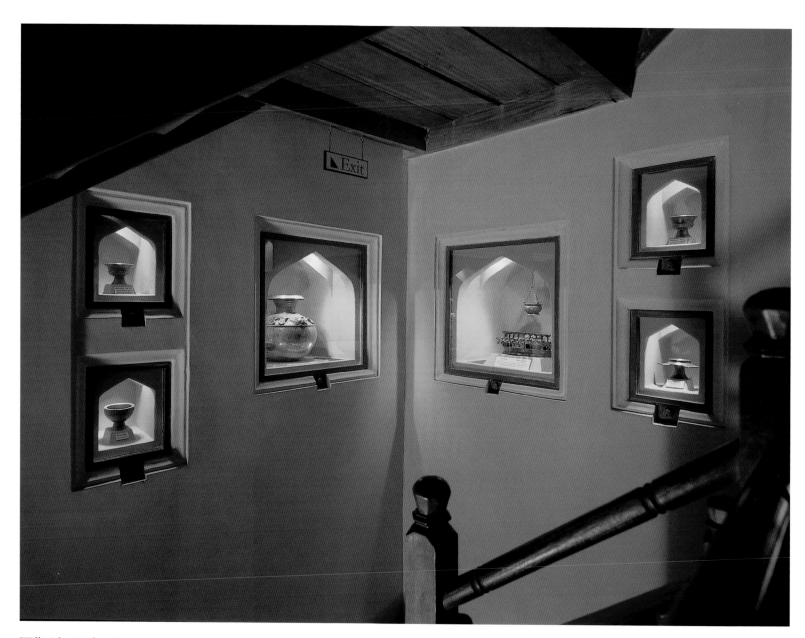

Wall niches in the exit staircase. The traditional motif of niches was adapted for showcases with concealed lighting in this narrow old staircase, giving it additional purpose as well as tangible expression to the depth of its ancient walls.
Photo Stanislav Klimek

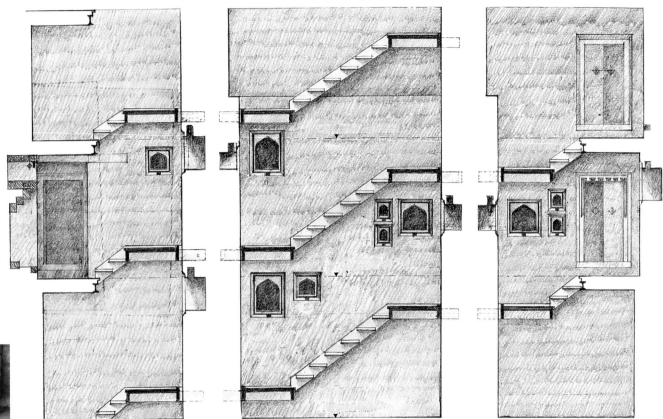

Wall elevations of the exit staircase. The niches are made of pre-cast concrete components set into the masonry walls.

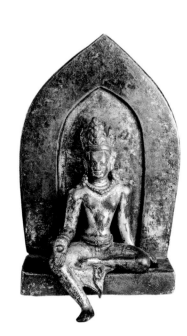

The typical pointed arch design of these niches is often attributed to Moghul influence but can already be found in an image of Indra, one thousand years old *(right)*, or in even older stone chaityas of the Licchavi period *(left)*, long before Islam reached this part of the world.

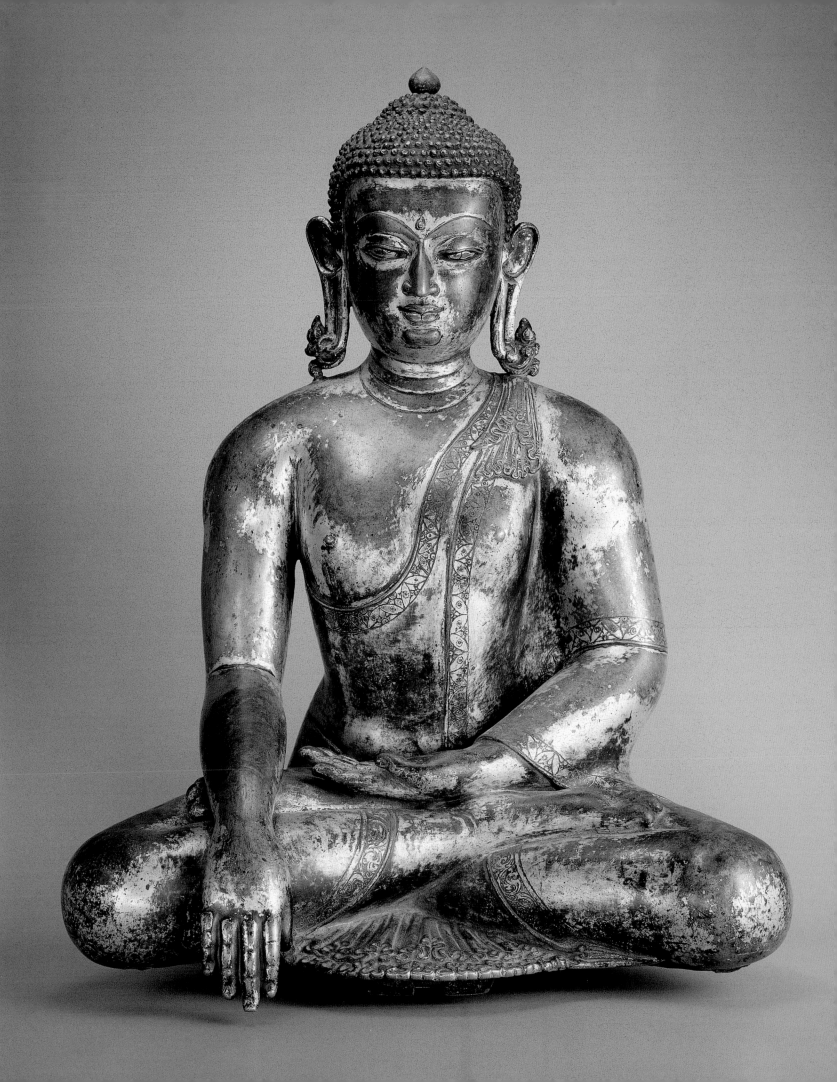

The Collection

Kanak Mani Dixit

Stolen Gods of the Valley

A superb 12th century image of Shakyamuni Buddha seated in meditation, an equally ancient relief of the divine couple Uma-Maheshvara in tender embrace, or a gilt bronze lingam in the gallery dedicated to Shiva – these items in the Patan Museum collection have one thing in common. They were stolen.

After a previously secluded Nepal opened to the world in the 1950's, an illicit trade in idols and devotional paraphernalia developed rapidly and reached its peak in the late 1970's and 1980's. As the world discovered the exquisite treasures of the Kathmandu Valley and smugglers shifted their gaze to Nepal, this art, in stone, bronze, terracotta and wood, was soon esteemed as "antique art", and a demand arose amidst collectors and connoisseurs in distant drawing rooms and museums. A criminal network sprang up, stretching from the petty thief on the ground in the Valley to middlemen and shippers in India and the Far East, to art dealers in the fashionable districts of New York, San Francisco, London, Paris and Tokyo. It helped to build up collections of Nepalese religious art in some 25 of the world's museums, and in many more private homes.

Back in the 1960's, the Kathmandu Valley was a vast and open museum, with abundant devotional art openly displayed in every courtyard, neighbourhood, field and hillock. It was, and to a large extent remains, a living museum, where the statuary on the votive stupas or atop the water spout, in public spaces and not just in the sanctum sanctorum of temples and monasteries, are actually objects of worship. Isolated in the middle of a forest, entwined in the all-embracing roots of the pipal tree, or crowded amidst a busy courtyard, these divine images accept the devotee's offerings of flowers, water and vermilion tika. Until, that is, the day they are picked up from their foundations with a pull and a tug: easily enough. The artists who created these ancient statues, and the priests who consecrated them, never imagined the necessity of securing a deity's image against theft.

Incongruously and ironically, this criminal and culturally insensitive world of idol-theft has become the single most important "benefactor" of the Patan Museum. It could be said with a fair degree of certainty that each and every piece of the larger stone and bronze statuary in Nepalese art collections all over the world – and in this very museum – is stolen property; the significant difference being that the Patan Museum pieces were abandoned by the thieves or traced by the authorities before they could leave the country. Today they provide a collection that is representative of the centuries of artistic endeavour of artists and artisans of the Kathmandu Valley, starting from the Licchavi era and winding down around the time of the invasion of the Kathmandu Valley by the Shah rulers from Gorkha.

It would have been impossible for the Patan Museum to have put together such a rich collection by the normal acquisition process of a museum. For, truly, the gods of the Valley are not for sale. No community to which they belong would consider parting with them, howsoever high the offered price. The societal bonding and the link between the statues and the citizenry remain strong, and it is not likely that this bond will diminish any time soon.

Of far lesser strength in Nepal is the protection of these gods and goddesses, placed centuries ago by kings and patrons who did not foresee that these

left: **Shakyamuni Buddha.**
12th century, copper alloy, gilt, 48 cm.
This superb example of Nepali metal craft depicts the historical Buddha in his most typical pose, seated in meditation, one hand in his lap, the other pendant in the earth-witness gesture. Replicas of its head are used to demonstrate the "lost wax" bronze casting process in the museum's technology section (see page 119)
Photo Rupert Steiner

Linga, symbol of Shiva.
Bronze, 15 cm, 11th century.

The abstract form of the linga ("sign") is the most sacred object related to the worship of Shiva. It signifies two concepts: Shiva's power to create and his power to control creativity by transmuting sexual energy into spiritual energy. The phallic shape of its upper part is the actual object of worship. Its lower part is a grooved and spouted base *(jalahari)* whose purpose is to drain off precious liquid oblations. It symbolizes the female principle and sexual organ *(yoni)*. The drain spout is always pointing to the North and, in Tantric belief, it is inauspicious to dwell in this direction from a linga.
Photo Rupert Steiner

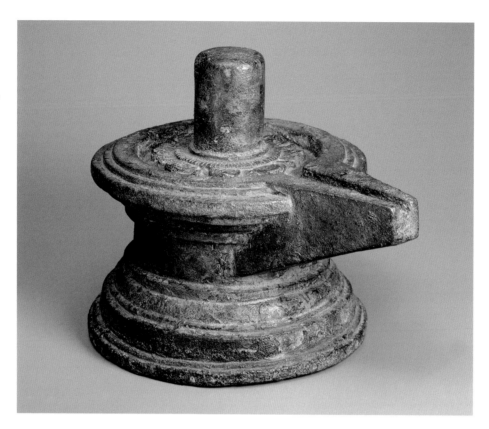

items of worship would be highly valued as works of art by a twentieth century Western connoisseurship - to be placed on faraway pedestals absent of the vermilion, the flowers, the incense and the veneration of young and old. Neither did they foresee a day when the disorienting fallout of headlong modernization would severely affect the age-old communal institutions of the Valley, so that the value of ancient heritage would become downgraded among the modernizing elite even though the lay citizenry remained as pious as ever. And so, the Valley watched helplessly as the gods and goddesses went into foreign exile.

Not that the crime of idol lifting is over. The very neighbourhood of the Patan Museum itself continues to be eyed by criminals. Statues of deities are still stolen here and elsewhere in the Valley,

and religious paintings spirited off. Across the square just to the North of the museum, barely a hundred feet away, is the shrine with a uniquely-crafted dancing Mani Ganesh in copper and bronze. The statue had been stolen years ago, but fortunately was recovered by the police and finally ended up in the museum's collection. Identified by local people as "their" Ganesh, the deity was returned to its temple, only to be stolen, recovered, and finally plundered again: more recently, thieves made off with the divinity's head and torso. What you see there today, peering through the steel security grills of the doorway, is a paltry replica of the top half.

Opposite the Patan Museum's main entrance, at the other end of a lane known for its sweetmeats, is a double-tiered temple dedicated to Laxmi-

This dancing figure of Ganesh, the elephant-headed god revered for any auspicious beginning, was the first exhibit to be installed in a prominent gallery location. It was also the first one to leave the museum returning to its original shrine nearby after its provenance had been verified by the temple community.
Photo Thomas Schrom

below: Ganesh now stands behind bars in a contemporary ambience of neon light and blue bathroom tiles, its popularity undiminished even though its upper part was stolen again and replaced by a copy.
Photo Leonard Stramitz

Narayan, half-goddess, half-god. A closer look will indicate that the statue does not boast the high-quality workmanship that was the specialty of Patan's ancients. But that is because the Laxmi-Narayan is an inadequate modern replacement. The original was stolen long ago, and was displayed in the 1994 catalogue of Sotheby's auction house, bright and polished. The starting price for the auction of the piece is marked as US$ 30,000-40,000 in the catalogue.

The question arises, what is to be done with the massive loot of Kathmandu Valley art that is presently scattered all over the Western world? Inasmuch as there is a compelling basis to demand the return of the Greek marbles or Inca jewellery, Pharaonic statues or (much closer to home) Gandharan Buddhistic art, there is an even more pressing need for restitution with regard to the Kathmandu Valley. The smuggled Valley images were part of a living culture rather than merely part of Nepal's archaeological heritage. As Lain Singh Bangdel, Nepal's premier art historian who

has worked tirelessly to highlight the pillage, observes, these are not mere objets d'art, but pieces brought "alive" by veneration. Till they were stolen, the idols would have been revered, and their loss is still deeply felt in the bahals and villages. In many cases, the empty pedestals of statues lifted decades ago still receive tika to this day.

According to one Kathmandu scholar who does not mince his words, "Idol theft is a demand-driven trade led by rapacious cultural cannibals. The culprits are not the local petty thieves who in any case earn a pittance compared to what the art they steal will fetch under the hammer in New York City." The only way to stop this trade in contraband deities, he says, is by hitting at the demand so that impoverished Nepalis at the bottom of the smuggling chain do not feel the need to wrench statues from their moorings for shipment overseas. The demand for Valley loot from art galleries, auction houses, and museums constitutes the "pull factor" as far as this criminal trade is concerned. The "push factor" has to do with the erosion of the Valley's traditional institutions, the absence of responsible leadership, as well as the greed of Nepali middlemen right down the social ladder.

Quite a few statuary images remain *in situ*. And all is not lost. The word is slowly spreading that Kathmandu Valley devotional art found in the museums and collections around the world is indeed, nearly to the last piece, stolen. Collectors and museums have begun to feel an ethical pang for restitution.

Kanak Mani Dixit is chief editor and publisher of the "Himal South Asian" monthly published in Kathmandu.

A New Abode for the Gods

When the devotees and people of the country are deprived of their gods and goddesses their hearts bleed. The stealing of such religious images is an atrocity, a serious crime which the civilized world should take steps to stop. Let us hope that someday these stolen sculptures will be returned to their respective temples and shrines.

Lain Singh Bangdel: *Stolen Images of Nepal* [1]

As much as one might hope for the return of the gods to their original abodes and places of worship, this would mean an end to many museums. As already mentioned, most of the treasures now in the Patan Museum came to this second home having first been pillaged for the international art trade.

But whenever looting and smuggling could be intercepted by police or customs officials, the confiscated artifacts would be kept as material evidence and locked up in police or court storerooms for years. By the time they were finally given over to various museums, there was no record of their provenance left, making it all the more difficult to return the images to their original sites.

In light of this, the idea to establish a new museum of ancient Nepalese art within the restored Patan palace was an obvious one: not only was the building there – in a most splendid setting – but the storerooms on its premises already contained two such repositories of stolen art, portions of which had once been exhibited, though no longer accessible to the public. Even if these two "collections" were not the result of any purposeful acquisition but rather of indiscriminate fate, they had been kept separate for the simple reason that one should contain only objects of metal, and the other one those of stone.

It took some convincing of officials to combine and reorganize these groups as an integrated museum collection and with only a select choice of exhibits. As this approach was further developed, it also included complementing the selected pieces with a small number of additional objects, in cases where they could enhance the intended educational import. These pieces were acquired from the local antiquities market – and thus also withdrawn from the risk of illicit export – or given as donations to the museum.

As much as the need for a new museum was obvious, the question as to how to realize it was definitely not. Apart from developing the physical and institutional museum design, the creation of a teaching collection from such a random assembly of objects, many of them damaged, posed a great challenge. How many of these artifacts could or should be displayed within the given space limits? Who would have the comprehensive knowledge and impartial wisdom to make such a choice among more than 1500 items of diverse religious connotation, to present the selection in a meaningful way, and with a didactic concept that hopefully would also appeal to visitors from abroad?

The task luckily was taken up by Mary Slusser,[2] one of the greatest experts in the cultural history of Nepal, a scholar acknowledged and esteemed by both Nepali and international colleagues. Significantly, she also had experience in conceptual museum design. Even though the task was daunting, as Slusser often admitted, she was able to create a meaningful collection, whose educational impact has been widely recognized.

Indra, king of the gods, lord of the rains. Gilt copper alloy, 14.3 cm, 9th–10th century. In this tiny image which is a thousand years old (reproduced here at almost double its real size), Indra holds a lotus seed in his hand extended in the charity hand pose, the *varada mudra*. In India, this once-exalted god is scarcely remembered but in Nepal his cult as the benevolent rainmaker still flourishes among both Hindus and Buddhists during the popular Indra Jatra festival, although many other gods now share his rain-making duties.
Photo Rupert Steiner

Object 219: unidentified image, Nepal, 17th-18th century, bronze.
One showcase in the first gallery explains why the identification of some deities is difficult because of their peculiar attributes and iconography.
Photo Thomas Schrom

above right: This gilt copper face of the Buddha (and the clay statue it was sheathing) was returned from the museum collection to its original shrine.
Photo Leonhard Stramitz

She joined the project at a time when the major restoration work on the building was being completed and the job of setting up the exhibits had just begun. Working for several years, she accomplished the actual selection of each object on display including its proper identification and, often for the first time, its accurate dating. She is also responsible for their thoughtful interpretation and coherent grouping within separate galleries, and the subdivision of these into "families" of related items. It was not only the oldest and best of these objects that were chosen but also sometimes even less masterful works, if they could help to illustrate or include a particular aspect or object otherwise missing in the context. The curious case of one unidentified object throws some light on her arduous task – and on the ingenious ways in which the mind of a serious scholar seems to work even in sleep. In one of her many letters she wrote: "Now I have to tell you a crazy thing about an addition to Case no.4. I seem to take this load with me (mentally) and "work" on it when I'm not in the office. But this one really is the limit. I woke up the other night and looked at the digital clock which said 2:19 and I thought, oh, that's the number of the unidentified image that would be good for Case 4. In the morning I felt that could not possibly be right but when I got to the register, sure enough object 219 was exactly the right choice to illustrate the particular point I had in mind. Go figure!"

One other instance of Slusser's comprehensive (and in retrospect clairvoyant) conceptions deserves telling. In the gallery dedicated to Lord Shiva and his family, she suggested we display at least a photograph of a typical stone relief showing the divine couple Shiva and Parvati amidst their

family and attendants, since the existing collection did not have such an original sculpture. This motif of *Uma-Maheshvara* is one of the most popular ones in the long history of Nepalese sculpture, and not surprisingly a prize target for the art trade.

As fate would have it, two years after the museum's inauguration, an anonymous American art collector voluntarily returned four pieces of pilfered art to Nepal after being shown "Stolen Images of Nepal", a book in which the eminent artist and art historian Lain Singh Bangdel documents such cases of plunder in the hundreds. Encouraged by this act of voluntary repatriation, the *Himal South Asian* magazine published a cover story, "Gods in Exile",[3] and reported which other objects from Bangdel's book had been identified in Western museums and auction houses. One of these happened to be an *Uma-Maheshvara* stone relief 800 years old, which stood on a lonely pedestal in the Museum für Indische Kunst in

Uma-Maheshvara, stone relief, Nepal, 12th century. Stolen in 1982, acquired three years later by the Museum für Indische Kunst in Berlin for 100.000 DM, and voluntarily returned to Nepal in 2000.
Photo courtesy Museum für Indische Kunst, Berlin

By far the oldest object on display is not an artifact but the fossil shell of an extinct mollusk, a hundred million years old. The ammonite, called *shaligram*, is found in abundance in the river gravel of the Kali Gandaki and symbolizes Lord Vishnu. Some also see in its whirl the coiled trunk of the elephant-headed Ganesha.
Photo Thomas Schrom

Berlin. Alerted by this article, the museum felt obliged, as had the anonymous American collector before, to give the sculpture back to Nepal.

The divine couple, back from exile,[4] now graces the Patan Museum where it replaces the photograph which Slusser had first insisted on including - an unintentional counterpoise to two items of the museum's own collection which were returned to their original sites after their provenance had been verified. One is a clay statue of Shakyamuni with its gilt copper sheathing which went back to its monastery in Kathmandu. The other one is the statue of Ganesh mentioned earlier (see page 97) that was returned to its temple from where its head and torso were stolen again.

To conclude this sad subject with some sort of consolation for those admirers of Nepali art who may deplore the fact that most of what they have bought, or have ever seen in museums, is loot: it seems that by far the largest and oldest collection worldwide – and one that has not been stolen in the first place – still exists in one sanctuary not very far away from, but, albeit, not in Nepal. It is in Lhasa's Potala,[5] particularly in the Lima Lakhang, where a repository of Nepalese images in the thousands has been collected, bearing witness to the long-lasting and extraordinary Tibetan patronage of craftsmen and artists from Nepal for more than twelve hundred years.

Mary Shepherd Slusser

Treasures beyond the Golden Door

Planning for the museum concept began in earnest in 1993. With the help of many individuals, particularly experts from the Smithsonian's museums of Asian art in Washington, D.C, an approach evolved which was novel for Nepal. The new museum would not offer a random sampling of art objects as did other museums in Nepal. Rather, it would stress the cultural aspects of the objects on display. Themes and ideas would drive the selection and arrangement of objects, not the objects themselves, allowing the museum to serve as an interpretive center for the vast outdoor museum surrounding it – the Kathmandu Valley itself – where many similar objects remain within their cultural context.

As a first step, the existing collections of more than 1,500 objects had to be analyzed. In the end fewer than 200 were selected for permanent display, some for their artistic significance, some for their didactic value alone. Categories were established and interpretive labels developed, an unusual addition to Nepalese museum practice. While the narrow interiors of the old palace afforded an unparalleled acquaintance with traditional architecture and a king's view of the royal square, they were not, however, ideal for the display of works of art. To maximize the limited floor space, suspended cases were designed – turning the low ceiling height into advantage – and were constructed on site, ingeniously using as a prototype a locally-made fish aquarium.

The museum today includes seven principal galleries spread over two floors of the Keshav Narayan Chowk: one is an introduction to Hindu-Buddhist iconography, three are devoted to Hinduism, two to Buddhism, and one to the

metal making technologies of lost-wax casting and repoussé. Both these techniques have long been practiced in Patan and are the principal methods by which the exhibited metal objects were created.

One singular exhibit, specifically purchased for the museum, is displayed in a separate room: it is an illustrated manuscript dating from the seventeenth or eighteenth century depicting various aspects of Hindu Tantric belief.

The open central stairwell is flanked by a number of immense carved wooden roof brackets and the ground floor foyer and adjoining garden display a representative selection of inscribed stone stele. The stele range from seventh century royal edicts (in Sanskrit and in an obsolete script) to nineteenth century examples which record religious affairs.

Displayed in a separate wing is a collection of historic views of Nepal with copies of early sketches and engravings and with duplicate photographs of those, among others, which had been discovered in the Vienna Ethnographic Museum. They document the Kathmandu Valley over the last 150 years and provide the only record of certain monuments destroyed in the 1934 earthquake. One historic photograph shows the Patan Darbar Square in 1899 (see page 34).

The majority of the objects exhibited are sculptures of Hindu and Buddhist deities created in the Kathmandu Valley, many of them in the nearby workshops of Patan itself. Most are "bronze" (or, more correctly, copper alloy), fire gilded and often inset with precious gems. There are also bronzes in the Tibetan style, many of them actually made by Nepalese artisans – and a number of splendid

Shikarakuta (small temple) Chaitya. Nepal, 15th-16th century, Copper alloy, gilt, semi-precious stones
Object 384/5, 17.3 cm.

This exquisite temple-like chaitya was undoubtedly destined for a monastery or household shrine. The chaitya's plinth is arranged as a *mandala* of 20 angles and each niche holds a tiny, movable Transcendent Buddha. Between the projecting tympanums *(toranas)* at each corner are *kinnaras*, mythical beings half-bird, half-human. Against the nine-ringed finial are shields embedded with jewels of the color associated with the Buddha enshrined below. The crest jewel, a crystal, represents the Buddha's cranial bump, the *ushnisha*. The pair of rings beside the finial probably once held a sacred canopy.
Photo Rupert Steiner

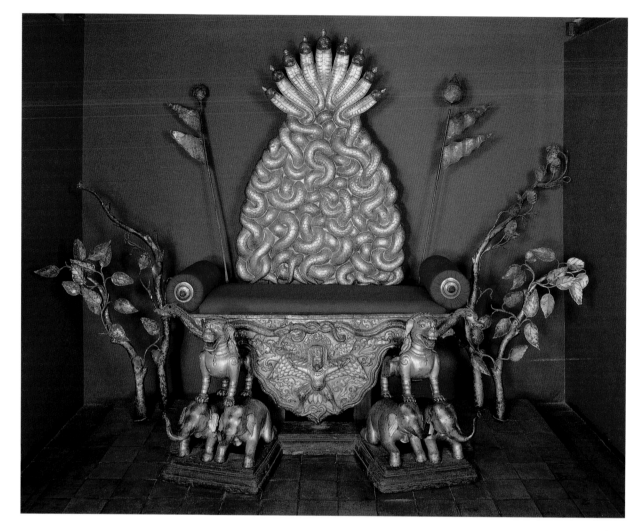

Throne of the Malla Kings. Local artisans presented the throne to the king Srinivasa Malla of Patan in 1666, and inscribed it with this curious injunction: "Anyone can hire this throne on payment of two rupees to the families of the coppersmith and carpenter."
Photo Stanislav Klimek

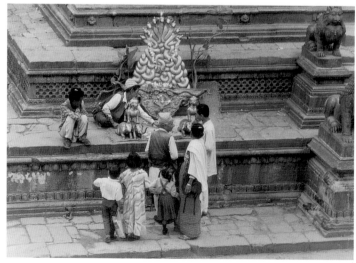

Views of the Bodhnath model

below and opposite:
Krishna Mandir, Patan Darbar Square. In a custom said to have been initiated by King Srinivasa (reigned 1661-1684) the throne is displayed once a year in front of the Krishna temple. Devotional songs are sung in Krishna's honor with instrumental accompaniment.
Photos Thomas Schrom

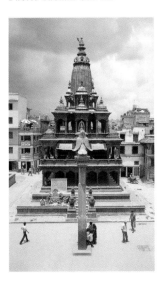

eleventh and twelfth century bronzes from the western Himalayas, Bangladesh and northern India. As a monument of paramount importance to Nepalese and Tibetan Buddhism, the stupa – or chaitya, as it is known in Nepal – is represented by a large-scale model of the monument known as Bauddha or Bodhnath made by the Nepalese artist Rabindra Puri, by a selection of miniatures designed as altar pieces or portable shrines, and by exquisite architectural drawings. One of these drawings depicts an impressive seventh century chaitya still to be seen a mere stone's throw from the museum's golden door (see page 24).

The miniatures include a bejeweled confection in gilt copper a few centimeters high, in which are enshrined tiny images of four of the Five Transcendent Buddhas, one on each side of the stupa; the fifth, Vairochana, is imagined at the zenith, or in the interior of the chaitya. These images are perfectly executed, and even though they are removable, they have remained with the chaitya up to the present day.

Among the most important objects in the collection are a circa twelfth century seated Shakyamuni Buddha, an epitome of the Nepalese achievement in the metallurgical arts (see page 94) and a group of eleven gilt-copper repoussé images which were discovered in the late 1970's, either as a bona fide archaeological find or possibly a thief's temporary cache. The latter had remained unstudied except for the most cursory examination until the reconstitution of the Patan Museum. They are important markers in the evolution of Nepalese art and were almost certainly made in Patan (dated by inscription to 1065), being stylistically comparable to a stone sculpture of the sun god, displayed on the opposite wall. This image of Surya was carved

in Patan in the same year and, until not long ago, stood near the museum and close to another statue of Surya from 1083, still in place.

Probably nothing on display more perfectly reveals the unity of the museum and the culture from which its exhibits derive than two related objects: a painting and a throne. The latter is a dazzling creation, its seat supported by large, hollow gilt-copper repoussé elephants and lions, and its back composed of intertwined serpents and flanked by pairs of gilt-copper trees. Nearby is a 17th century painting illustrating the texts of devotional songs to Krishna. A precious document, the painting bears the second oldest text in the Newari language to be critically studied and translated.

After the last Patan king was defeated and left the palace, a legend arose that one day he would return, and thus, until 1950, the throne, the king's bed, and hookah were kept in readiness behind the Golden Window. Every spring, however, the throne is carried across the street to be shown for a day at the Krishna temple in accordance with a royal command dating from around the time the throne was constructed – a command that the Patan Museum still honours. After a day's homage by the citizenry, the throne is returned to the museum, none the worse for wear.[1]

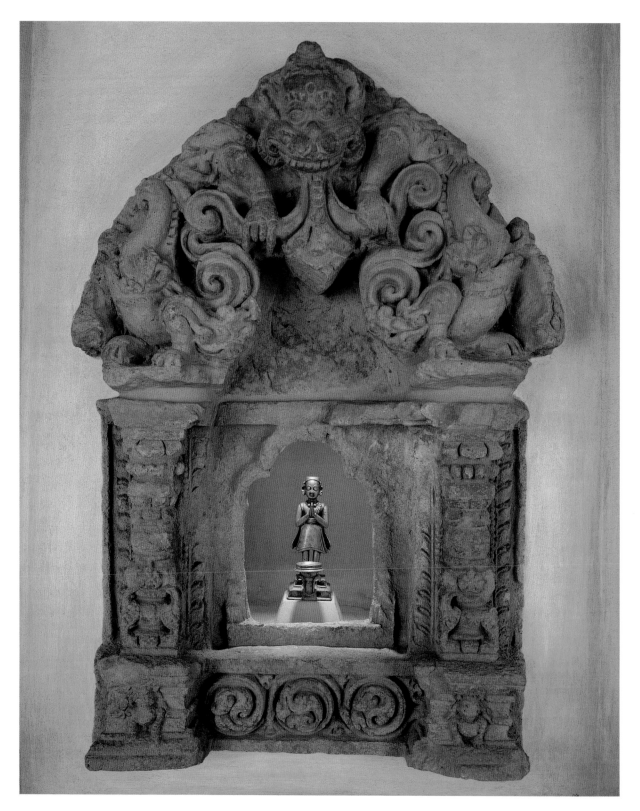

Donor figure with ritual oil
lamp installed in a wall niche
at the entrance to the museum
galleries. The two parts of the
terracotta framing were found
in the museum's garden during
renovation and are probably
remains of a temple destroyed
in an earthquake.
Photo Stanislav Klimek

Museum Design

Darkness and Light[1]

Already as children we have felt an inexpressible chill as we peered into the dark depth of an alcove which no ray of sun ever reached. Where is the key to this mystery? Ultimately it is the magic of shadows. If the shadows were banned from its corners, the alcove would become a mere void.

Jun'ichiro Tanazaki: *In Praise of Shadows*[2]

In Asia, light and darkness seem to be much closer together than in our minds. As two sides of the same coin they belong to each other. What our occidental intellect divides into particles, opposites, contrasts, and cause and effect, in the holistic world view of the Orient appears as a whole, a totality with no distinct borders, both this and the other, yin and yang, darkness and light. *In Praise of Shadows* is a pensive and still provocative essay on the oriental perception of beauty, written in the 1930's by the Japanese novelist Jun'ichiro Tanazaki. He reflects upon the different attitudes between East and West with regard to darkness and light:

Darkness does not distress us; we surrender to it as inevitable. If light is scarce then light is scarce; we will immerse ourselves in the darkness and there discover its own particular beauty. But the progressive Westerner is set upon always to better his lot. From candle to oil lamps, from oil lamps to gaslight, and on to the electrical one. His quest for better light never ends, he spares no pains to eradicate even the slightest of shadows.

The design of this back-lit wall niche in Bhaktapur's Kuthu Math served as a prototype in the development of similar showcases at the Patan Museum.

Since the time of the Gothic cathedrals, the Christian sanctuary, the altar, stands in the brightest part of the church. And when we exhibit the precious old idol of a saint in a museum today, then it is always in the best possible spotlight. For us, darkness is negative, murky; in the Western

perception of architecture light is essential. "The sun never knew how wonderful it was," the architect Louis Kahn once said in Kathmandu, "until it fell on the wall of a building". Some 40 years earlier, Le Corbusier had written in the same vein, "Architecture is the masterly, correct and magnificent play of built volumes brought together in light. To see form under light is what our eyes are made for."[3]

In Nepal, however, the gods dwell in darkness, in the smoky, innermost shrine of the temple, surrounded in stillness by a few butter or oil lamps. Only rarely do they leave this abode: then, however, the gods are bathed with water and light and are carried around through their cities in festive processions, until they return again to the darkness of their sanctuaries.

Many of the treasures now in the Patan Museum were taken from their places of worship a long time ago, mostly by thieves, as previously noted, and were kept in government repositories, with no record of their original sites. This posed a serious question: should we treat these bronze sculptures as the deities which they are, or as art objects and exhibits? Should one leave them in the darkness of a deep alcove, with traces of blood sacrifice and vermilion on them, the golden patina just barely lit, or should one expose them to bright daylight or its equivalent of cold halogen or fluorescent illumination, profaning them once and forever to become objects in the histories of religion and art?

There is no denying – and for some it is even consoling – that the transfer of icons and ritual objects from churches and temples to museums and private collections divorces religious art from its lived experience, in worship of the Divine, but

Wall niche displaying a statue of Lord Vishnu carried by the sunbird Garuda.
Photo Rupert Steiner

also elevates it to the status of a secular religion – the worship of art.[4] Can we, to paraphrase Joseph Beuys, forego a grace which goes beyond beauty? Would not a humane museum concept almost demand that the gods of an ancient culture be left, as far as possible, in their context and not be divested of darkness, their most common shroud?

It would have been a great relief at the time of these early reflections, had I known the opinion of Ian Alsop, a scholar of Newar scripture and culture (and operator of an Asian art domain on the Internet which also hosts the website of the Patan Museum). When we discussed a draft of this chapter, he provided the following comment:

The above use of "profaning" is perhaps too strong. It is true that there is tremendous value in maintaining the state in which these objects are now seen in temples. I feel that the contrast between viewing an image of a deity as a sacred icon and as a work of art do not have to be mutually exclusive, as they are so often thought to be. To see a sculpture in its original condition, cleaned and repaired, divested of offerings of clothing, jewelry and puja powder, and under flattering lighting, is not necessarily to profane it. From a certain point of view one can make a strong case that it is in fact the reverse.

The difference between a statue in a temple and a statue in a museum is more in the attitudes of the people who view it than in the lighting. I remember visiting the display of Bertie Aschmann's collection in the Rietberg Museum in Zürich, and being struck by an elderly Tibetan lady performing discreet devotions before the images. They instantly became gods again. I'm sure you've seen flowers offered to the Shiva Linga or coins to Ganesh in the Patan Museum – in fact in almost any museum.

From the other angle, that these sculptures are also art, it was always instructive for me to watch the reactions of my sculptor friends in Patan – all good Buddhists – when they were examining illustrated books of Nepalese art, which they devoured. They praised fine workmanship and elegance, but criticized failings and crudeness. The comments and appreciation were all, quite naturally, from the point of view of the artists. These gods were clearly primarily works of art to them. Since what excited these artists were photographs of well-lit images, it seems obvious that for the perception of art, good light is essential – whereas it does not preclude a devotee's admiration.

We had not found a precise answer to these questions with regard to the Patan Museum, preferring ambiguous ones which meander between darkness and light. We had to accept as inevitable the metamorphosis of gods into exhibits, and to illuminate them at least with mellow incandescent lights. The best we could devise in some cases, and as a small consolation to their past, was to emulate the traditional way of lighting a deity's statue from below with oil lamps. This was achieved by inserting a mirror at the bottom to reflect the showcase light from above, also giving additional illumination of the exhibit's contours from below.

Before getting lost in these serious and technical matters, let me deviate for a moment with the metamorphosis of another specific and previously sacred object. On my journeys in quest of comparable palace museums at home and abroad, I once came to Schloss Ambras[5] in Tyrol. In the 16th century, this castle had been the summer seat of Ferdinand II, an archduke of the House of Habsburg. It was he who had established one of Europe's first *Wunderkammern* or curiosity cabinets, as these early forerunners of museums were

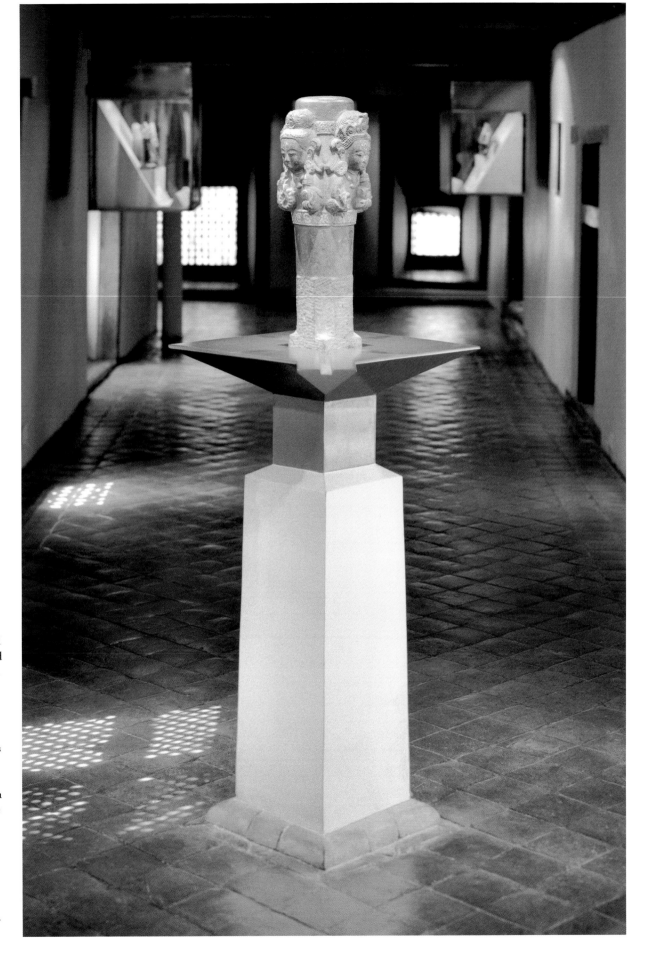

*Where there is no darkness,
there is neither day nor night,
neither being nor nonbeing,
only the one Shiva alone.*

Stella Kramrisch: *The Presence
of Shiva*[6]

View of the gallery dedicated
to Lord Shiva and his family,
including Ganesha, his
elephant-headed son. Mounted
on a pedestal in the foreground
is a "four-faced linga" of stone,
its original base *(jalahari)* lost
and replaced in a deliberately
adapted, modern design
(compare with the linga on
page 96). One of the four faces
on the linga's shaft shows both
Shiva and Uma, his spouse, in
a joined, androgynous image, a
popular motif in Nepal. As the
number five is sacred to Shiva,
representing the five elements
of the cosmos, a fifth face has
to be imagined at the top,
facing the zenith and
connecting the light from
above with the darkness below.
Photo Stanislav Klimek

A bronze cast of Ganesha's mount, the "rat" *(mussa)*, offering a ball of sweetmeat to his master who is known for his sweet tooth.
Photo Stanislav Klimek

called. There, in a corn silo renovated for his "collection of collections", he sheltered a great treasure from overseas that would fall victim of a curious fate. It was the multi-feathered "Crown of Montezuma",[7] an exhibit which, according to evil tongues, was plucked of its plumes of Quetzal, the bird-god of the Aztecs, to add a feather to the hunting hats of imperial guests in the Alps. Today, the headdress is a showpiece in Vienna's Ethnographic Museum while a replica, though more complete, must suffice in Mexico City.

One other purpose of visiting Ambras – and thus to return to the subject at hand – was to see Christian Bartenbach, a renowned lighting specialist, in his local studio. He rewarded me with some basic advice on museum illumination and warned me not to walk into the fashionable trap of exposing singular exhibits with bright spotlights in an otherwise almost dark room. At that time, I admit, this seemed rather attractive to me, just having seen such a stunning display in Oaxaca, at Rufino Tamayo's museum of pre-Columbian art, surely one of the finest of Mexico's many exquisite museums.

Such stark contrasts of light,[8] Dr. Bartenbach said, put a great strain on those functions of the brain which first of all have to consume physiological energy in our need for visual orientation in near darkness, thus leaving only little for the actual "seeing" of objects. The usual result is, as anyone may learn from personal observation, that the museum visitor gets tired much sooner than in less contrasting light conditions - even if one may feel exalted from the little which was actually perceived with full attention.

The existing light conditions in the old galleries in Patan proved conducive for the essence of what I

believe I learned. The many small windows, cut deep into the external walls, provide sufficient daylight, filtered through delicate lattice, to orient oneself. Set rather low and close to the floor, they do not have a blinding effect on one's eyes when standing in front of a showcase. But when seen in the long perspective of the palace's narrow rooms, they cast a row of faint glows into the enveloping semi-darkness, picking up the distant glimmer from outside and reflecting it on well-polished floor tiles. In a few places, where such windows would be distractingly mirrored in the glass of a showcase, the windows are shaded with a panel suspended before them.

Within the two galleries of the new and reconstructed East wing which are much wider however, we limited this daylight for orientation to horizontal strips, openings left between the roof and external walls. These strips of light make the roof seem to float as a wide brim while its interior timber surfaces receive indirectly reflected ambient light. This softens and absorbs the exterior's dominant blue tones, blending them with the warm hues of the interior (see page 46). All other gallery illumination comes from incandescent bulbs which spotlight the exhibits, usually from more than one side, before melting into the darker background.

Only one ray of sun penetrates this interior twilight: it comes, and only at noon, through a small triangular hole on the southern wall high up under the roof. Sometimes cutting through the wafting trails of incense smoke, announcing a draft that found its way into the stillness, this shaft of light slowly traces a short-lived arc on the floor to give orientation – both in time and in space – for those who seek it (see page 88).

One of the many different lattice windows in the museum, typically found on the first floor of Malla period buildings.
Photo Stanislav Klimek

Showcase interiors are individually designed for groups of related exhibits. They are lit from above, but sometimes a mirror is placed at the bottom to render an additional reflection of light from below to a particular object.

Exhibition Technology and Design

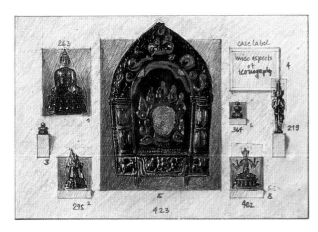

An ambitious state-of-the-art design for the museum installations had to take into account the technology, skills and products available in Nepal. One could import sophisticated showcases and lighting, for example, but how would they be maintained and repaired in the future? All solutions had to be as simple as possible, adapted to local constraints, yet purposeful and visually attractive.

Technical questions like long-term preservation of sensitive exhibits (under adverse environmental conditions), appropriate illumination, and security provisions against theft or burglary often required answers for which no patent solutions existed and where no catalogues of high-tech equipment would help. The following outline of certain design solutions suggests, however, that necessity can be a fertile mother of invention, and Patrick Sears, a museum design specialist from the Smithsonian Institution in the United States and advisor to the project, was a most helpful midwife in the process.

The Kathmandu Valley's humid climate and the high level of dust and other pollutants are fundamental problems for a museum, particularly in a historical building like this whose wooden latticed

Design development for showcase interiors.

openings did not allow the introduction of glazing to seal the environment, a prerequisite for an air-conditioning system. The necessary protection of exhibits was therefore relegated almost completely to the showcases – apart from a number of large, freestanding objects. The showcases are made of simple, handmade steel sections, welded and screwed together, with glazing and sealing made as airtight as possible – a home aquarium of sorts serving as our prototype. Easy access to showcases would have introduced the problem of how to lock and seal a hinged door, so a system was developed in which the showcase is accessible only by removing the entire glazed box from its base and interior display structure. This operation is considerably more difficult, but also a greater deterrent to theft, even for museum insiders, than to use a masterkey or a picklock. Within the case, the objects are insulated from the radiant heat of the light compartment above with sandwiched panels of frosted glass. The light compartments in turn are well ventilated to avoid heat accumulation and can easily be opened for inspection and maintenance.

The tempting array of contemporary light fixtures in the international market has also been dispensed with, due to the difficulties of maintenance and supply. With great satisfaction we even determined – after many a mock-up – that the incandescent light of the normal reflector bulb available in Nepal provides the most flattering illumination for sculptures anyway, especially those in bronze and gilt copper. This light is neither as sharp as that of 12 volt Halogen bulbs, nor as diffuse and unreflective as fluorescent tubes.

Showcase interiors are standardized to some extent with regard to size and technical detail. But each case has a somehwat different shape, individually

Detail from an illustrated manuscript of Hindu Tantrism; Bhaktapur, Nepal, 17th–18th century. Handmade paper, ink, watercolors. Donated by the Patan Museum Project.

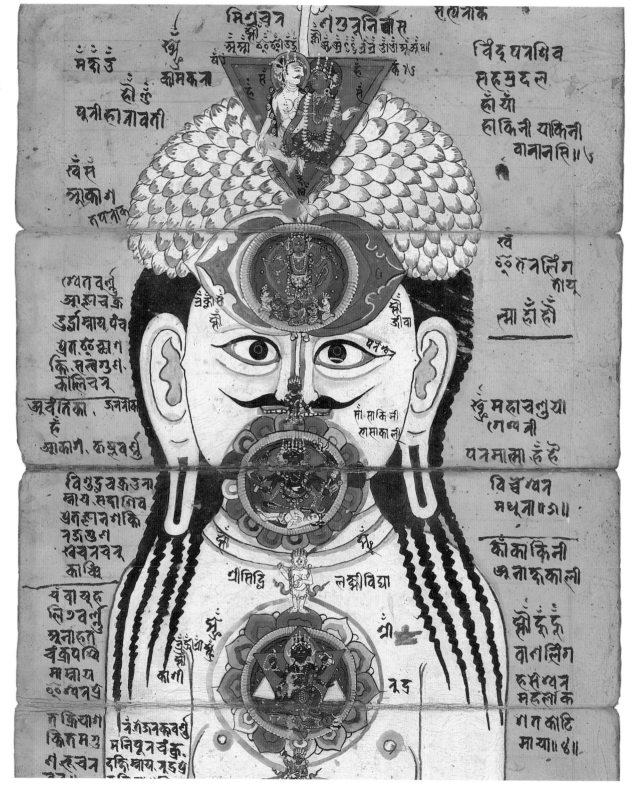

The 21 folios of this illustration show an annotated diagram of the esoteric "subtle body" which Hindu tantrism conceives to lie within the "real" human body. This body contains specific energy centers, lotuses or *chakras* (wheels, circles), usually seven, and arranged vertically as illustrated here.

Each *chakra* represents an ascending level of consciousness, beginning with the *muladhara chakra* at the base of the spine and ending above the head (shown here) in an inverted, thousand-petaled lotus, the *sahasrara chakra*. This chakra is the locus of Shiva in his esoteric form of Pure Consciousness (*chaitanya*) which pervades the universe.

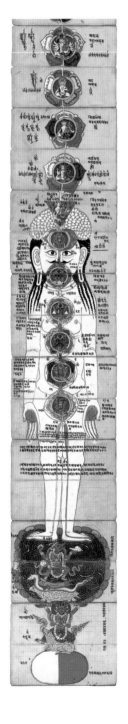

designed for a group of related exhibits. In turn, each object is given its own particular space, either in a niche receding from the slanting main plane, or elevated on a small ledge protruding from that slope – an interplay between negative and positive volumes of the same simple triangular form. Thus, in contrast to the typical and repetitive "line-up" of objects in museum showcases, each image gains its own spatial aura and dignity, distinctive from its neighbours, yet in balanced harmony with them.

The design of one particular showcase takes into account the unusual dimensions of the exhibit: a continuous illustration measuring 20 cm in width and two meters in length spreading over 21 pages of a leparello-type manuscript. It would have been logical to display it vertically in order to keep upright both script and image (a schematic human figure representing the *chakras* of the esoteric "subtle body"), but that would have meant forgoing the possibility to see each page at close range. Thus, the folio is laid out horizontally, as it would have been on a floor or table and the glass top of the case is tilted at an angle just above a handrail to invite visitors from both sides to come up and lean over the manuscript for a close view.

This gallery dedicated to Lord Vishnu also exhibits some of the royal paraphernalia of the former kings of Patan – believed to be incarnations of Vishnu.

Stone sculptures are left uncased, inviting a reverential touch by the hand. The one in the foreground deliberately blocks the long vista behind, withholding for a few further steps the surprise view of the Malla throne at the far end (see page 104). Discernible on the wall in the left background is a pair of ceremonial staffs, sheathed in embossed silver. An angled mirror above them enables a convenient view of their top.

Photo Stanislav Klimek

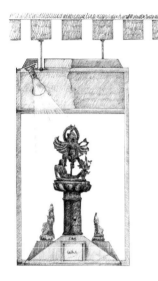

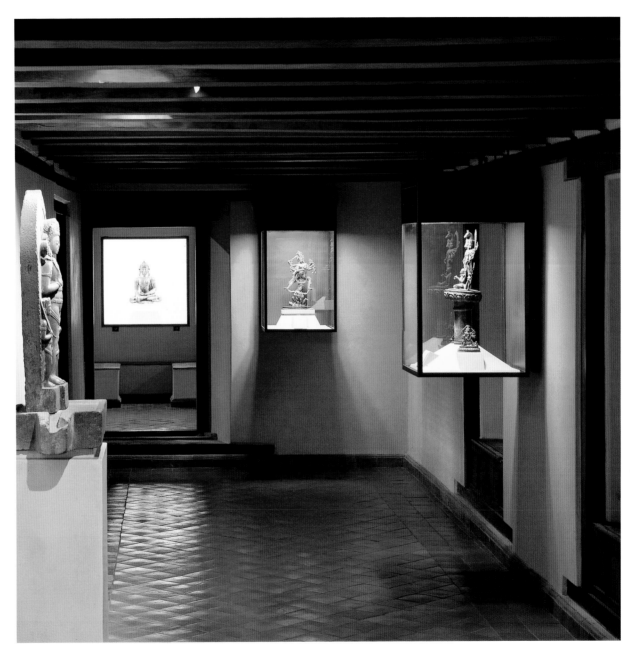

Design sketch and view of showcases typically suspended from the low ceiling, thus leaving the floor beneath uncluttered from otherwise needed pedestals. The vista through the door of this narrow room entices one to step into the next gallery for an encounter with the museum's superb image of Shakyamuni Buddha (see pages 46 and 94).
Photo Rupert Steiner

Mary Shepherd Slusser

Traditional Metal Crafts of Nepal

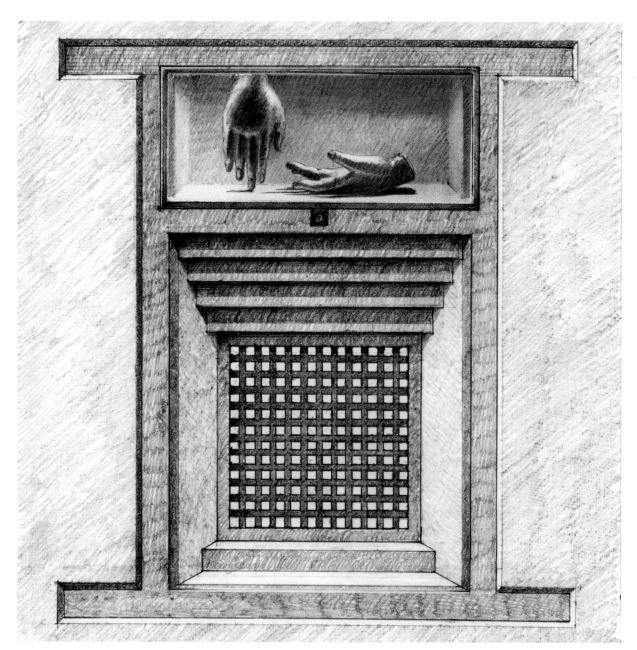

Technology gallery: the niche above one of the typical latticed windows was converted into a showcase with a glazed steel frame in front and a hidden light box above. The case exhibits a pair of gilded bronze hands, cast in the lost wax process which is explained in this gallery. Bigger than life-size, the hands may have been part of a large image of Shakyamuni Buddha. In this most common pose he is seated in meditation, one hand in his lap, the other in the gesture of "calling the Earth to witness" by touching her with the tip of the middle finger at the moment of his enlightenment.

The skill in transmuting metal into superb works of piety – and art – such as exemplified in this museum's exhibits is an outstanding Nepalese achievement. It has been the object of foreign esteem since at least the seventh century A.D. when a Chinese diplomat commented on it in his memoirs. In the 13th century at the request of

Kublai Khan, a deputation of some eighty Newar artists came to Tibet and their leader, Aniko, went on to fame as head of the imperial workshops in what is now Beijing. But since long before that, Tibetans have been patrons for cult objects and roof finials, fashioned either in Nepal or in Tibet by domiciled Newars.

Succeding stages of the lost
wax bronze casting process,
demonstrated with replicas of
the 12th century Buddha statue
on page 94.
Photos Thomas Schrom

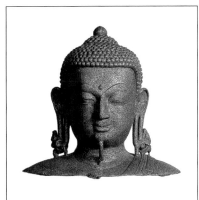
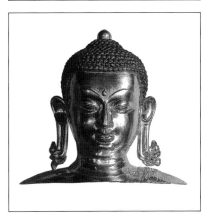

Flow chart of metal casting in
the lost wax process.
Diagram by Renuka Savasere

4 LAYERS OF
CLAY ADDLIED
AROUND THE WAX
FIG FOR CASTING
MOULD

WAX REMOVED
FROM MOULD

MOULD IS BAKED
AND HOT MOLTEN
METAL POURED
INTO MOULD

MOULD IS
BROKEN

METAL FIG
IS FINISHED
WITH FILES
AND CHISELS
AND SAND PAPER

DECORATION AND
REPAIRATION

ASSEMBLY OF
ALL PARTS

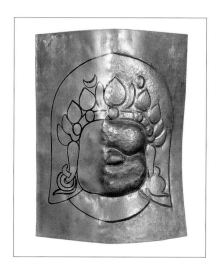 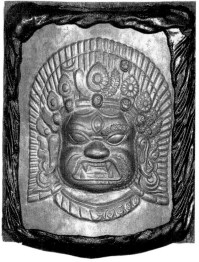 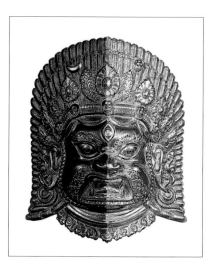

Three stages of the *repoussé* process of making a Bhairav mask. The last half-image shows the final fire-gilt sheen.

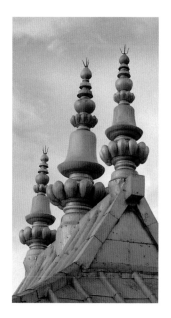

The gilt finials of the Jokhang, Lhasa's most sacred shrine, were made by Newar artisans in the same basic shape as on their temples at home.

Images and ritual or domestic objects are either created by pouring molten metal into a prepared mold or hammering out a design from sheet metal. During an internship with the museum, Renuka Savasere, graduate of the National Institute of Design in Ahmedabad, did a thorough study of the lost wax casting process *(cire perdue)* in the workshops of Patan and developed the first conceptual design for an educative display of this traditional craft in which a wax model is encased in clay, then melted out ("lost") to be replaced by molten metal. After the metal hardens the clay mold is broken away to reveal a metal replica of the wax model.

The other technique of hammering sheet metal into relief is called embossing or *repoussé*. The latter is a French term loosely translated as "pushed again," reference to the alternating front and back hammering necessary. The practice of this difficult technique is relatively rare worldwide. Nepal is an exception with a continuous tradition which accounts for a wealth of sacred images, objects, and architectural embellishment throughout

Nepal. Large hollow images of dovetailed sheet metal are often supplemented with solid cast hands and other details.

Curated by James Giambrone, the technology section of the museum illustrates and explains the various stages of both techniques as a still flourishing tradition of Patan.

A widespread application of *repoussé* are the many variations of finials *(gajura)* which crown the ridges and tops of all temples and shrines both in Nepal and Tibet. They sanctify such pious works of man, linking him – and the building – with the firmament's zenith, and thus with the universe and creation. For Hindus, the bell-shaped base of the *gajura* is a symbol of Shiva. The bell's inherent sound is Shiva himself who, in this manifestation, incorporates the sound of all other instruments – the primordial sound of the universe. Typically, *gajura* and images, whether hammered or cast, are "fire gilt". The use of paint and "cold gold" (gold leaf applied without heat) is confined to works made by Tibetans or by Newars for the Tibet trade.[1]

One page of an 18th century metalsmith's reference manual. Both sides of this small accordion-folded manuscript are filled with sketches and notes pertaining to technical and stylistic aspects of the metallurgical arts. This particular page shows, on a square grid, the proportions of a typical *gajura* as preferred in Patan – as distinct from the style favoured at that time in Bhaktapur.

Temple finial *(gajura).*
Gift of Niels Gutschow and Götz Hagmüller.
This finial is a replica of the one crowning the reconstructed Gyasilin Mandap on Bhaktapur Darbar Square (see page 11). Both were made in Patan in 1990 from several pieces of sheet metal joined by skillful dovetailing.
Photo Stanislav Klimek

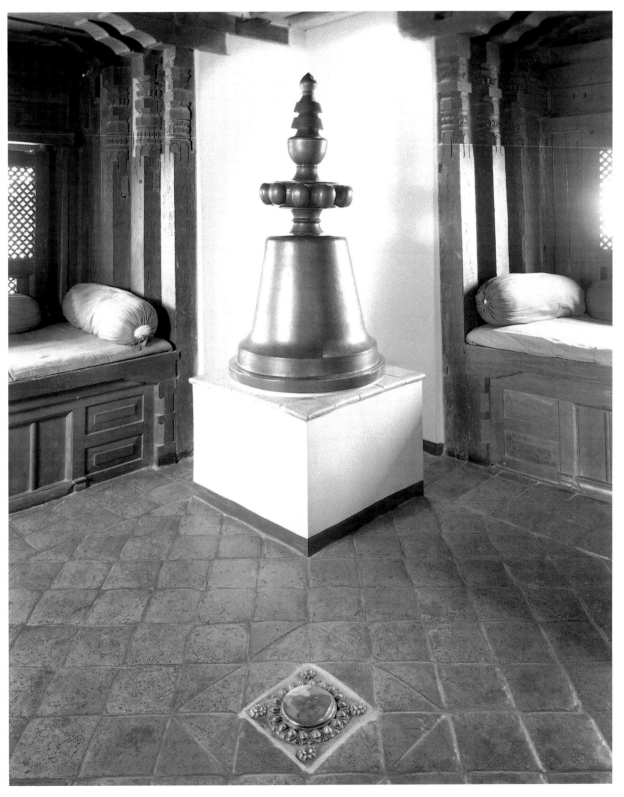

The Colour Scheme:
Monochrome

In 1887 Max Müller, the German Sanskrit scholar and editor of *The Sacred Books of the East,* noted that our ancestors of two thousand years ago were more or less colour-blind – like most animals.[1] Xenophon and Aristotle, for example, were aware of only three colours in the rainbow and Democritus knew only four. Today's children even in the West, till the age of about eight, are not aware of the mixed colour violet,[2] a hue defined only in the 18th century. Before that, the violet was a blue flower and the purple dye of the *purpura* shellfish was deemed to be red.

One could make a similar claim about rural Nepal. Like in many traditional societies of the world, differences and nuances of colour are not consciously perceived and therefore not distinguished by specific words, as if colour were a luxury unaffordable in pre-industrial cultures. The hues that predominate are those of rust or dust, earth and terracotta, untreated wood and natural yarn.

Most people's clothing in the villages of the Valley is "earth-brown", the same colour as their buildings. And while a few colours are precisely defined by symbolic values in painting and ritual– like the red of cloth aprons on pagoda roofs, colours are otherwise neither artistic nor individual means of expression in everyday village life.

Coloured interior rooms are found only in a few historical buildings in Nepal. An even rarer sight are painted wooden elements visible from outside, as on the carved timber framing of the palace's Golden Door and Window which Gustave Le Bon documented in some detail and published in the form of a coloured lithograph. However, since the date of the paintwork is unknown and its authenticity doubtful, we did not attempt to reconstruct what can in any case hardly be ascertained from the scarce traces of paint which remain.

right: The museum's "Golden Door" showing the timber jambs painted in bright red. *Lithograph after a photograph by Gustave Le Bon*[3] *in 1885*

far right: Brick and stone pavement details at the center of the garden courtyard. The four corner features are receptacles for oil lamps, adding the soft colour of flames in the evening. *Photo Rupert Steiner*

If the above assumption of "colour-blindness" in much of Nepal seems like a justification for the monochrome use of colour in the Patan Museum, the choice of colours (or rather their reduction) did in fact also have practical reasons. Exposed building components such as brick, terracotta and wood were already there, as were a couple of whitewashed elements. Yet we deliberately did not paint the inner walls the traditional white in order to reduce any brightness of the background in favour of the illuminated exhibits – Frank Lloyd Wright once called white the "loudest colour of all".[4] We chose a soft brick-red for the practical reason that the underlying plaster, which consists of brick-dust lime mortar, had this colour anyway, so that the inevitable damage caused by the wear and tear to the paint would then not be too conspicuous.

The choice of colour for the frames of the show-cases and for all new, visible construction and fur-nishing elements made of steel was inspired by a similar reason. The dark rust-brown colour has the same tone as the usual rust-protection prime coat-ing, which can be obtained in every paint shop and which would therefore not have to be spe-cially mixed when used for redecoration in the future. We obtained the satin surface by adding boiled linseed oil.

Consequently, the colours used for the insides of the showcases, as well as for the information labels and boards which present pictures and texts, were simply a consequence of the foregoing: their matt brick, red, sepia or sandy hues produce a kindred colour scheme for the majority of the exhibits, the smooth and reflective surfaces of which are usually of bronze or copper and in many cases are also gilded.

To bring the circle to a close, even the museum's few textiles have been included in this scheme of reddish colours.

right: Painted steel bracket and pillar of the arcade at the museum's rear elevation.
Photo Stanislav Klimek

far right: Roof framing detail at one of the café pavilions. The different hues of natural timber are enhanced under indirect daylight, though blend in monochrome harmony.
Photo Andrew Bordwin

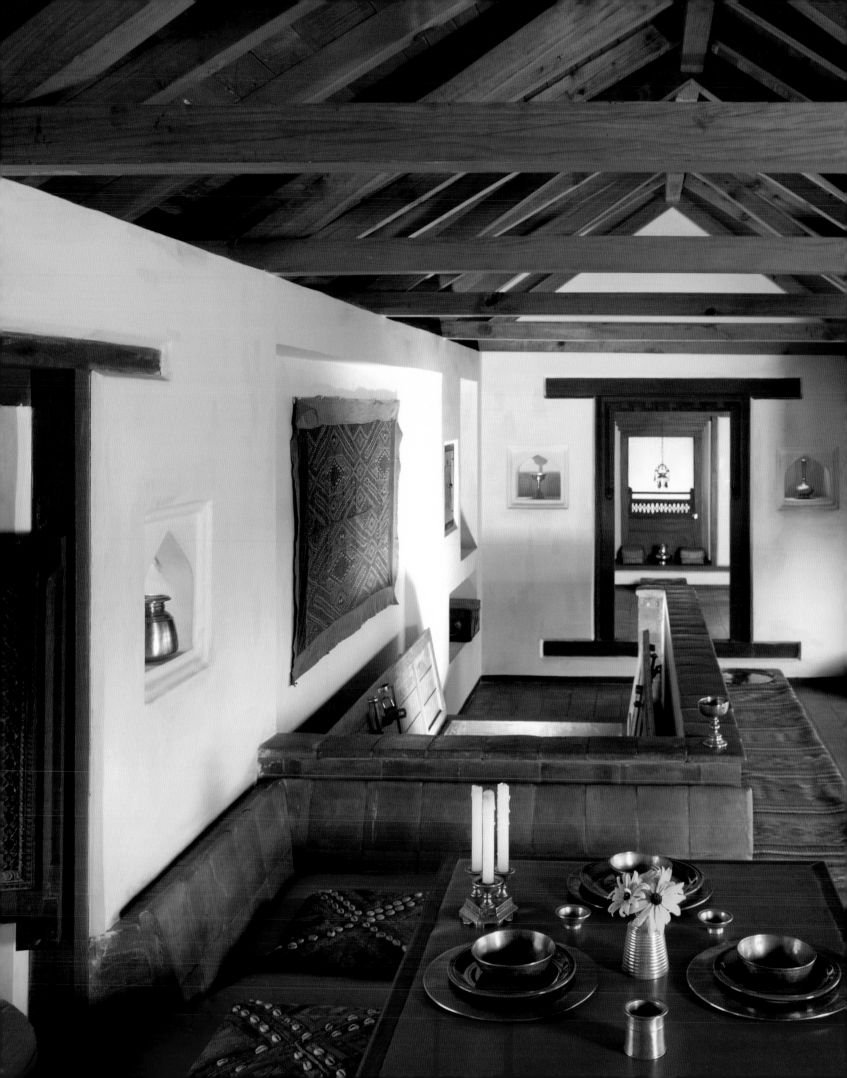

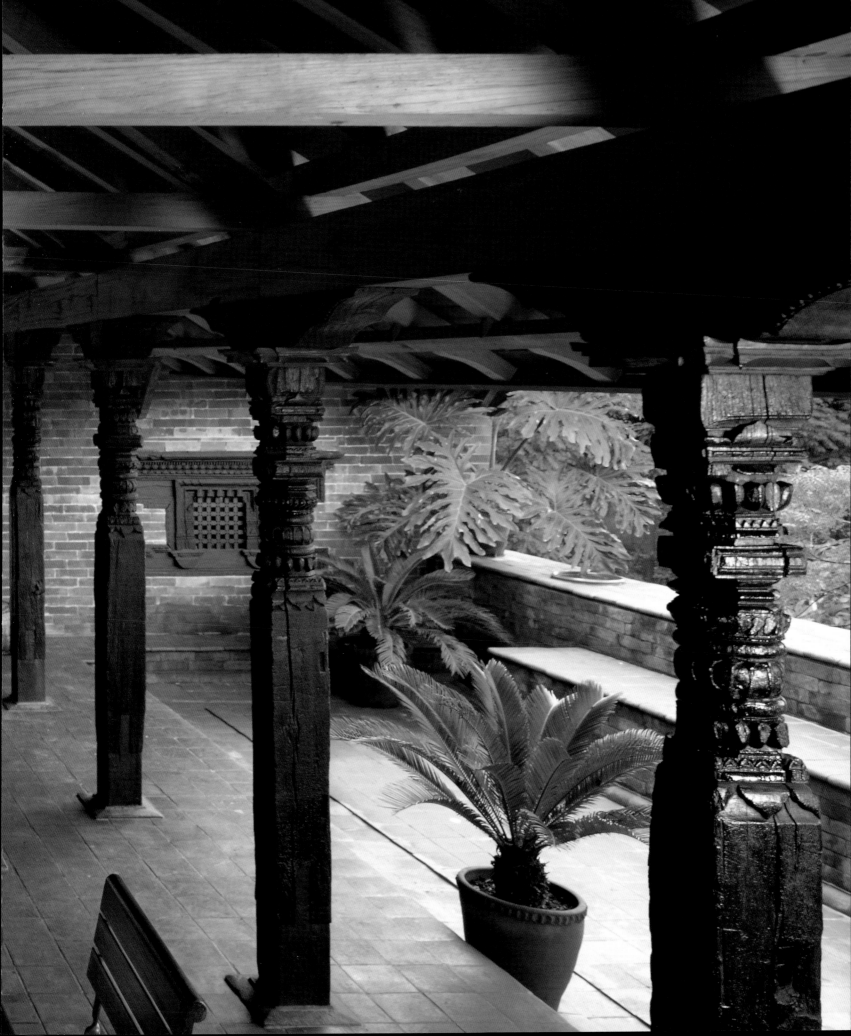

A Sustainable Future?

Not Just a Museum Piece

What took my breath away was the Patan Museum, which is arguably the best museum on the subcontinent with plenty of lessons for us in India. What is so exceptional is the world class presentation, the quality of the display, accompanied by educative commentary, impeccable maintenance and expert management.

Gurcharan Das: *Miracle in Patan*[1]

Giving a historic building that has outlived its original purpose a new lease on life is one way to utilize a cultural resource for the benefit of future generations. Often an innovative, adaptive design is required for an appropriate new use that ideally preserves the substance and value of historic buildings. The former palace of the kings of Patan, and its current incarnation as a museum for Nepal's sacred art, the Patan Museum is an example not only of architectural precedence in the region, but also of its institutional design.

Nepal affords extremely limited funding for culture – and heritage-related institutions and activities. Not surprisingly, public museums generally have low standards of display, information and maintenance, inadequate security provisions, and under-qualified staff. Sometimes, there isn't even enough money for the electricity bill or to replace a light bulb – bad news for the visual enterprise of a museum. South Asian art museums in general appeal to neither local people nor to foreign visitors used to higher standards. They typically don't achieve their educational aims or realise their potential as tourist attractions despite the often high quality of their collections.

Museums are traditionally conceived as non-profit cultural and educational institutions. They depend on annual government allocations for operating costs and their staff are civil servants. Entrance fees, kept deliberately low by government bodies, are not at the museum's disposal and there are no incentives to raise other revenue because such income would go back to the central budget office. Maintaining and operating a museum of international standards in a country like Nepal is thus impossible unless the issue of independent sustainability is addressed. How to operate such a museum without further burdening the national budget?

The challenges for a new alternative museum in Patan were not only in devising an institutional structure that allowed autonomy and income

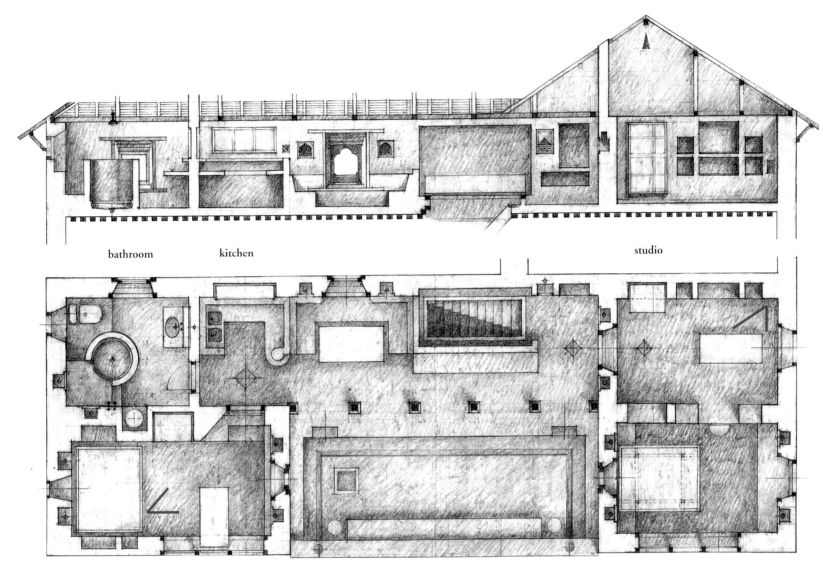

bathroom kitchen studio

terrace

above: Guest studio, plan and section. The visual angle of the two photos below is indicated in red.

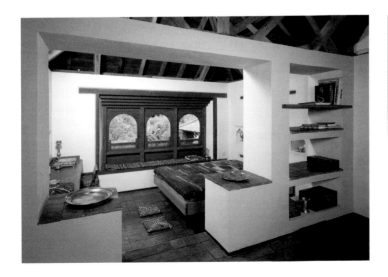

right: Guest studio interiors. The theme of "thick walls" is also employed in the design of these new interiors. *Photos Stanislav Klimek*

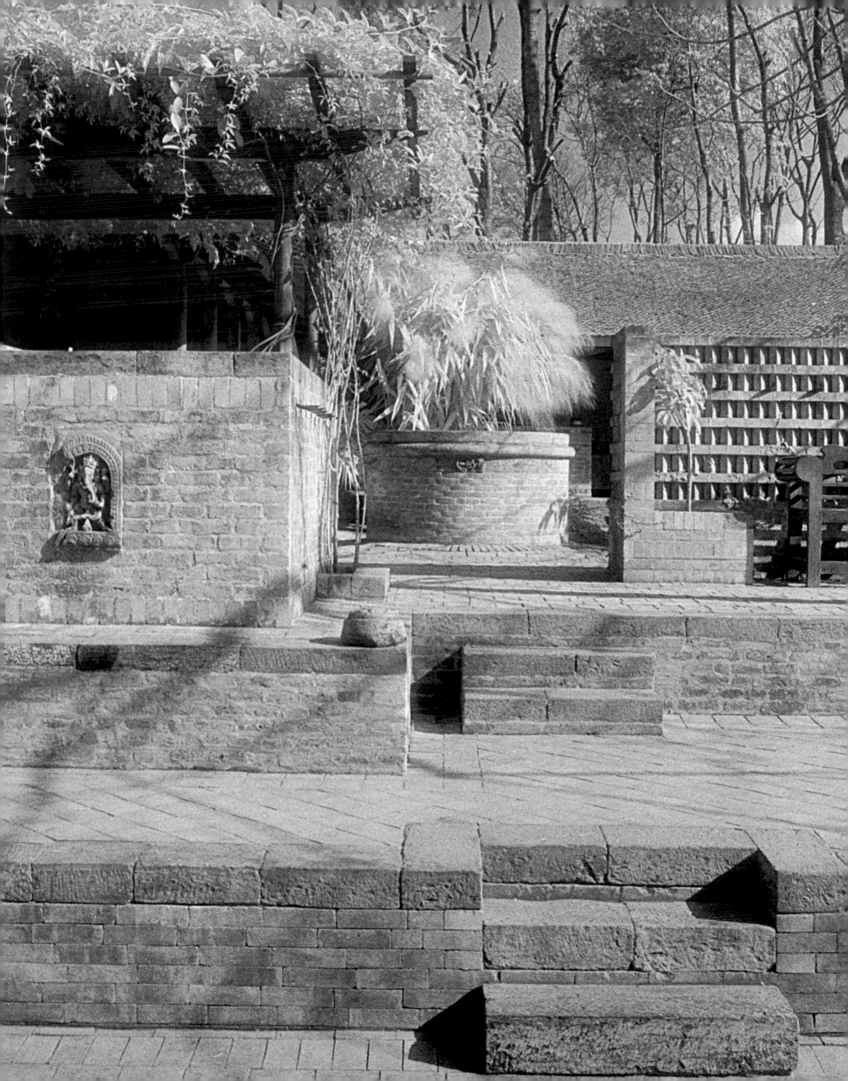

Design sketch for the Museum Gift Shop and its logo.

left: The entrance to the museum café leads between new screening walls towards the ancient well of the palace. Ganesha's stone image to the left augurs well for a new lease of life of this garden.
Photo Tim Linkins

generation, but also convincing the Government to try out such a novel scheme. With the advice of local and Austrian consultants, the Department of Archaeology, the legal custodian of Nepal's cultural heritage, agreed to an institutional framework allowing the Patan Museum to be administered as a semi-autonomous, public corporation. This was the first time that a cultural institution in Nepal was granted this critical legal basis which allows it to run more like a private company than a government office. In this case the restoration of the building and installation of the museum, largely funded by an Austrian gift, served as the start-up capital for this venture.

The constitution of the Patan Museum Board gives it the right and duty to operate the museum as a revenue-generating cultural institution, guide its development plans and programmes, employ its own staff, and decide on its pricing policy and revenue generation. Thus, managing its own operational and maintenance expenditures, the museum can maintain high standards independently.

When it opened in 1997, the museum fixed the entrance fee at Rs 10 for local visitors, and Rs 30 for tourists from SAARC countries. For other visi-

tors from abroad, the fee was set experimentally at Rs 120, the equivalent of two US dollars then, but has been doubled since, in light of the Patan Museum's international recognition. The sale of tourist tickets will remain the mainstay of the museum's economy, but there are other facilities to generate additional revenues and also provide client services, a vital component of an international-standard museum. These include:

• The Patan Museum Café in the newly landscaped palace gardens, which has become one of the Kathmandu Valley's most attractive outdoor restaurants.
• The Patan Museum Gift Shop with a selection of Himalaya-relevant art and other books, as well as posters, postcards and other publications, as this book itself, exclusive to the museum.
• The Guest Studio with an open terrace on the top floor overlooking the gardens, an exclusive palace residence suite in the heart of Patan.
• One gallery and the courtyard's open arcades for temporary exhibitions, another gallery overlooking Durbar Square for lectures or seminars, and the main courtyard for cultural performances.

The Patan Museum has had around 40,000 visitors per year since 1997, on average 100 per day. About half of these are foreign tourists. Such numbers seem small in comparison to museums overseas, but Patan Museum's 20,000 annual visitors from abroad constitute 5% of all tourist arrivals (in a country of 24 million), a claim which no other museum in the world can make. Supported by the praise of major travel guidebooks and by coverage in local and international publications, the number of visitors and the accompanying income may well guarantee a sustainable, self-reliant future for the Patan Museum.[2]

Garden and Museum Cafe

The removal of two hundred tractor loads of earthquake rubble from the walled-in area of the gardens behind the museum revealed the remnants of foundations and walls that were most likely part of the original seven courtyards of the palace. A cylindrical deep-well was discovered, excavated and reconstructed with its rim of original stones. Sunken courtyards were laid open with their pavement repaired, and integrated in the landscaping concept which incorporates new buildings, terraces and pergolas for an up-market museum café.

With no features of the ancient garden layout and plantings remaining, the new landscape design employs no historic garden pastiche, either local or foreign. For its footprint of screening brick walls I was inspired by the *Devnagari* and Tibetan scripts to inscribe an abstract and timeless metaphor of Asian culture into the historic soil of this garden.

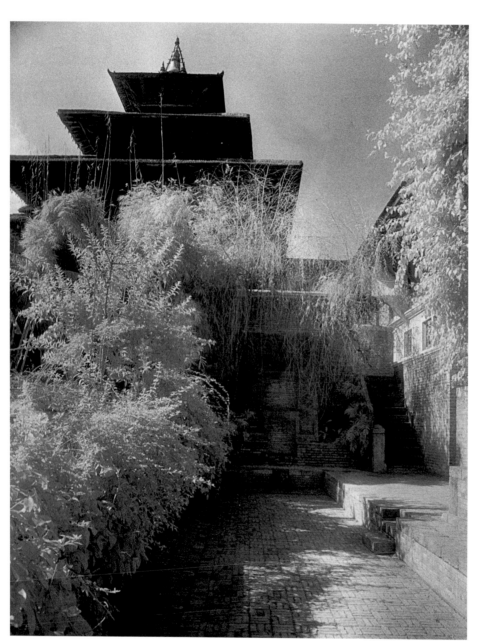

The pagoda roofs of Degutale also dominate the view from the garden. An ancient courtyard pavement was excavated and repaired.
Photo Tim Linkins

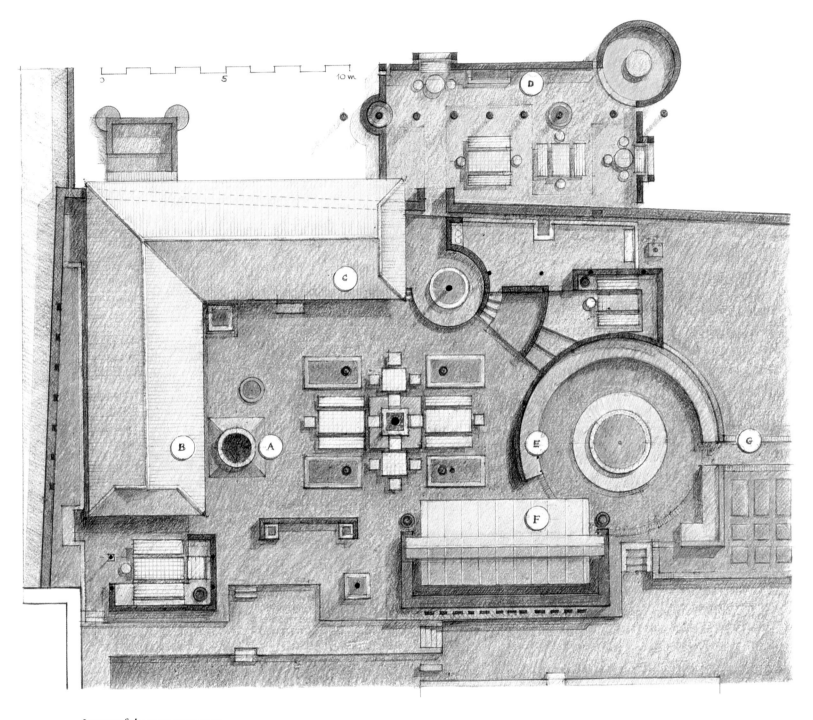

Layout of the open restaurant
area of the museum café.

A historical well
B tile roof pavilion
C kitchen
D beer garden
E open air classes
F brass roof pavilion
G puja flower garden

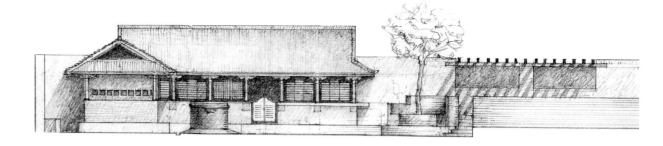

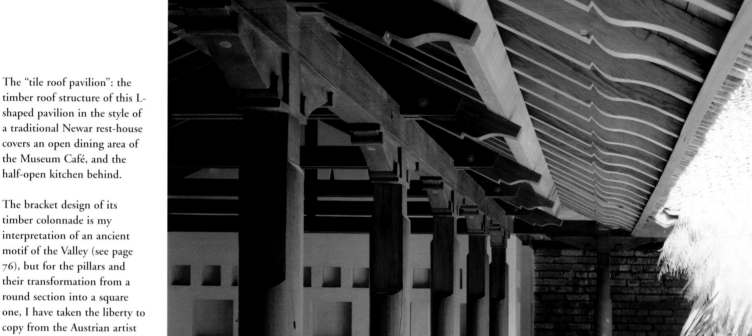

The "tile roof pavilion": the timber roof structure of this L-shaped pavilion in the style of a traditional Newar rest-house covers an open dining area of the Museum Café, and the half-open kitchen behind.

The bracket design of its timber colonnade is my interpretation of an ancient motif of the Valley (see page 76), but for the pillars and their transformation from a round section into a square one, I have taken the liberty to copy from the Austrian artist Walter Pichler whose work I greatly admire.
Photos Stanislaw Klimek

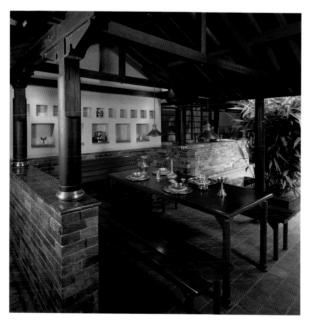

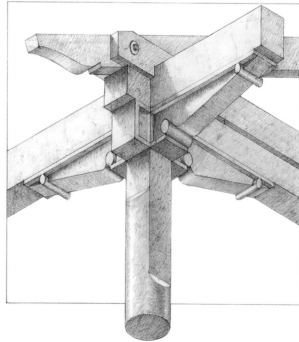

Screening brick walls in circular shape are part of the imagined "ancient" Asian script mentioned before, and – as I realized only after the fact – an unwitting play with the juxtaposition of voids, and with stellar movements in space. *Photos Stanislav Klimek*

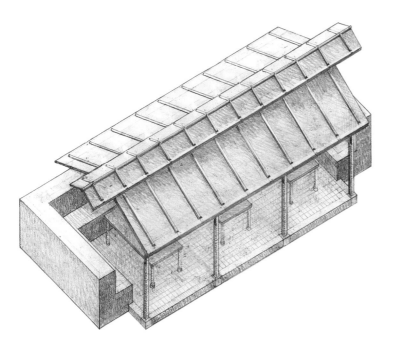

The openness of the "brass roof pavilion" is embraced by the remnants of an ancient wall. *Photos Stanislaw Klimek*

Some tables are adorned with Nepalese board games inlaid with glazed ceramic mosaic.
Photos Stanislav Klimek

both pages: The "brass roof pavilion" with its modern light-weight roof structure of steel and plywood. It is covered with brass sheets, as are many of the pagoda roofs nearby. To avoid the mid-day heat of the tin roof from radiating further beneath, the roof panels are sandwiched with ventilation space in between. The roof's configuration, double-tiered and open to all sides, induces welcome airflow even on hot summer evenings.
Photos Stanislaw Klimek

Garden lamp made by ceramic artist Carole Irwin (mounted on a cast-iron sewer pipe). Its cross section recalls the shape of typical one-tiered pagoda temples of the Valley.
Photo Stanislav Klimek

left: Tables and seats outside the pavilions are exposed to rain but are well shaded by trees and pergolas. All plants in the garden are either indigenous to the lower Himalayas or otherwise well adapted to their monsoon climate.
Photo Stanislav Klimek

Epilogue

Inauguration address by the author at the opening of the Patan Museum in 1997 in the presence of His Majesty, the late King Birendra Bir Bikram Shah. The Austrian Minister of State for Foreign Affairs, Mrs. Benita Ferrero-Waldner, was the guest of honor.

It is a great privilege to say a few words at this august occasion – just as it was the greatest privilege of my professional life to see this palace regain its historical beauty – over a span of almost 15 years.

With the lighting of a sacred lamp in front of Lord Vishnu, to whom this shrine is dedicated, His Majesty the King has honoured an ancient tradition of invoking the blessing of the Divine to such works of man, and at each new beginning.

And a new beginning it is, in the cyclical nature of time, to use this building as a museum, and to display some of the finest art treasures of Nepal in a palace which once was the residence of the Kings of Patan. It has been used for other purposes in the meantime, and only ten years ago, the back wing of this courtyard was still part of a public school. (I know some of our distinguished guests first came here when they were school-boys.)

There is an old inscription on that stone tablet over there which is dated more than a thousand years ago, and which indicates that this site was already a centre of royal power before the Malla dynasties. But even earlier than that, a Buddhist monastery must have been located here, according to the still living tradition of a public ritual which every year places a Buddha image in front of the golden door, and thus recalls the ancient sanctity of this place. Unfortunately, history has recorded neither the architects and master craftsmen who built this palace, nor the artists who created the treasures now in the galleries inside. But even if their names remain unknown, their work is now honoured and accessible as part of the cultural heritage of the world.

That this result was possible – and of such quality – we owe foremost to the descendants of these Nepalese artisans whose craftsmanship has been passed down through generations. To name only two of the project's many carpenters and masons and at the same time to honour them all: Tulsi Silpakar from Bhaktapur was the project's head carpenter and wood carving artist for many years, and Purna Maharjan from Patan was the head mason.

Next in line to be honoured are Thomas Schrom, construction and project manager for six years, and Suresh Shrestha, our main project assistant. They were personally responsible not only for each object's installation but also for the graphic design, layout and production of all museum information visuals.

While they did all this physical and visual work,

the scientific "brain" behind the museum's exhibition concept was the eminent historian of Nepalese cultural anthropology, Dr. Mary Slusser of America's Smithsonian Institution. We owe a lot to her tremendous gift for selecting the exhibits from existing national collections and of providing the abundant information for each object and for each of the galleries.

One particular section of the museum was prepared by Dr. Niels Gutschow, giving insight into one of the world's most mystical architectural symbols, the Buddhist chaitya or stupa.

Another special section, curated by James Giambrone, demonstrates the traditional metal crafts and techniques of repoussé sculpting and of the so called lost wax casting process for which the many workshops of Patan are famous. However, none of all this would have been possible without the support of our home agency, the Institute for International Cooperation in Vienna and without our friends and partners here in the Department of Archaeology. In particular I would like to honour the continuous encouragement of its Director General, Dr. Shaphalya Amatya and his unfailing trust in our endeavours.

Finally, an homage is due to Professor Eduard Sekler: once, for the very personal reason that he was one of my eminent teachers in architectural history in Vienna long ago, and secondly, because it was Professor Sekler who, some 20 years ago, persuaded our Government to renovate this palace with bilateral Austrian assistance. Thus Eduard Sekler is the true "spiritus rector" of this project.

Thank you all. *Namaskar!*

The donors of a public resthouse at Svayambhu, in the reverential gesture of *namaskar*. Carved in stone relief displayed at the Patan Museum.
Drawing by Bijay Basukula

Restoration in progress, 1995.
Photo Tuomo Manninen

Credits:
Patan Museum Project

Executive Partner(Nepal)	**Department of Archaeology**, HMG Nepal, Ministry of Youth, Sports, and Culture
Directors General	Ramesh Jung Thapa, Kadga Man Shrestha, Shaphalya Amatya
Museum Director	Jal Krishna Shrestha
Exploration Officer	Shobha Shrestha
Chief Overseers	Tej Ratna Tamrakar, Amrit Shakya, Jai Charan Kastee
Conservators	Laxmi Mishra, Laxman Shakya
Photographer	Kiran Shrestha

Patan Museum Board (in 1997)

Chair Person	Riddhi Pradhan
Members	Durga P. Pandey, Chitra Thakuri, Ashok Shrestha, Sagar S. Rana, Kamal M. Dixit, Bikash R. Dhakhwa, Sanunani Kansakar, J. K. Shrestha

Executive Partner (Austria)	**Institute of International Cooperation** (IIZ), on behalf of the Ministry for Foreign Affairs
Director	Herwig Adam
Project Administrator	Gertrude Leibrecht
Architect	**Götz Hagmüller**
Cultural Advisor and Curator	**Mary S. Slusser**
Project Manager	**Thomas Schrom**
Exhibition Design Consultants	Davis Alex, Peter Auer, Kai Gutschow, Kai Hagmüller, Roland Hagmüller, Patrick Sears, Georg Schrom, Mohammed Sharique
Conservation Consultants	John Sanday, Erich Theophile
Special Section Curators	James Giambrone, Niels Gutschow
Research Consultants	Alfred Janata, Deborah Klimburg-Salter, Renuka Savasere, Nutan Dhar Sharma
Conservation of Art Objects	Ruediger Andorfer, Paul Jett, Leonard Stramitz, Conny Stromberg
Photography	Andrew Bordwin, Stanislav Klimek, Mani Lama, Tim Linkins, Rupert Steiner, Tuomo Manninen
Graphic Design	Lee Birch, Hans Ljung
Model Maker	Rabindra Puri
Public Relations Consultants	Lee Birch, Patricia Roberts, Liesbeth Waechter-Böhm
Management Consultants	Rabindra Pradhan, Christian Reder
Project Administrator	Ludmilla Hungerhuber
Auditor	Pravin Joshi
Site Coordinator	Suresh Shrestha
Construction Supervisor	Radash Tauzale
Engineering Consultants	Prayag Joshi, Walter Mann, Badan Lal Nyauchu, Sonam Rapten,
Draftsmen	Bijay Basukala, Surendra Joshi, Sushil Rajbandhari

Supporting Institutions:	**Museum für Völkerkunde**, Vienna
	Arthur M. Sackler Gallery and Freer Gallery of Art, Smithsonian Institution, Washington DC

Notes and References

Preface (9-11)

1 **Carl Pruscha** (ed.), *Kathmandu Valley: Preservation of the Physical Environment and Cultural Heritage, a protective Inventory*. Vienna 1975
2 **Eduard Sekler** (ed.), *Master Plan for the Conservation of the Cultural Heritage in the Kathmandu Valley*. UNESCO, Paris 1977
3 **Niels Gutschow & Götz Hagmüller** with R.J. Thapa and Shaphalya Amatya, *Svayambhunath Conservation Masterplan*. Kathmandu 1989
4 **Niels Gutschow and Götz Hagmüller**, *The Reconstruction of the Cyasilin Mandap on Darbar Square in Bhaktapur, Nepal*. ICOMOS International Wood Committee 8th International Symposium 1992. Tapir Forlag, Norway 1994

Introduction (13-17)

1 **Niels Gutschow**, *Stadtraum und Ritual der newarischen Städte im Kathmandutal*. Stuttgart 1982
2 **Robert Powell** – see also pages 24, 36, and 64. Comprehensive presentations of his documentary œuvre are given in **Robert Powell**, *Himalayan Drawings* (ed. Michael Oppitz), Völkerkundemuseum der Universität Zürich 2001; and in *EARTH. SKY. DOOR. SKY – Paintings of Mustang by Robert Powell*. Serindia, London 1999
3 Paraphrased from **Götz Hagmüller** and **Elisabet Lind**, *The Royal Palace Museum of Luang Prabang: Conservation and Restoration Needs*. NIAS, Copenhagen 1991
4 **Bharati Agehananda**, *The Ochre Road*. London 1961. In his autobiography the Austrian authority on *Tantra*, Leopold Fischer, describes his initiation as a *sannyasi* in Benares.

The Legendary Origin of Nepal (18-19)

1 This text is based on the previous publications of **Niels Gutschow & Götz Hagmüller** with R.J. Thapa and Shaphalya Amatya, *Svayambhunath Conservation Masterplan*. (op. cit.); **Götz Hagmüller**, *Wenn das Licht ausgeht in Kathmandu*. Picus, Wien 1991; and quotes **Daniel Wright**, *History of Nepal*. Cambridge 1877, reprint New Delhi 1990
2 **John Irwin**, *The Stupa and the Cosmic Axis; The Archaeological Evidence*. Naples 1979
3 "**Lotus flower**" – just as the acanthus motif of ancient Greece travelled world wide as a universal design pattern (even where the plant itself is not native) and even reached Nepal, so has the lotus symbol spread far from its origins in South Asia. Already in the eighth century it was used in Mongolia where the plant certainly never grew. (Information provided by Niels Gutschow)

Sacred Urban Space (22-25)

1 **Italo Calvino**, *Invisible Cities* (*Cittá Invisibile*. Torino 1972). My rendering is based on the English and German translations by William Weaver and Heinz Riedt.

2 **Richard Lennoy**, *Benares Seen from Within*. Bath and Varanasi 1999. In this outstanding and very personal book on the city of Shiva, Lennoy explains the circular form of two pilgrim maps of Benares as a *mandala* of cosmic order and structure, in comparison with two medieval European examples which also depict Jerusalem as a circle: the psalter map of the British Museum with Jerusalem at its center, and a 12th century crusader map showing the intersection of the city's main streets as a central Christian cross.
3 **Mircea Eliade**, *Images and Symbols*. London 1961
4 **Niels Gutschow**, *Stadtraum und Ritual*…(op. cit.)
5 **Niels Gutschow**, *The Nepalese Chaitya*. Stuttgart/ London 1997
6 **Pratapaditya Pal**, *The Arts of Nepal*, Vol. 1, Sculpture. Leiden 1974

Patan Darbar in Legend and History (26-33)

1 **David N. Gellner**, "Monuments of Lalitpur (Patan)" in **Michael Hutt**, *Nepal – A Guide to the Art and Architecture of the Kathmandu Valley*. Shambala, Boston 1995
2 **Perceval Landon**, *Nepal*. London 1928, reprint Kathmandu 1976
3 **David N. Gellner** (op. cit.)
4 **Eduard Sekler & Michael Doyle**, *Urbanistic Conservation and design Study* PATAN DARBAR SQUARE *1979-1983*. Unpublished
5 **Nutan Dhar Sharma**, *Chaukot Darbar, The Royal Palace of Patan*. Unpublished MA dissertation, Tribhuvan University 1998
6 Such emanations from the large reserves of earth gas in the deep alluvial soil of the Kathmandu Valley have been recently considered for commercial exploitation
7 **Mary Shepherd Slusser**, *Nepal Mandala*. Princeton University Press 1982, reprinted by Mandala Bookpoint, Kathmandu 1998. This two-volume work remains the most comprehensive and insightful study of the cultural history of Nepal.
8 **Daniel Wright**, *History of Nepal*. Cambridge 1877, reprint New Delhi 1990
9 **Hemraj Shakya**, *Manigla Raja Prasada* (The Royal Palace of Mangal Bazaar). Lalitpur 1961

Malla and Habsburg (38-41)

1 **Italo Calvino**, *Invisible Cities* (op. cit.)
2 **Eduard Sekler & Michael Doyle** (op. cit.)

Musings on the Patan Museum (43-51)

1 This quotation of the New York Times architecture critic **Ada Louise Huxtable** is cited from **Victoria Newhouse**, *Towards a New Museum*. The Monacelli Press, New York 1998
2 The original version of this text appeared in the MIRROR, published by the United Nations Women's Organization of Nepal in October 1998.

The Musical Structure of a Palace Façade (52-53)

1 "**musical staff notation**" – I am indebted to ethnomusicologist Dr. Gert Wegner for warning me not to take the simile too far: the linear time dimension of music is on a different perceptual level than the spatial dimensions of buildings – and symmetry occurs only in rare cases as a compositional feature in music.

Restoration and Adaptation (56-67)

1 **John Sanday**, *Building Conservation in Nepal. A Handbook on Principles and Techniques*. Published by UNDP/UNESCO. Paris 1978
2 **Wim Denslagen**, *Conservation in Western Europe: Controversy and Continuity*. Amsterdam 1994
3 "**Charter of Venice**" *International Charter for the Conservation and Restoration of Monuments and Sites*. (Venice 1964) Although its claim to be universally applicable has been repeatedly doubted – with its notion of authenticity challenged as a post-colonial bias and its inconsistencies hardly taken seriously by restoration architects – this declaration of principles is still viewed, for better or worse, as a basic reference for conservation policies throughout the world. See **Wim Denslagen** (op. cit.); **A.G. Krishna Menon**, *Rethinking the Venice Charter. The Indian Experience* (unpublished lecture, Paris 1992). See also **Niels Gutschow**, "Restaurierung und Rekonstruktion. Gedanken zur Charta von Venedig im Kontext Südasiens" in: Deutsche Kunst und Denkmalpflege, 41. München 1991; and **Romi Khosla**, "Current Architecture in India" in MIMAR 41. New Delhi 1992

Thick walls and Long Vistas (86-93)

1 **Christopher Alexander**, *A Pattern Language*. New York 1977. His concept of the "Thick Walls" pattern, originally published in Architectural Design, July 1968, has inspired me ever since.

A New Abode for the Gods (99-101)

1 **Lain Singh Bangdel**, *Stolen Images of Nepal*. Royal Nepal Academy, Kathmandu 1989
2 **Mary Shepherd Slusser**, *Nepal Mandala* (op. cit.)
3 **Kanak Mani Dixit**, "Gods in Exile" in Himal South Asian. October 1999
4 **Götz Hagmüller**: "Divine Couple back from Exile" in Orientations, Vol. 31, No. 10. Hong Kong, December 2000. See also **Sujata Tuladhar**, "Return of the Gods" in Nepali Times, August 16-22, 2000
5 "**It is in Lhasa's Potala**" – see **Ulrich von Schroeder**, *Buddhist Sculptures in Tibet*, Vol. I, Visual Dharma Publications, Hong Kong 2001. I am indebted to Ian Alsop for his assessment that the Lima Lakhang of Lhasa's Potala probably contains more Nepali Buddhist sculptures than all other collections combined.

Treasures behind the Golden Door (103-105)

1 The original version of this text by Mary S. Slusser, "The Museum behind the Golden Door", was originally published in Orientations, vol. 28, No. 10. Hong Kong, Nov 1997

Darkness and Light (107-111)

1 Parts of this chapter were previously published in **Götz Hagmüller**, *Wenn das Licht ausgeht in Kathmandu*. Picus, Wien 1991
2 **Jun'ichiro Tanazaki**, *In Praise of Shadows* (Tokyo 1933 and 1934). My rendering is based on the translations by E.G. Seidensticker and Th. J. Harper. New Haven 1977
3 **Le Corbusier**, *Vers une architecture*. Paris 1923, my translation
4 "**the worship of art**" – the discussion is informed and inspired by **Victoria Newhouse**: *Towards a New Museum*. The Monacelli Press. New York 1998
5 "**Schloss Ambras**" ibid., p.16
6 **Stella Kramrisch**" *The Presence of Shiva*. Princeton 1981. In her powerful evocation of the Great Yogi, she calls him "Ender of Time", the ferryman to take us from this world to the other one, to a nameless beyond to which also the darkness of death is only an allusion.
7 "**Crown of Montezuma**" – personal communication with the late Alfred Janata, curator at the Völkerkundemuseum in Vienna.
8 "**Such stark contrasts of light**" – personal interview with Christian Bartenbach in 1991.

Traditional Metal Crafts of Nepal (118-121)

1 This text is based mainly on Mary Slusser's gallery information in the technology section of the Patan Museum.

The Colour Scheme: Monochrome (122-123)

1 **Max Müller**, *The Science of Thought*. New York 1887
2 "**the mixed colour violet**" – **Adolf Loos**, *Ornament und Verbrechen*. Wien 1908
3 **Gustave Le Bon**, *Les Civilisations de l'Inde*. Paris 1887
4 "**the loudest colour of all**" – quoted in **Victoria Newhouse** (op. cit.) p.11

A Sustainable Future? (126-129)

1 **Gurcharan Das**, "Miracle in Patan" in The Sunday Times of India, January 14, 2001
2 This text was originally published in Nepali Times, December 1-7, 2000

Index